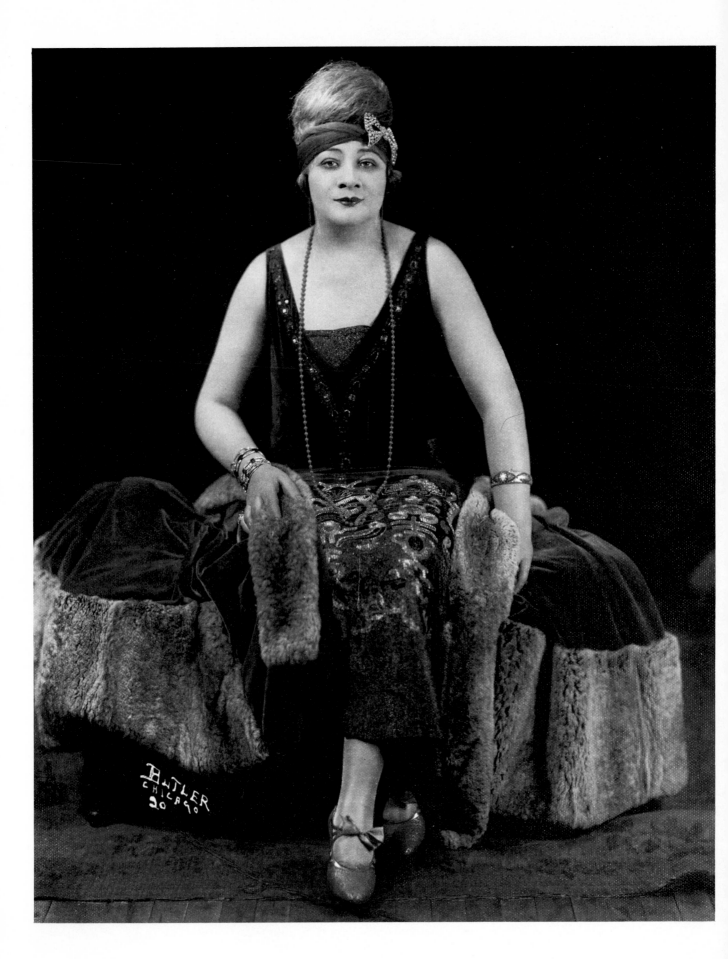

Stars of the
AMERICAN
MUSICAL THEATER
In Historic Photographs

361 Portraits from the 1860s to 1950

Edited by
Stanley Appelbaum
and
James Camner

Dover Publications, Inc., New York

Frontispiece: SOPHIE TUCKER (Sophie Kalish/Abuza; 1884–1966; born in Russia). For decades a pillar of American entertainment. Entered show business 1905. Aside from extensive vaudeville and nightclub work, appeared in at least nine American theatrical shows including *Ziegfeld Follies of 1909; Earl Carroll Vanities of 1924;* and *Leave It to Me* (1938; Porter score). Last N.Y. show: *High Kickers* (1941). Also London and Chicago shows, films, radio, TV. Subject of the 1963 musical *Sophie*. (Photo: Butler, Chicago, ca. 1925, just about the time she introduced "A Yiddisha Momme" in vaudeville.)

Published in Canada by General Publishing Company, Ltd., 30 Lesmill Road, Don Mills, Toronto, Ontario.
Published in the United Kingdom by Constable and Company, Ltd., 10 Orange Street, London WC2H 7EG.

Stars of the American Musical Theater in Historic Photographs: 361 Portraits from the 1860s to 1950 is a new work, first published by Dover Publications, Inc., in 1981.

International Standard Book Number: 0-486-24209-9
Library of Congress Catalog Card Number: 81-66303

Manufactured in the United States of America
Dover Publications, Inc.
180 Varick Street
New York, N.Y. 10014

INTRODUCTION

Almost everyone knows of America's great contribution to the musical theater, and many people know the names of the great composers who made it such a unique American form—Victor Herbert, Jerome Kern, Irving Berlin, George Gershwin and Richard Rodgers among them. But the same immortality has eluded many of the great stars for whom the musicals were created. There wouldn't have been a *Sally* without Marilyn Miller, or a *Naughty Marietta* without Emma Trentini, but both stars are in danger of being forgotten. Today, who remembers Fay Templeton, Peter F. Dailey, William Gaxton or the Brox Sisters?

These performers will finally receive their due in this collection of the most important stars of the American musical theater, surely the most complete ever assembled. The photos, many of them autographed for presentation, are full of the charm of these performers: Lillian Russell, Adele Astaire and the Dolly Sisters are just four of the stars whose photographs capture something of the personality we read about in their reviews.

Through the book (organized roughly by theme within chronology) we can trace developments and trends on the American musical stage. And this volume also sets the record straight on many counts, dispelling myths and popular misconceptions. Some readers will be surprised to see that the original Joe in *Show Boat* was *not* Paul Robeson, as Jerome Kern had wanted, but Jules Bledsoe, a great performer in his own right.

PICTURE SOURCES

The publisher and the two editors are most grateful to the following lenders of pictures. In a sense, this book is dedicated to the energy and generosity of these private collectors and dealers, who have made such a volume possible at a moment when public institutions are sorely tried. (The numbers are those of the illustrations.)

Eubie Blake: 194.
Robert Connally: 153, 159, 193, 195, 206, 215, 220, 231, 235, 254, 288, 301, 308, 335.
Dover Publications picture archive: 62, 65, 78, 167, 237, 238, 269, 270, 309.
Diane Koszarski: 163.
Lim M. Lai: 150.
W. Neale Lanigan: 168.
La Scala Autographs, Inc.: 101, 113, 164, 166, 184, 198, 207, 214, 222, 223, 232, 250, 251, 253, 296, 302, 306, 337, 356, 357.
Robert Tuggle: 114.

The following 83 autographed photos in this book come from M. Wesley Marans' International Gallery of Autographed Photos (This Is My Favorite Photograph of Myself) © (the collection includes all occupations and interests from all over the world, e.g. aviation, politics, sports, women's liberation, literary, the arts, inventors, etc.; competent authorities say no other similar collection compares with this in quality or scope; the Boston Athenaeum had a two-week exhibition in May of 1981 devoted entirely to the showing of 125 of the 5000 autographed photos in this collection): 57, 61, 71, 80, 86, 88, 95, 115, 117, 121, 127, 135, 138, 143, 146, 149, 151, 172, 174, 177, 178, 192, 197, 199, 200, 201, 203, 204, 208, 209, 216, 227, 228, 241, 242, 246, 247, 248, 252, 256, 257, 260, 261, 268, 271, 273, 274, 276, 279, 281, 282, 283, 285, 286, 289, 291, 293, 294, 300, 303, 304, 305, 307, 310, 311, 315, 316, 318, 319, 320, 323, 328, 329, 330, 345, 346, 347, 348, 350, 351, 354, 358, 359.

All the other pictures are from the collection of co-editor Appelbaum.

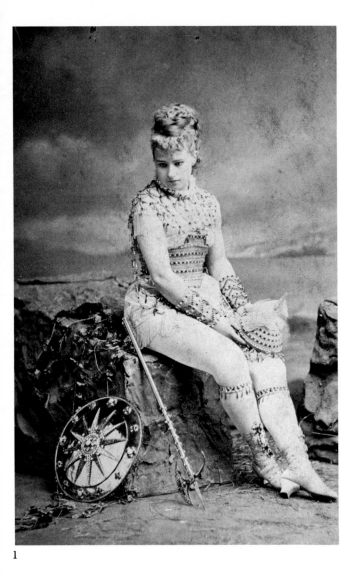

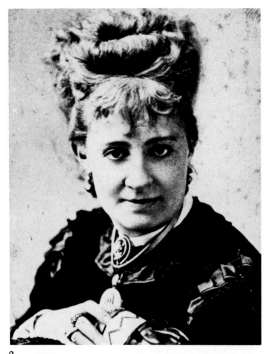

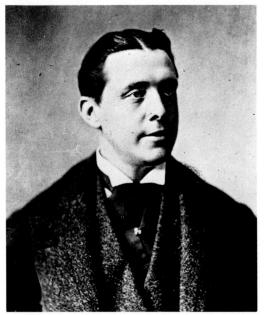

1

2

3

The unprecedented social upheaval and flow of money attendant on the Civil War left American audiences receptive to the more daring entertainments already current in Europe. *The Black Crook* of 1866 (not a musical but a romantic play with ballet sequences) and its spinoffs familiarized New Yorkers with pretty girls in tights. Then in 1868 the American conception of burlesque (a musical spoof of literature or history with parody lyrics fitted to standard tunes) was broadened by the arrival of Lydia Thompson's British Blondes. The three stars, all English, are shown on this page.

1. PAULINE MARKHAM (ca. 1847–1919) was the chief beauty of the troupe. She continued to appear in N.Y. burlesque and variety (the earlier phase of vaudeville) and starred in the *Black Crook* revivals of 1870 and 1873. In the later 1870s she headed her own troupe but by the 1880s was connected only with seedier attractions. (Photo: Mora, N.Y.) **2. LYDIA THOMPSON** (1836–1908). On stage in England from 1852 in burlesque and pantomime (not a wordless show, but a musical clown extravaganza based on children's literature). Appeared in burlesques and other musicals in N.Y. 1868–74, 1877, 1888, 1891–92. **3. HARRY BECKETT** (1839–1880), chief comedian of the troupe. Had appeared earlier in Liverpool. With Lydia Thompson until 1872; then, until shortly before his death, principal low comedian of the leading N.Y. stock company—Wallack's.

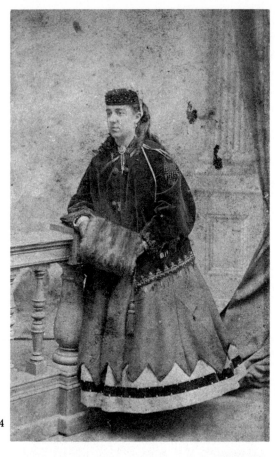

4

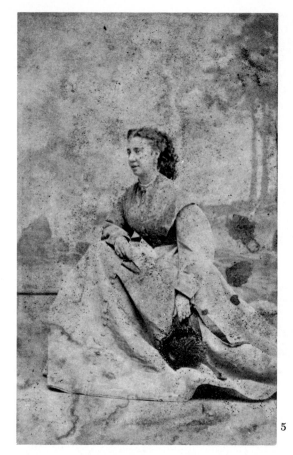

5

6

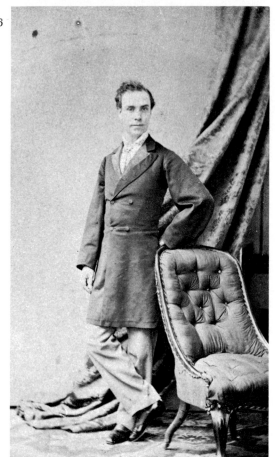

7

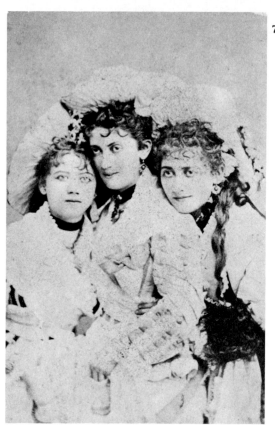

2

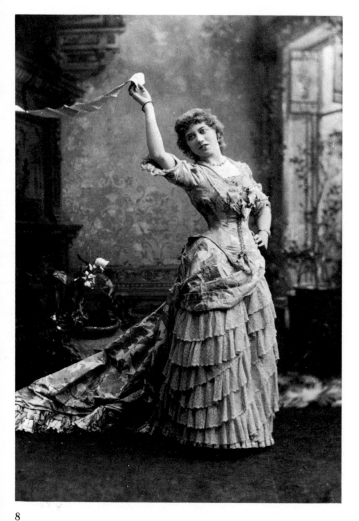

8

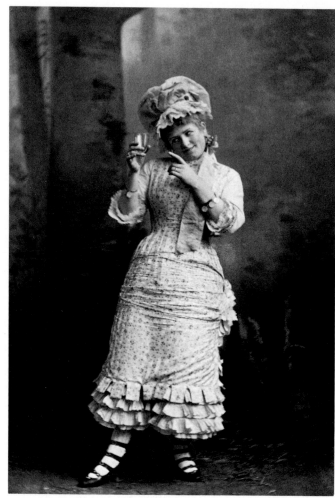

9

4. JENNIE WORRELL (ca. 1850–1899). **5. SOPHIE WOR-RELL** (died 1917). The Worrells (there was another sister, Irene) were the outstanding American exponents of burlesque (preceding Lydia Thompson's arrival) and also prefigured the French *opéra-bouffe* craze that hit the U.S. hard in 1869. They first appeared in N.Y. in 1866 as dancers and general performers in variety and had their own theater in 1867. In the 1870s the sisters went their separate ways, Sophie enjoying the longest career as Mrs. George S. Knight; with Knight, whom she married in 1879, she appeared in straight comedies and some musicals. Knight died at the outset of the 1890s; Sophie's last N.Y. appearance was in 1893. (Photos: Black & Case, Boston.) **6. WILLIAM HORACE LINGARD** (ca. 1838–1927; born in England). In N.Y. variety from 1868 as singer, actor in his own sketches, quick-change artist and burlesque performer. Introduced many English music-hall song hits to America, including "Captain Jinks of the Horse Marines." In full-length plays by 1872; not seen in N.Y. after 1882. (Photo: London & Provincial Photographic Co., London.) **7. VOKES SISTERS.** Left to right: **ROSINA VOKES** (1854–1894), **JESSIE VOKES** (1851–1884), **VICTORIA VOKES** (1853–1894); all born in England. The Vokeses, on stage at home from 1862, came to N.Y. in 1871 with their two-year-old show *The Belles of the Kitchen,* a distinctive kind of musical offering widely imitated in years to come: an everyday-situation comedy for a few performers interspersed with songs and specialities. The sisters returned to N.Y. every season through 1876. Jessie and Victoria appeared here without Rosina in 1881–82; Victoria was in N.Y. variety in 1890. **8. ROSINA VOKES.** Rosina struck out on her own, at the head of a troupe, by the early 1880s. Her N.Y. appearances in this capacity were in 1885 and from 1888 to 1893. (Photo: Falk, N.Y.; in costume for *My Milliner's Bill.*) **9. NELLIE McHENRY** (ca. 1853–1935). From 1875 to 1889 the star of Salsbury's Troubadours, one of the foremost American groups imitating the Vokes idea (the leader, Nate Salsbury, became Buffalo Bill's manager in 1884). From 1890 with her own troupes in variety. In *The Quaker Girl* (1911). (Photo: Sarony, N.Y.)

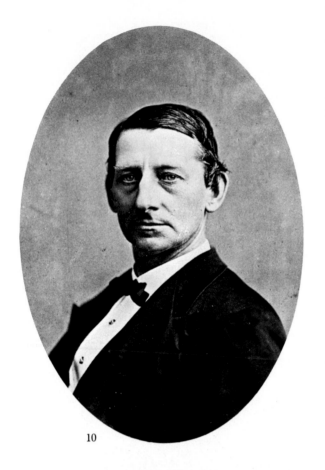

10

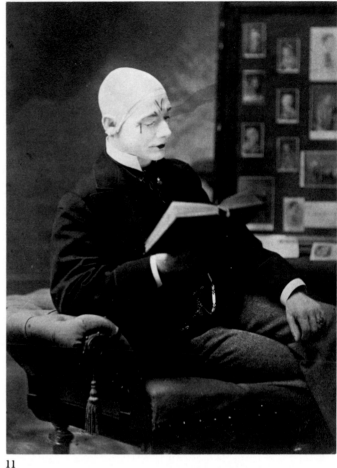

11

12

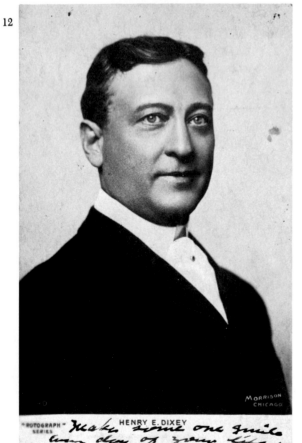

HENRY E. DIXEY

"ROTOGRAPH" SERIES

10. GEORGE (W.) L. FOX (1825–1877). Chief American exponent of the English type of clown pantomime. On stage 1830; straight comedian in N.Y. from 1850 (in first successful *Uncle Tom's Cabin*, 1852). Manager of several theaters. Pantomime work from 1863. Greatest success as Clown in long-running *Humpty Dumpty* (1868–69; revived 1871–72, 1873 and 1875, year of his last appearance). 11. GEORGE H. ADAMS (1853–1935; born in England). One of the foremost pantomime clowns in the U.S. after Fox. First appeared as a man-monkey in Brooklyn variety in 1870; clown in Brooklyn circuses, 1871 and 1872; first N.Y. appearance in full-length show, 1874. In Tony Denier's *Humpty Dumpty* troupe 1880–81; from 1882 to 1885 head of own *Humpty Dumpty* troupe, sometimes billed as the "The King of Stilts." Last N.Y. appearance 1890. 12. HENRY E. DIXEY (1859–1943; real surname Dixon). On stage from 1868. Long association with composer/producer E. E. Rice, including roles in Rice's trend-setting extravaganza-burlesque *Evangeline* (Boston, 1875; N.Y., 1877). Became star in long-running *Adonis* (from 1884); then in *The Seven Ages* (from 1889). Numerous other shows, chiefly straight plays after 1900, but was in *Chu Chin Chow* (1917 N.Y. production of London musical) and joined the cast of *The Merry Malones* (Cohan) in 1928. (Photo: Morrison, Chicago.)

4

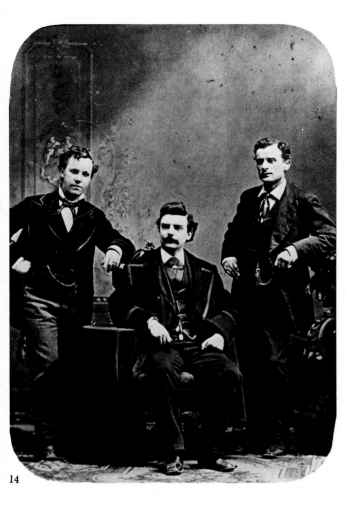

14

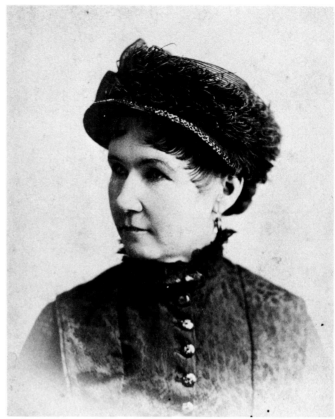

15

13. **AMELIA SUMMERVILLE** (ca. 1863–1934; real surname Shaw; born in Ireland). On stage from age 7 as singer and dancer. With an E. E. Rice company in N.Y. 1883. Leading role in *Adonis* (from 1884, and in 1893 revival). Numerous other musicals through 1913; later in *The Gingham Girl* (1922). Last N.Y. appearance 1925. (Photo: Sarony; in costume for *Adonis*.) **14. HARRIGAN & HART.** Left to right: **TONY HART** (1855–1891; real name Anthony Cannon), Martin W. Hanley (the team's business manager), **EDWARD HARRIGAN** (1843–1911). Harrigan, who first appeared in N.Y. in 1870, had already had previous variety partners before teaming with Hart in 1871. They appeared regularly at the Theatre Comique from 1872 (managers from 1876) until it burned in 1884, their act growing organically from sketches to full-evening shows (book and lyrics by Harrigan)—comic adventures of the Irish, German and black minorities in the city. Among their classics: *The Mulligan Guards' Ball* (1879 and 1883); *Squatter Sovereignty* (1882); *Cordelia's Aspirations* (1883). Separated after 1885, Hart appearing only one more year, and Harrigan opening his own theater in 1890 with *Reilly and the 400* and continuing to 1896. **15. ANNIE YEAMANS** (1835–1912; née Griffiths; born in England). In N.Y. as general actress 1866; with George Fox 1870–71; at Theatre Comique from 1873. Female lead of most of the Harrigan & Hart shows; in *Reilly and the 400* (1890). Further musicals included *A Chinese Honeymoon* (1902) and *The Echo* (1910; Deems Taylor score; her last N.Y. appearance). (Photo: Mora, N.Y.)

13

16

17

18

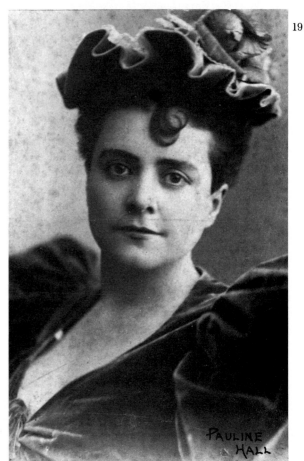

19

PAULINE
HALL

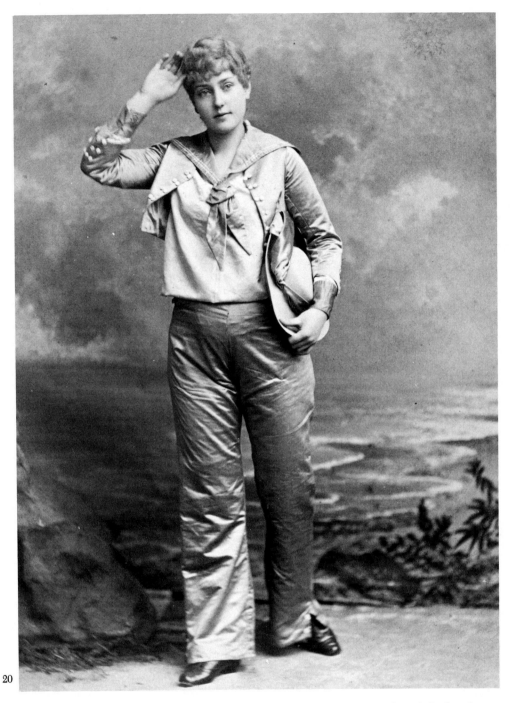

20

For about 20 years after the Casino Theatre opened in 1882, it was one of N.Y.'s leading homes for comic opera (operetta) and musical comedy. These were some of its top stars. **16. FRANCIS WILSON** (1854–1935). In minstrel shows (including N.Y.) from 1872, other shows from 1878. At Casino (and with impresario Col. McCaull) from 1882 as singing comedian; greatest fame in *Erminie* (1886). Star of own comic-opera company from 1889. In *Erminie* revival as late as 1921; last appearance 1930. First president of Actors Equity. (Photo: Falk, N.Y.; in costume for *The Lion Tamer*, 1891.) **17. MATHILDE COTTRELLY** (1851–1933; née Meyer; born in Germany). From Berlin to N.Y. German-language stage 1875. With Casino and McCaull from 1882; appeared until 1897. (Photo: Falk, N.Y.; in costume for *Falka*, 1884.) **18. MARIE JANSEN** (1857–1914). In comic opera from 1880. With Casino and McCaull from 1883; in *Erminie* (1886). With Francis Wilson 1889–91. Last N.Y. appearance 1895. **19. PAULINE HALL** (1860–1919; real surname Schmidgall). On stage very young, in N.Y. operetta from 1879. Created title role of *Erminie* (1886). Own companies from 1890. Joined Francis Wilson 1900. Later: vaudeville, revivals. (Photo 1894.) **20. LILLIAN RUS-SELL** (1860 or 1861–1922; real name Helen Leonard). On stage 1877; to N.Y. 1880, rising swiftly in Tony Pastor's variety company. At Casino off and on in 1880s and 1890s as top operetta star. With Weber & Fields from 1899 to 1904 and in 1912. Vaudeville, straight plays; archetypal figure of turn-of-century U.S. (Photo: Anderson, N.Y.; in costume for *Billee Taylor*, ca. 1883.)

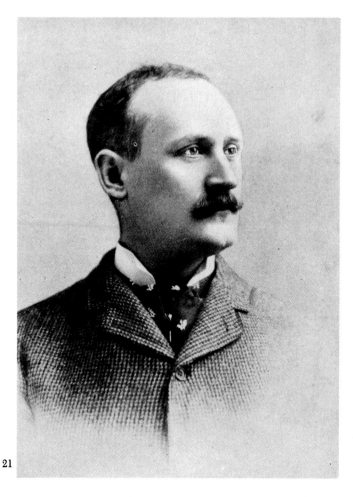

21

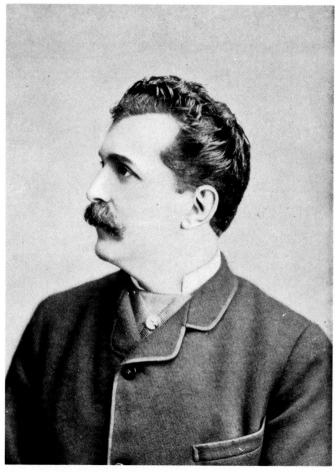

22

23

The photos on this page and the following show some of the stars of the greatest American comic-opera aggregation of the end of the 19th century, the touring company (making frequent N.Y. appearances) known as The Bostonians. **21. WILLIAM H. MacDONALD** (ca. 1850–1906), the principal baritone. In N.Y. operetta from 1879; joined the Boston Ideal Company (later The Bostonians) in 1880. In Victor Herbert's *Prince Ananias* (1894) and *The Serenade* (1897). Last N.Y. show 1904. **22. TOM KARL** (1846–1916; real surname Carroll; born in Ireland), the principal tenor. In major English-language opera companies visiting N.Y. from 1871 (also extensive concert career). Into Boston Ideal Company 1880. **23. EUGENE COWLES** (ca. 1860–1948; born in Canada), the principal bass. Joined Bostonians in 1888. First N.Y. appearance 1891 in the troupe's second year with De Koven's *Robin Hood*. In *Prince Ananias* (1894) and *The Serenade* (1897). Defected from the company with Alice Nielsen and appeared with her in Herbert's *The Fortune Teller* (1898; introduced "Gypsy Love Song") and *The Singing Girl*. Later shows included Herbert's *Babette* (1903) and *The Rose of Algeria* (1909). Last appearances in Gilbert & Sullivan, 1911–14.

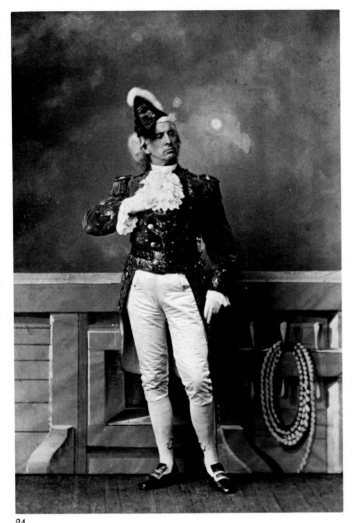

24

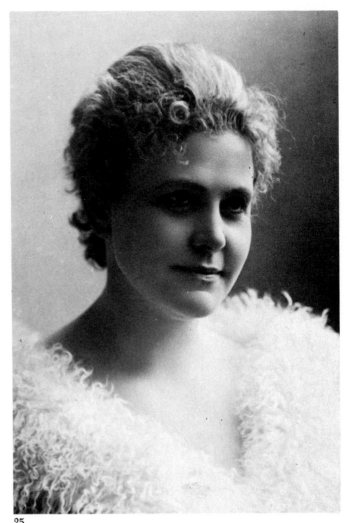

25

24. HENRY CLAY BARNABEE (1833–1917), founder and principal comedian of The Bostonians. Amateur entertainer for many years; professional monologist and actor from 1865. Own concert company from 1870. In 1879, in the wake of the *H.M.S. Pinafore* craze, he created the Boston Ideal Company ("ideal" for doing *Pinafore*), which was reorganized as The Bostonians in 1888. First appeared in Brooklyn 1879; in N.Y. 1880. In N.Y. with De Koven's *Robin Hood*, the company's greatest success, from 1890. In *Prince Ananias* (1894) and *The Serenade* (1897). Last N.Y. appearance 1902. (Photo: A. Marshall, Boston; as Sir Joseph Porter in *Pina-*

fore.) **25. JESSIE BARTLETT DAVIS** (1860–1905), principal contralto. In church concerts and the like from adolescence; into comic opera 1879 (starting with a *Pinafore* company, as did so many others). N.Y. appearances (concerts at Casino Theatre, etc.) from 1882. With The Bostonians in N.Y., 1891, when they returned with *Robin Hood*, the show in which she introduced theatrically De Koven's interpolated art song "Oh, Promise Me." In *Prince Ananias* (1894) and *The Serenade* (1897; last N.Y. appearance). (Photo: Falk, N.Y.)

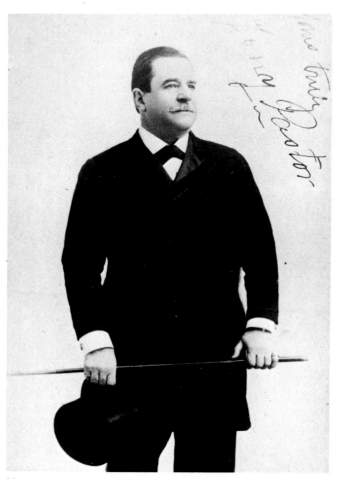

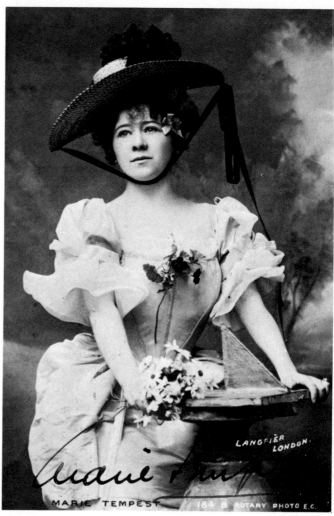

26

27

26. TONY (Antonio) PASTOR (1837–1908). Clown in circuses visiting N.Y. from 1852, and in clown pantomime 1860. Into variety, his lifelong field, 1861. Manager of own theaters at various N.Y. locations from 1865. A major force in making the earlier rough-and-tumble variety (later, vaudeville) a popular family entertainment. Sang and appeared in sketches and condensed musicals at his own theaters. **27. (DAME) MARIE TEMPEST)** (1864–1942; real surname Etherington; born in England). On stage at home from 1884.

Enormous success in revised version of comic opera *Dorothy* (1887). In U.S., 1890–94, she was a supreme operetta heroine both vocally and dramatically, appearing in *The Red Hussar* (1890); *The Tyrolean* (1891); and De Koven's *The Fencing Master* (1892) and *The Algerian* (1893). Triumphal return to London 1895 in *An Artist's Model*. Abandoned musicals in 1900 (gave concerts later) to become the outstanding female English star of comedies of manners for many decades.

28

29

30

28. **LAURA JOYCE** (1856–1904; born in England; from 1883 billed as Laura Joyce Bell). This comic-opera singer came to the U.S. in the early 1870s and appeared in the Niblo's Garden extravaganza *Leo and Lotos* in 1872. In 1875 she undertook the title role in the first major production (in Boston) of Rice's *Evangeline*. In 1883 she married Digby Bell (see No. 51) and usually appeared with him thereafter. In the 1880s they were at the Casino and with Col. McCaull. Her last N.Y. appearance was in 1903. (Photo: H. Rocher, Chicago.) **29. WILLIE EDOUIN** (1841–1908; real name William Frederick Boyer; born in England). In music hall and pantomime from childhood; in N.Y. burlesque and variety from 1870. In Lydia Thompson's company in N.Y. 1871–73 and 1877. With E. E. Rice 1879–80. From 1880 produced his own shows in N.Y. (and touring): *Dreams* (1880), *A Bunch of Keys* (by Hoyt; 1883). Important producer of musicals in London. Back to N.Y. for last time with his famous London show *Florodora* (1900). (Photo: Sparks, Philadelphia.) **30. ALICE ATHERTON** (1860–1899; née Hogan; born in England). Wife of Willie Edouin. In N.Y. with Lydia Thompson (and other burlesque troupes) between 1870 and 1877. With Edouin from 1879. In N.Y. vaudeville 1897; last N.Y. show 1898. (Photo: Scholl, Philadelphia.)

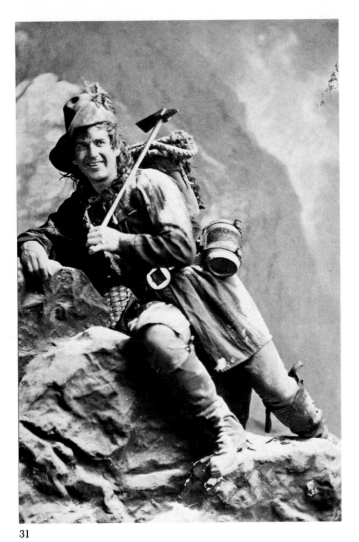

31

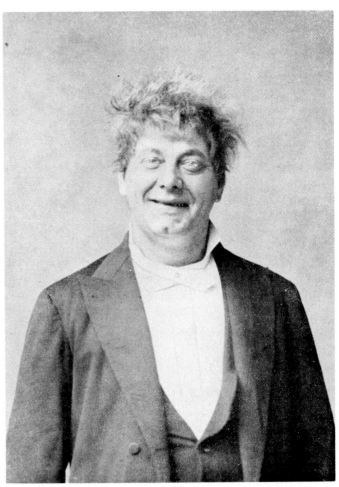

32

Some stars of the German-American and Irish-American musical shows that were extremely popular in the late 19th and early 20th centuries. **31. J(OSEPH) K(LINE) EMMET** (ca. 1841–1891). In N.Y., both in minstrel shows and with William Horace Lingard, 1868–69. In 1870 began starring in *Fritz, Our Cousin German*, the first of his lifelong series of plays-with-songs in which he portrayed the young German immigrant Fritz. (Photo: Sarony, N.Y.) **32. GUS WILLIAMS** (1847–1915). This singer and "Dutch [German] comic" appeared in N.Y. variety (at Pastor's, in German-language theaters, etc.) from 1868 to 1880. Thereafter he usually appeared in full-length shows such as *Our German Senator* (1880) and *One of the Finest* (1882). In 1891 he toured with the attraction *U and I*. **33. WILLIAM J. SCANLAN** (1856–1898; name often appears as Scanlon). In variety (N.Y. from 1875). In various touring shows from 1880 to 1882, when he began starring in plays-with-songs on Irish subjects. Unable to perform after 1891. (Photo: Launey, N.Y.) **34. CHAUNCEY (Chancellor) OLCOTT** (1858–1932). In minstrel shows (and in N.Y.) from 1880. In comic opera in N.Y. from 1886 (*Pepita*, with Lillian Russell). In 1893 he picked up where Scanlan had left off, under the same management, and remained a star of Irish plays. Important shows and songs introduced: *A Romance of Athlone* (1899; own song, "My Wild Irish Rose"); *Barry of Ballymore* (1910; "Mother Machree"); *The Isle o' Dreams* (1912; "When Irish Eyes Are Smiling"); *Shameen Dhu* (1913; "Too-Ra-Loo-Ra-Loo-Ral"); *The Heart of Paddy Whack* (1914; "A Little Bit of Heaven"). Last N.Y. show: *Macushla* (1920). (Photo: Morrison, Chicago.) **35. ANDREW MACK** (ca. 1864–1931; real name William Andrew McAloon). On stage, Boston, 1876. Into vaudeville 1892. Irish plays-with-songs from 1897. In *The Last of the Rohans* (1899) sang "Heart of My Heart." Last N.Y. appearance 1910.

33

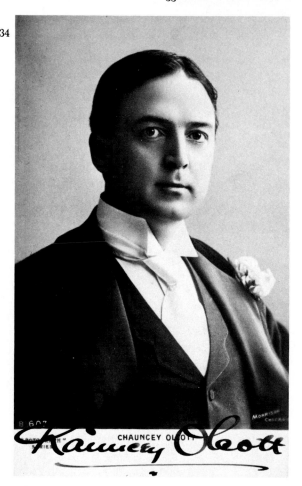

34

CHAUNCEY OLCOTT

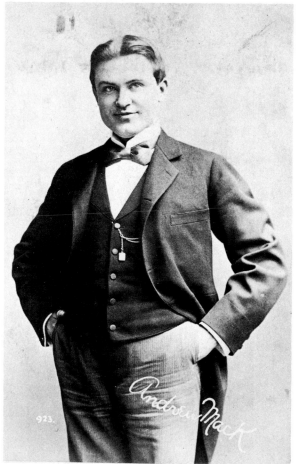

35

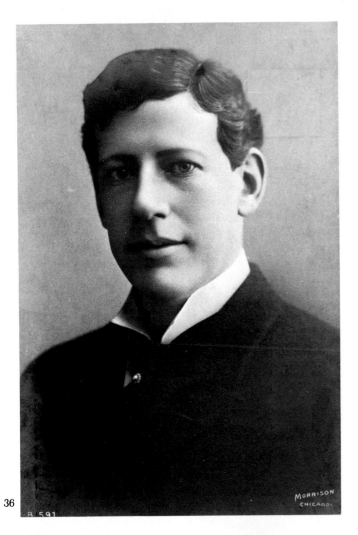

36

MORRISON
CHICAGO.

B 591

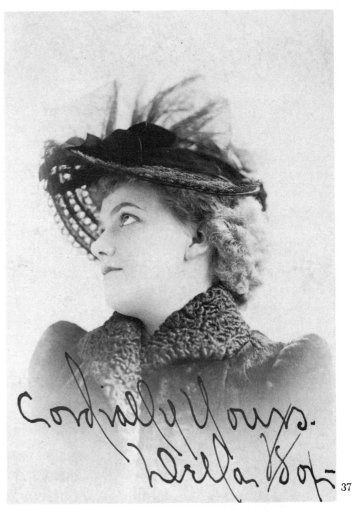

37

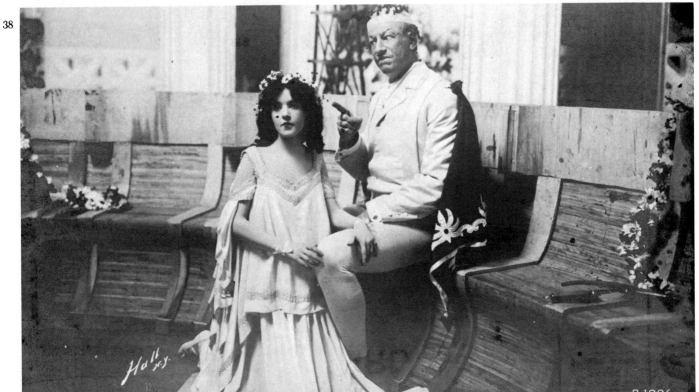

38

Hall
N.Y.

B 1096

14

36. **(William) DeWOLF HOPPER** (1858–1935). On stage (and in N.Y.) from 1878. With Harrigan & Hart 1882. Much comic opera and straight drama, leading to stardom 1890 in *Castles in the Air.* Outstanding shows included *Wang* (1891) and *El Capitan* (1896; Sousa score). With Weber & Fields 1900–01. Unusually long career: last N.Y. show 1928; last appearance 1933. Tireless reciter of "Casey at the Bat" from 1888. (Photo: Morrison, Chicago.) 37. **DELLA FOX** (1871–1913). Stage from 1879; with Hopper from 1889; in N.Y. from 1890. Separation from Hopper, and stardom, 1894. Last N.Y. show: *The Rogers Brothers in Central Park* (1900). (Photo: Sarony, N.Y.) 38. **MARGUERITE CLARK** (1887–1940). In light opera (and in N.Y.) from 1900; with Hopper on and off 1902–08; last musical 1910, then drama and silent films. (Photo: Hall, N.Y.; scene from De Koven's *Happyland,* 1905, with Hopper.) 39. **FLORA WALSH (HOYT)** (1870–1893). On stage with E. E. Rice at age 6; developed into dancer; in N.Y. in two plays by her husband, Charles Hoyt, great creator of satirical Americana with songs: *A Brass Monkey* (1888) and *A Texas Steer* (1890). 40. **CAROLINE MISKEL (HOYT)** (ca. 1873–1898), Hoyt's second wife. In N.Y. 1892. In his *A Temperance Town* (1893). 41. **HARRY CONOR** (ca. 1856–1931). In N.Y. in Hoyt shows from 1886. Male star of Hoyt's masterpiece *A Trip to Chinatown* (from 1890; introduced "The Bowery"). Other N.Y. musicals to 1918. (Photo: Falk, N.Y.; in costume for *A Trip to Chinatown.*)

39

40

41

42

43

Two of Victor Herbert's earliest stars, exemplifying his lighter and heavier sides in composition. **42. FRANK DANIELS** (late 1850s–1935). Stage, Boston, 1879. Variety, N.Y., 1882. In Hoyt's *A Rag Baby* (1884) at Pastor's. From 1887 in *Little Puck* (Harry Conor in this company by 1889). In Herbert's *The Wizard of the Nile* (1895), *The Idol's Eye* (1897) and *The Ameer* (1899). Later shows to 1912 (Weber & Fields's *Roly-Poly*). **43. ALICE NIELSEN** (1876–1943). On stage from age 8. After English-language opera work in San Francisco, joined The Bostonians, becoming a major soloist with them in Herbert's *The Serenade* (1897). Taking along the excellent bass Eugene Cowles, she formed her own company in 1898, starting with the same composer's *The Fortune Teller* (introduced "Romany Life") and continuing with his *The Singing Girl* (1899). Then she studied for a career in grand opera, in close association with the impresario Henry Russell. Her opera appearances began in 1903 and she was a top star of Russell's Boston Opera Company from 1909 on, also appearing at the Metropolitan Opera between 1909 and 1913. (Photo 1915.)

44

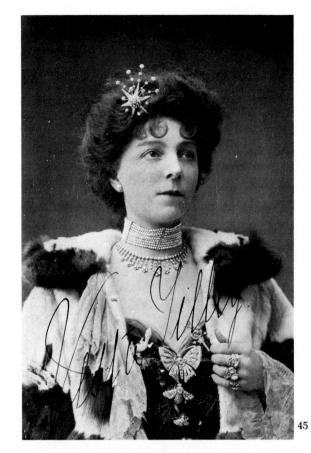

45

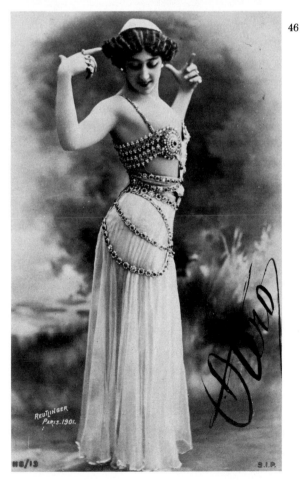

46

Some distinguished foreign vaudeville stars of the 1890s.
44. LOTTIE COLLINS (1866–1910; born in England). N.Y. debut
1889 as part of a visiting troupe from the famous Boston variety
house, the Howard Athenaeum; she was billed as the "originator of
the skirt dancing." In the early 1890s she captivated London with
her cleaned-up but still very lively version of the American sporting-
house number "Ta-Ra-Ra-Boom-De-Ré." She performed this in N.Y.
in 1892 and 1893 in vaudeville and in the show *Miss Helyett*. In
1914 she was in *The Belle of Bond Street*. (Photo: Sarony,
N.Y.) **45. VESTA TILLEY** (1864–1952; real name Matilda Ball).
On the halls in England from infancy, she began her career as a
male impersonator when she was 5. In London from 1878; in pan-
tomime from 1882. First N.Y. appearance at Pastor's 1894. In N.Y.
book show *My Lady Molly* (1904). Retired 1920. **46. CAROLINE
OTERO** (1868–1965). Exotic dancer who appeared in operetta in
Spain, in cabarets and the Folies-Bergère in France, at fashionable
European spas, etc. In 1890 she was at the Eden Musée (vaudeville
house) in N.Y. (Photo: Reutlinger, Paris, 1901.)

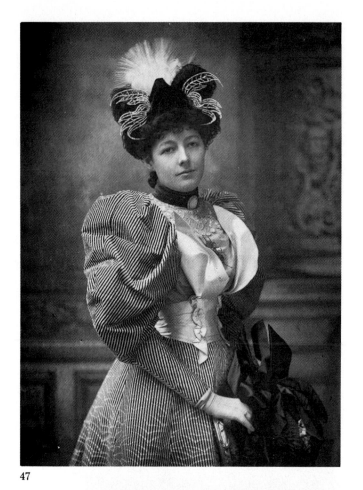

47

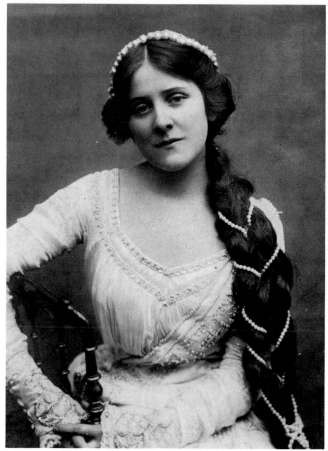

48

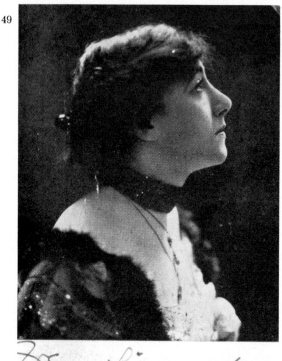

49

On the other hand, some Americans became even better-liked in England than they had been here. **47. MAY YOHE** (1869–1938). Chorus girl in Philadelphia; into David Henderson's major Chicago extravaganzas 1887–88. To N.Y. 1888. Toured with Gus Williams 1891. Real success 1893–96 in London, where she married Sir Francis Hope and became mistress of the Hope Diamond. Desultory appearances later in U.S. and England; American vaudeville to at least 1923. (Photo: Alfred Ellis, London, 1895.) **48. EDNA MAY** (E. M. Pettie, 1878–1948). Stage from 1883, N.Y. from 1896. In 1897 was in three shows, beginning with Hoyt's *A Contented Woman* and ending with the lead in *The Belle of New York* at the Casino. It was her London appearance in this show in the following year that made her a great star and a London resident. Her other N.Y. shows were *The Girl from Up There* (1901); *The School Girl* (1904); and *The Catch of the Season* (1905). Retired 1907. **49. ADA LEWIS** (ca. 1875–1925). Began in show business on West Coast. In Harrigan's *Reilly and the 400* in N.Y. (1890) she became famous as a "tough girl." Highlights of long career: May Irwin shows 1895–1904; Lew Fields shows 1909 ff.; Jerome Kern shows, including *Very Good Eddie* (1915), *The Night Boat* (1920) and *Good Morning, Dearie* (1921). Last N.Y. appearance 1924. **50. HARRY DAVENPORT** (1866–1949). Member of great stage family; acting from 1871, with many straight roles and films as well as musicals. The latter included: Harrigan's *Reilly and the 400* (1890); *The Belle of New York* (1897); Herbert's *It Happened in Nordland* (1904); and *Sari* (1914, last year of musicals). (Photo: Byron, N.Y., 1897; scene from *The Belle of New York* with Edna May.)

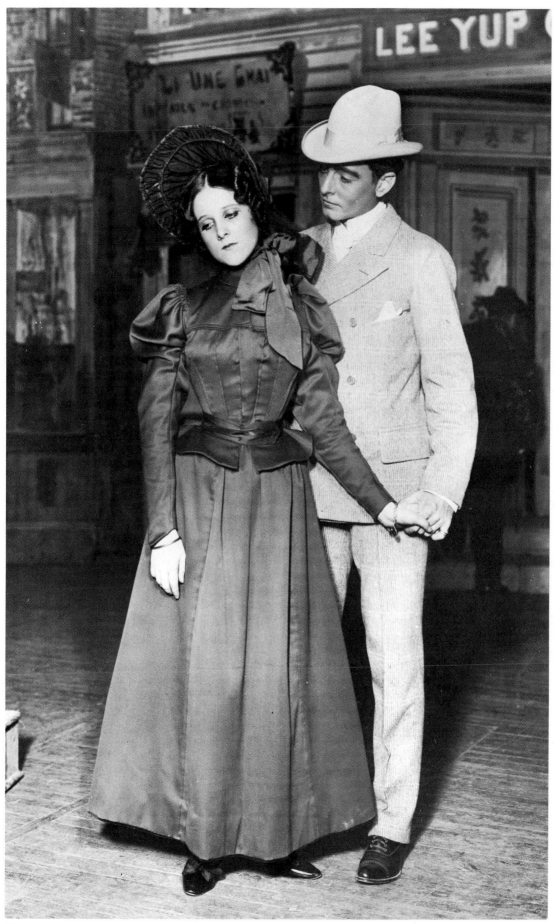

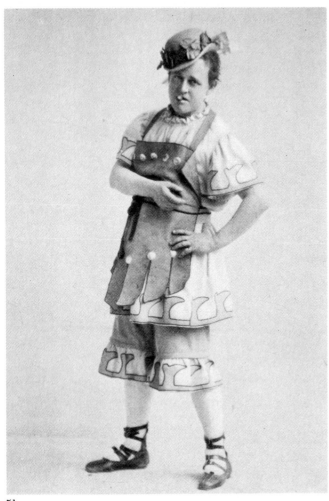

51

This page and the next are devoted to star comedians of turn-of-the-century musicals. **51. DIGBY BELL** (1851–1917). In a N.Y. concert 1878. Into operetta 1879. With Col. McCaull from 1880 to 1889; Casino appearances in 1880s. Star 1892 in the show *Jupiter* (shown here). In 1893 and 1894 at the Casino without his wife Laura Joyce Bell (see No. 28). Last N.Y. appearance 1903. **52. LOUIS MANN** (1865–1931). On stage in N.Y. 1868 in German-language theater. Stock actor in San Francisco. Back to N.Y. 1883, chiefly in straight plays until *The Merry World* (1895); chiefly in musicals thereafter. With Weber & Fields 1903. Last N.Y. show 1921. Appearance in 1927. **53. THOMAS Q. SEABROOKE** (1860–1913; real name Thomas Quigley). On stage 1880; in N.Y. 1882. In Hoyt's *A Midnight Bell* (1889). With Hopper in *Castles in the Air* (1890). On his own in *The Cadi* (1891). Greatest success: *The Isle of Champagne* (1892). Numerous other N.Y. shows to 1906.

52

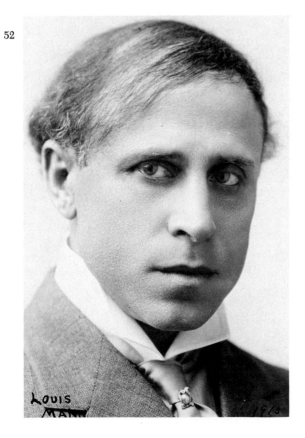

53

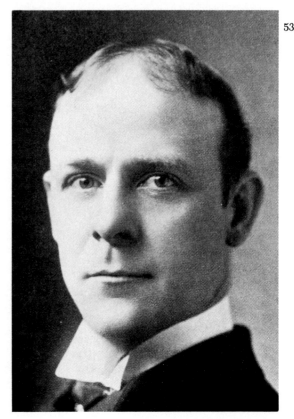

54. DAN DALY (1858–1904). Mournful comedian and eccentric dancer; on stage from 1874. In N.Y. variety 1884 as one of the Four Dalys. Into shows, late 1880s. In *The Belle of New York* (1897) and many other musicals up to 1901. **55. JAMES T. POWERS** (1862–1943). In variety (and in N.Y.) 1878. Worked with Willie Edouin in *Dreams* (1880) and *A Bunch of Keys* (1883). Also in 1883 he played in a London pantomime with the Vokeses. In the 1880s he appeared in Casino shows. Big hit in *A Straight Tip* (1891). From 1897 to 1902 at Daly's Theatre as chief comedian in the N.Y. productions of the finest London musicals (continued to appear in shows of English origin into the 1910s). Rare appearances in 1920s. In a revival of *The Geisha* (1931). **56. JEROME SYKES** (ca. 1868–1903). On stage from 1884 in operatic and straight companies. In several De Koven shows: *The Fencing Master* (1892); *The Highwayman* (1897); *Foxy Quiller* (1900). In Sousa's *Chris and the Wonderful Lamp* (1902). Last N.Y. show 1902.

54

55

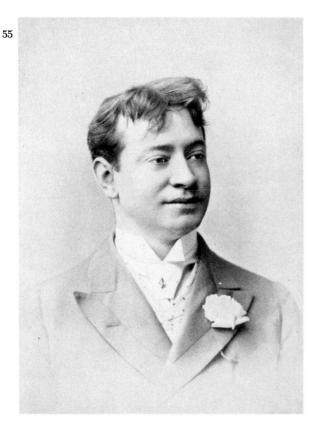

56

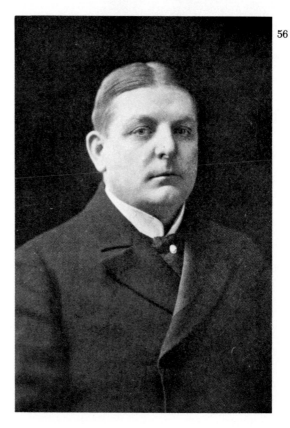

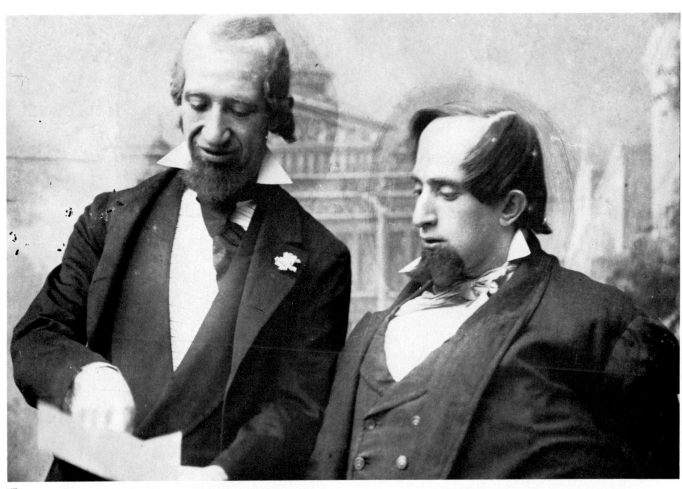

57

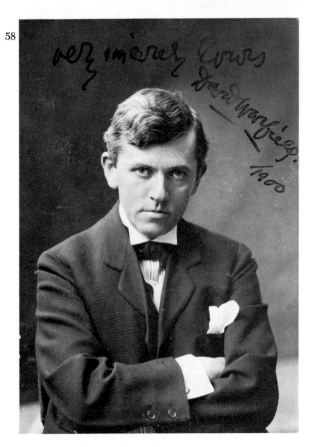

58

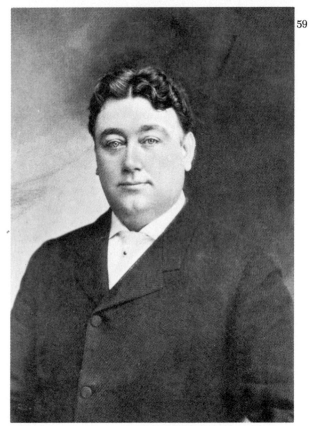

59

60

57. LEW FIELDS (1867–1941; real name Lewis Schanfield) & **JOE (Morris) WEBER** (1867–1942). Variety partners from 1877; in bigtime N.Y. variety as "Dutch comics" from 1882; own variety troupes from 1885; own Music Hall from 1896, presenting brilliantly cast and staged social satires and spoofs of current plays. Independent producers after their 1904 split, with Weber somewhat feebly repeating past tricks and Fields blossoming out into one of the greatest American showmen. Brief reunion from 1912. In 1920s Fields produced early Rodgers & Hart shows, and performed in N.Y. musicals up to 1928. **58. DAVID WARFIELD** (1866–1951). On stage 1888; in N.Y. 1890. At Casino 1894–97; with Weber & Fields 1898–1900; then straight star for Belasco 1901–23. (Photo: Peck Bros., N.Y.; signed 1900.) **59. PETER F. DAILEY** (1863–1908). Early example of screwball, ad-libbing comic. On stage (and in N.Y.) ca. 1876. In variety 1877–85 as one of the American Four. At Howard Athenaeum 1885–88. Into full-length shows ca. 1890. With James T. Powers 1891 ff. With Weber & Fields 1897–98. Last show 1908. **60. FAY TEMPLETON** (1865–1939). Amazing career of over 60 years. On stage (and in N.Y.) by 1869. Many comic operas in 1880s and 1890s. With Weber & Fields 1898–1901 (introduced "Ma Blushin' Rosie" in their *Fiddle-Dee-Dee* in 1900). Introduced "Mary's a Grand Old Name" and "So Long, Mary" in Cohan's *Forty-five Minutes from Broadway* (1906). Last show: Kern's *Roberta* (1933; introduced "Yesterdays").

61

61. GEORGE H. PRIMROSE (1852–1919; real surname Delaney; born in Canada) & **WILLIAM H. WEST** (1853–1902). Heroes of the later years of minstrelsy. Primrose, a minstrel from 1867, teamed with West in 1873; their first N.Y. appearances (with the impresario Haverly) was in 1874. Between 1878 and 1898 they were partners in varying managerial combinations. Primrose, without West, was a partner of Dockstader from 1898 to 1903, then worked alone; he was the greatest exponent of soft-shoe dancing. (Photo 1875.) **62. LEW DOCKSTADER** (1856–1924; real name George Alfred Clapp). Minstrel from 1873. In N.Y. variety 1879. Own N.Y. minstrel theater 1888–90. Continued to lead troupes; employed young Al Jolson. Appeared in 1922 show *Some Party*. **63. GEORGE "HONEY BOY" EVANS** (1870–1915; born in Wales). Great minstrel singer and composer. Was in the show *Cohan and Harris Minstrels* (1908). **64. JEFFERSON DE ANGELIS** (1859–1933). Operetta comedian, on stage from childhood. Into N.Y. shows 1884, with McCaull 1887–89, at Casino 1890–95, star from 1906. Last N.Y. musical: *Some Party* (1922); in 1930 play. **65. EDDIE FOY, SR.** (1854–1928; real name Edwin Fitzgerald). On stage 1869; in Brooklyn 1885; in N.Y. (with the G. S. Knights) 1886. In Henderson's Chicago shows 1888 ff. Steady in N.Y. from 1898. Last show: *Over the River* (1912), then into vaudeville with his 7 children.

62

63

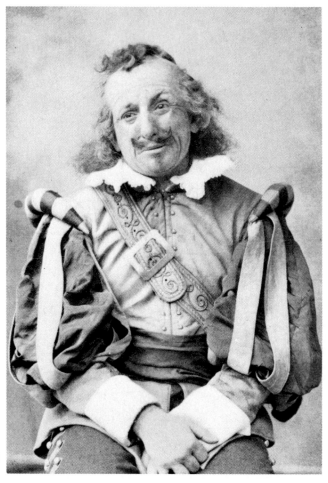

64

65

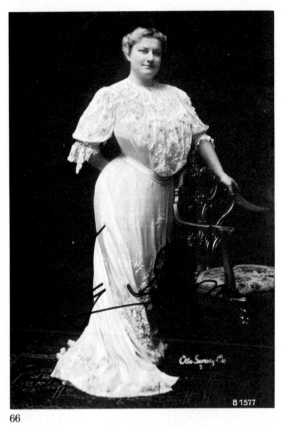

66

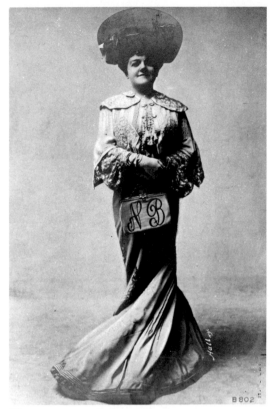

67

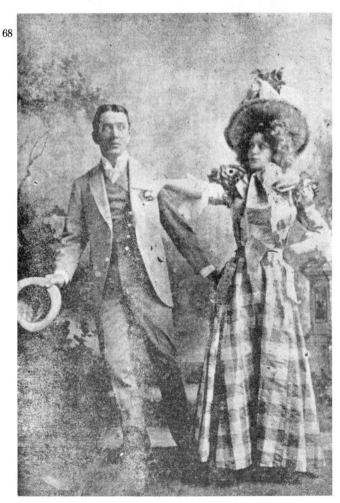

68

This page and the next are devoted to the ragtime revolution of the 1890s and to the exponents, white and black, of the most vital and original American show music up to its time. **66. MAY IRWIN** (1862–1958; born in Canada). Into variety 1875, at Pastor's 1877–83, straight actress for Augustin Daly in the later 1880s. From the mid-1890s, star of farce-comedies (humorous plays with song interpolations) in which she popularized "coon songs" (as ragtime songs were known at the time). Last N.Y. show 1922. (Photo: Otto Sarony Co.) **67. MARIE CAHILL** (early 1870s–1933). In N.Y. from 1888. In Herbert's *The Gold Bug* (1896). Star of farce-comedies in the 1900s (popularized "Under the Bamboo Tree" in *Sally in Our Alley*, 1902). In Herbert's *It Happened in Nordland* (1904). Last N.Y. show 1930. (Photo: Hall, N.Y.; in costume for *Nancy Brown*, 1903). **68. BARNEY FAGAN** (ca. 1850–1937). In N.Y. in an Irish variety act in 1877. In 1880s and 1890s, sang and directed pageantry for top minstrel troupes. Long vaudeville career. Wrote "My Gal Is a Highborn Lady." In N.Y. show *Sidewalks of New York* (1927). With him in the photo (1898) is his wife Henrietta Byron, who died in 1924.

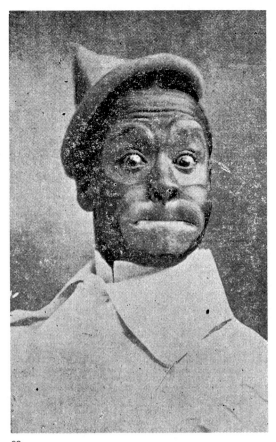

69

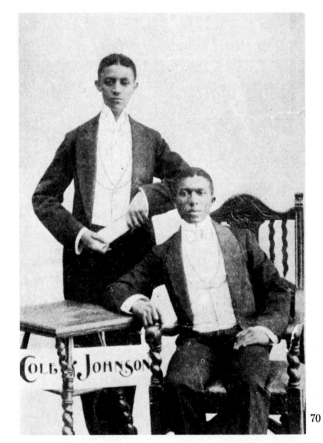

70

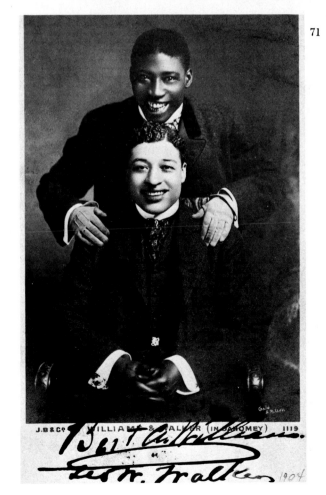

71

Black ragtime stars. **69. ERNEST HOGAN** (late 1860s–1909; real name Reuben Crowder). Outstanding entertainer and composer. In late 1890s, toured along with "The Black Patti." Was in the pioneering black shows *The Origin of the Cake Walk or, Clorindy* (1898) and *Jes Lak White Folks* (1900). In 1905–06, toured with own show *Rufus Rastus*. Also in *The Memphis Students* and *The Oyster Man*. **70. BOB COLE** (1868–1912) & **BILLY JOHNSON** (dates unavailable). Composer and performer Cole was in the musical act *Jolly Coon-ey Island* (1896) and in the show *A Trip to Coontown* (1897), as well as vaudeville. Billy Johnson was a brother of J. Rosamond and James Weldon Johnson, with whom Cole later teamed. **71. GEORGE W. WALKER** (1873–1911; above in photo) & **BERT (Egbert) WILLIAMS** (ca. 1874–1922; born in Antigua). On stage from 1892, Williams teamed with Walker by 1896, when they started appearing in Broadway shows and top vaudeville. In small-scale black shows from 1898; great success with *In Dahomey* (1903). With Walker unable to perform after 1909, Williams entered *Ziegfeld Follies* as enormously popular singing comedian in 1910; also in 1911, 1912, 1915, 1916 & 1917 editions. Last show: *Broadway Brevities* (1920). (Photo: Gale & Polden, England, 1904.)

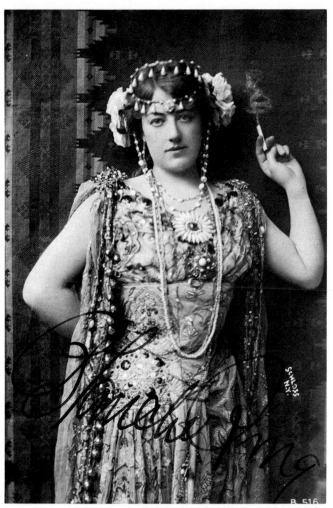

72

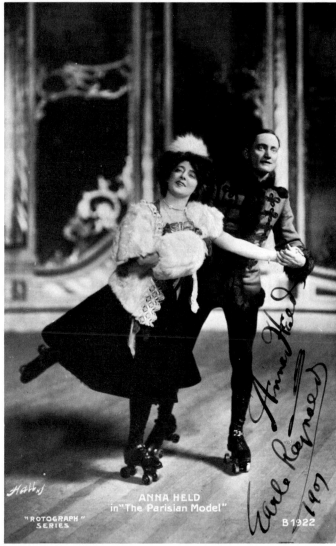

73

72. BLANCHE RING (1876–1961). First show (Boston & N.Y.): *The Defender* (1902; "In the Good Old Summertime"). Long career, working with Victor Herbert, Joe Weber, Lew Fields and many others. Also introduced: "Waltz Me Around Again, Willie" (in *His Honor the Mayor*, 1906); "Yip-I-Addy-I-Ay" (in *The Merry Widow Burlesque*, 1908); "Rings on My Fingers" (in *The Midnight Sons*, 1909); and "Come, Josephine, in My Flying Machine" (in vaudeville, 1910). Other major shows: *The Passing Show of 1919;* the original Chicago production of *No, No, Nanette* (1924); *Strike Up the Band* (1930; Gershwin). Last show 1938. Married for some years to Charles Winninger (see No. 223). (Photo: Schloss, N.Y.) **73. ANNA HELD** (1865–1918; born in Poland). Yiddish theater in London and Paris in 1880s. In Parisian music halls from 1889, into London music halls 1895, brought to N.Y. by Ziegfeld (common-law husband) in 1896. Numerous shows 1897–1916, often featuring her "Gallic" come-hither personality. With Weber & Fields 1904. (Photo: Hall, N.Y.; scene from *A Parisian Model*, 1906, in which she introduced "I Just Can't Make My Eyes Behave"; also depicted is champion ice and roller skater Earle Reynolds, later in politics; signed 1907.)

74

75

76

74. ADELE RITCHIE (1874–1930). First show (and N.Y. debut) 1893. Soon engaged at Casino Theatre; was in the pioneering Casino revue *The Passing Show* (1894). Star by early 1900s. In *Fantana* (1905). Last N.Y. show 1912. (Photo: Morrison, Chicago.) **75. VIRGINIA EARLE** (also occurs as Earl; 1873–1937). On stage by 1886; in N.Y. by 1889. Rose to fame in Casino shows: *The Passing Show* (1894); *The Casino Girl* (1900); etc. Also in Herbert's *The Gold Bug* (1896) and in the London-originated shows *The Circus Girl* (1897) and *A Runaway Girl* (1898). Star from 1903 to 1905, year of last N.Y. appearance. (Photo: Falk, N.Y.) **76. EVA TANGUAY** (1878–1947; born in Canada). In N.Y. shows from 1898 to 1909, when she joined the cast of that year's *Ziegfeld Follies*. Greatest fame in vaudeville, especially with 1905 song "I Don't Care." (Photo 1909.)

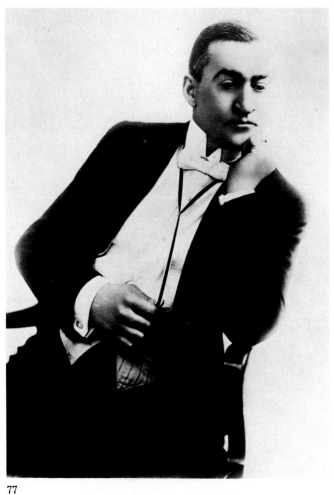

77

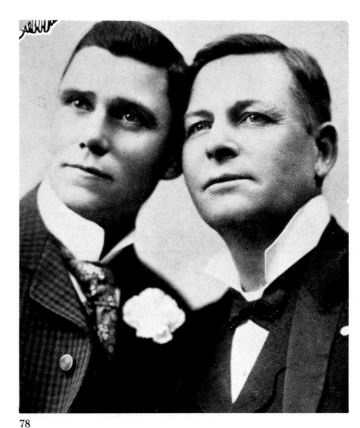

78

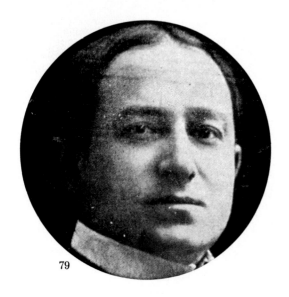

79

77. **JOSEPH E. HOWARD** (1867–1961). Immensely long career. After minstrelsy, and vaudeville with boxer Bob Fitzsimmons as partner, appeared in many shows from 1903 on, especially in Chicago, which was then enjoying a golden age of musical comedy of local origin. In 1909 (Chicago), introduced "I Wonder Who's Kissing Her Now" (composed by Harold Orlob) in *The Prince of Tonight*. A few N.Y. appearances, 1906–08 and 1942. **78. JAMES T. McINTYRE** (1857–1937) & **THOMAS K. HEATH** (ca. 1853–1938). McIntyre, on stage from 1868 in variety, circus and minstrel shows, teamed with Heath in 1874. They were said to have introduced buck-and-wing dancing to N.Y. at Pastor's in 1880. N.Y. shows: *The Ham Tree* (1905); *In Hayti* (1909); *The Show of Wonders* (1916); *Hello, Alexander* (1919); *Red Pepper* (1922). In Chicago *Headin' South* (1928). Their Alexander character inspired Berlin's "Alexander's Ragtime Band" (1911). **79. SAM BERNARD** (1863–1827; real surname Barnett; born in England). In N.Y. 1888; with Weber & Fields 1896–97 & 1901. Star "Dutch comic" in musicals from 1898 to his last show in 1927. In Berlin's first *Music Box Revue* (1921). (Photo 1906).

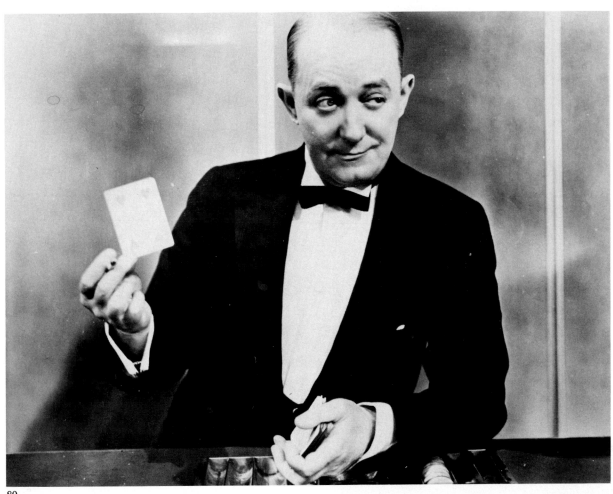

80

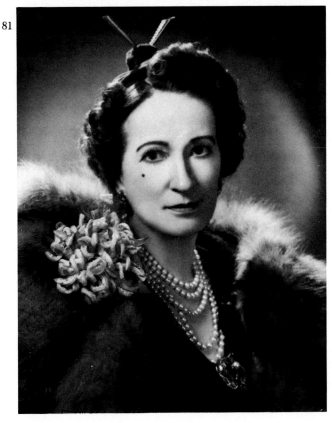

81

80. GEORGE M. COHAN (1878–1942). On stage with family from 1887; N.Y. from 1893. After much vaudeville (1897 in a Vesta Tilley troupe), in own shows: *The Governor's Son* (1901) and *Running for Office* (1903). Teamed managerially with Sam Harris from 1904, the year of *Little Johnny Jones* (introduced "The Yankee Doodle Boy" and "Give My Regards to Broadway"). From 1906, also wrote many plays and shows for others while continuing to appear in such musicals of his own as *George Washington, Jr.* (1906; introduced "You're a Grand Old Flag") and *The Yankee Prince* (1908). In 1933 in O'Neill's, *Ah, Wilderness!* In 1937 (last show) in Rodgers & Hart's *I'd Rather Be Right.* **81. ETHEL (Grace Ethelia) LEVEY** (1880–1955). Cohan's first wife. On stage 1897 in San Francisco. In N.Y., some vaudeville and some work with Weber & Fields, then in Cohan shows between 1901 and 1907 ("Ethel Levey's Virginia Song" in *George Washington, Jr.*, 1906). Between her N.Y. shows of 1911 (*Folies Bergère*) and 1922 (*Go Easy, Mabel*) she made a sensation in musicals in London and Paris. She was also in the N.Y. shows *Sunny River* (1941) and, as the famed Madame Sacher of Vienna, in *Marinka* (1945). (Photo: Lucas & Pritchard, N.Y.)

82

83

84

82. IRENE FRANKLIN (1876–1941). In N.Y. by 1892; top vaudeville attraction 1895–1907. Shows from 1907 to 1929 included *The Passing Show of 1917*; *Greenwich Village Follies of 1921*; and Kern's *Sweet Adeline* (1929). **83. BESSIE CLAYTON** (ca. 1885–1948). Dancer; N.Y. shows from 1891. Connected with Hoyt shows in 1890s (*A Trip to Chinatown*, 1892–94 or even later); *A Black Sheep* (1896). With Weber & Fields 1899–1901 and 1912. In: Herbert's *It Happened in Nordland* (1904); *Ziegfeld Follies of 1909*; *The Passing Show of 1913* (last N.Y. appearance). Wife of superb musical-comedy director Julian Mitchell. **84. ALICE LLOYD** (ca. 1873–1949; real surname Wood; born in England). Sister of top English music-hall star Marie Lloyd; wife of Tom McNaughton (see No. 132). Onto halls in England 1888; pantomime from 1889. Smash hit in American vaudeville from 1907. Toured U.S. in Nora Bayes's role in *Little Miss Fixit* (1912). **85. BESSIE McCOY (DAVIS)** (ca. 1886–1931), outstanding eccentric dancer of her day. With Weber & Fields at turn of century. Other N.Y. shows, 1903–19, included *Three Twins* (1908; introduced "The Yama Yama Man"); *The Echo* (1910; Deems Taylor score); *Ziegfeld Follies of 1911*; *Greenwich Village Follies of 1919*. Wife of leading journalist Richard Harding Davis.

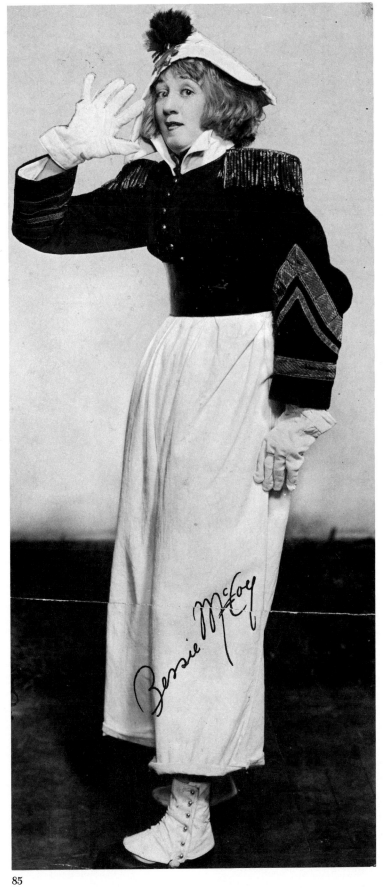

85

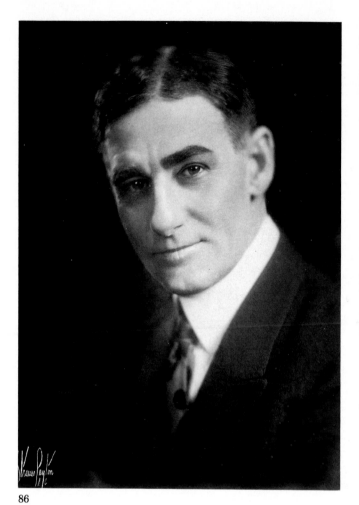

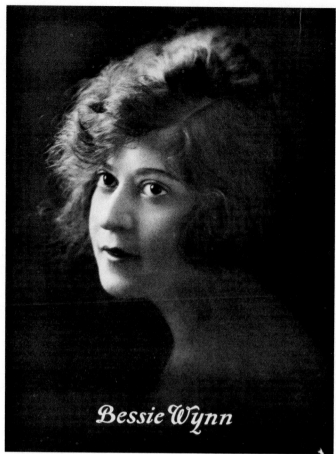

Bessie Wynn

87

86

This page and opposite: Montgomery & Stone and two singers from their 1903 show *The Wizard of Oz*. **86. FRED STONE** (1873–1959). **88. STONE** (right) with **DAVID MONTGOMERY** (1870–1917). Stone, a circus performer from 1884, teamed with Montgomery in 1894. After much vaudeville, their first show was with Edna May in *The Girl from Up There* (N.Y., 1901). They were the top stars of all their other shows, from *The Wizard of Oz* to *Chin-Chin* (1914), in 1906 introducing "The Streets of New York" ("In Old New York") in Herbert's *The Red Mill*. From 1917 to 1932 Stone continued to star on his own, and made a personal appearance in

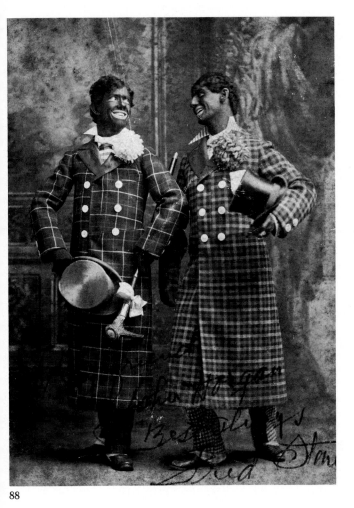

88

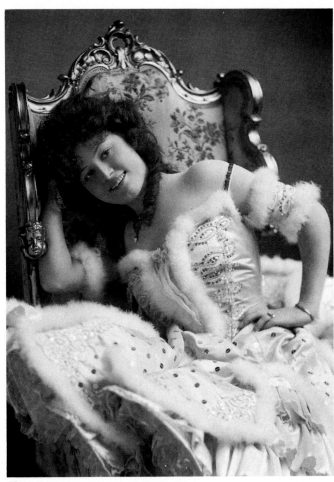

89

Hollywood as late as 1950. (Photo 86: Strauss Peyton, N.Y., at the time of Stone's show *Criss Cross*, 1926. Photo 88: Marceau & Power, Indianapolis, 1899.) **87. BESSIE WYNN** (dates unavailable). In N.Y. shows from at least 1897 up to 1912. In Herbert's *Babes in Toyland* (1903) she introduced "Toyland." In 1910 she appeared in the Chicago show *Miss Nobody from Starland*. She was still appearing in vaudeville in the mid-1920s. **89. LOTTA FAUST** (1881–1910). In N.Y. shows from *The Casino Girl* (1900) to *The Midnight Sons* (1909). (Photo: Otto Sarony Co., N.Y.)

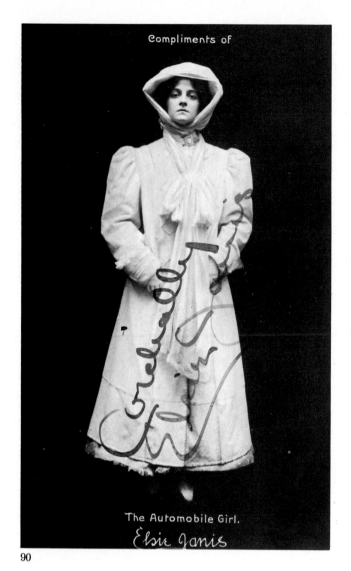

Compliments of

The Automobile Girl.

Elsie Janis

90

"ROTOGRAPH" SERIES B1834

91

90. ELSIE JANIS (1889–1956; real surname Bierbower). On stage from 1897; in N.Y. vaudeville from 1900, primarily as an impersonator. In shows from 1905 (*When We Were Forty-one*). In *The Passing Show(s) of 1914* and *1915*. During World War I, the "Sweetheart of the A.E.F.," entertaining U.S. troops in France; also in London revues. Returned to Broadway in *Elsie Janis and Her Gang* (1919; Eva LeGallienne in cast); last N.Y. show 1925. Later, Hollywood writer and producer. (Photo: in costume for *The Vanderbilt Cup*, 1906.) **91. EDNA WALLACE HOPPER** (1864–1959). On stage (in N.Y.) 1891. Associated with DeWolf Hopper (see No. 36)—whom she married—1893 ff. (in Sousa's *El Capitan* with him, 1896). Other important shows: *Florodora* (1900); *Fifty Miles from Boston* (1908; Cohan). Last N.Y. show 1918. (Photo: as Little Dutch in number "Amsterdam" from Lew Fields's *About Town*, 1906.)

92. MARIE DRESSLER (1869–1934; real name Leila Koerber; born in Canada). On stage from 1886; in N.Y. operetta and musical comedy from 1892. With Weber (& Fields) ca. 1905–12. In *Tillie's Nightmare* (1910) introduced "Heaven Will Protect the Working Girl." In *The Passing Show of 1921*. Last N.Y. show 1923. Important film career in 1930s. (Photo: in *The Century Girl*, 1917.) **93. JOSEPHINE SABEL** (1866–1945). In vaudeville from 1894 (she popularized "A Hot Time in the Old Town," 1896). N.Y. shows: *Earl Carroll Vanities of 1925*; *Oh, Please* (1926; Youmans score); *Sidewalks of New York* (1927). (Photo: Apeda, N.Y.) **94. EMMA CARUS** (ca. 1879–1927). Already big in vaudeville as a "female baritone" by 1901; introduced "Alexander's Ragtime Band," 1911. In N.Y. shows 1900–11, including the first *Ziegfeld Follies* (1907). (Photo: White, N.Y., 1917).

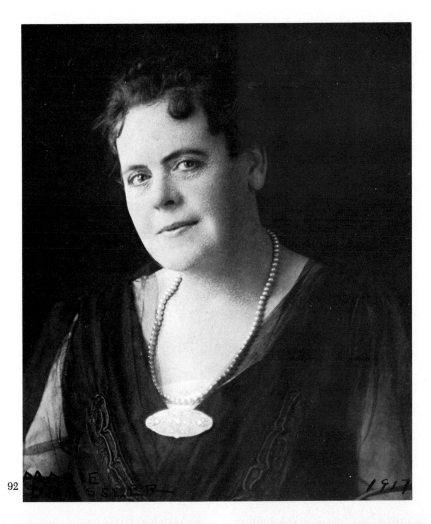

92 MARIE 1917

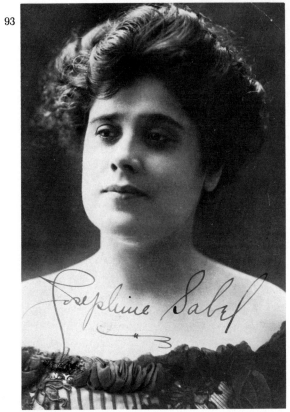

93

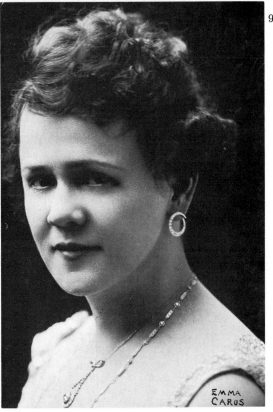

94

EMMA
CARUS

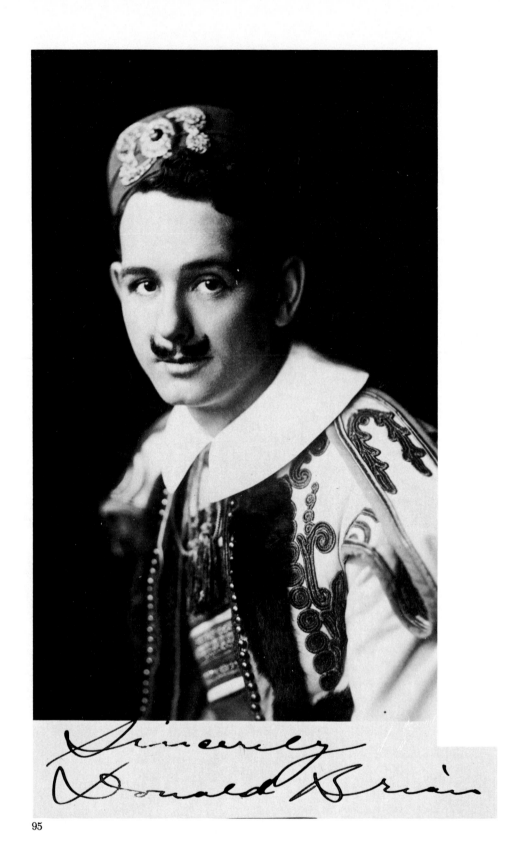

95

95. DONALD BRIAN (1871–1948; born in Newfoundland). On stage from 1896; in N.Y. musicals from 1901. Important shows: *Little Johnny Jones* (1904; Cohan); *Forty-five Minutes from Broadway* (1906; Cohan); *The Merry Widow* (1907; his outstanding success); *The Dollar Princess* (1909); *The Girl from Utah* (1914); *Very Warm for May* (1939; Kern; Brian's last N.Y. show). Chicago appearance 1942. (Photo: as Danilo in *The Merry Widow*.)

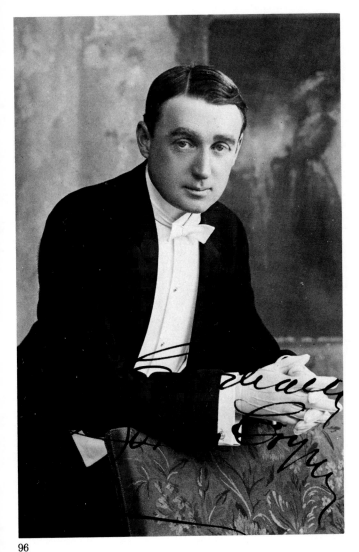

96

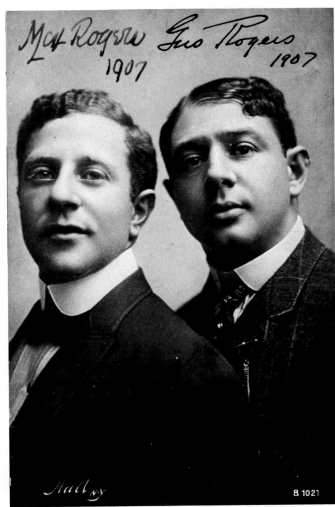

97

96. JOSEPH COYNE (1867–1941). In musicals from at least 1883; in N.Y. variety from 1886; in N.Y. musicals from 1897. Some work in London 1901. In *The Rogers Brothers in London* (1903). Last N.Y. show 1906. In 1907, back in London, was a smash hit as the first English-language Danilo in *The Merry Widow*, and continued in London shows into the 1930s. (Photo: Foulsham & Banfield, London; as Danilo.) **97. ROGERS BROTHERS** (real surname Solomon): **Max** (ca. 1873–1932) & **Gus** (1869–1908). When they entered N.Y. variety in 1888, they had already been on the stage at least three years. For a while part of a Weber & Fields variety troupe, they based their career on imitating that slightly older team. First N.Y. show 1897. From 1899 until the death of Gus, in a series of shows with titles beginning *The Rogers Brothers in* Max appeared on his own in *The Young Turk* (1910) and in Lew Fields's *Hanky-Panky* (1912). (Photo: Hall, N.Y.; signed 1907.)

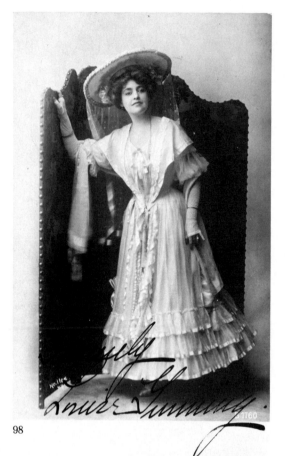

98

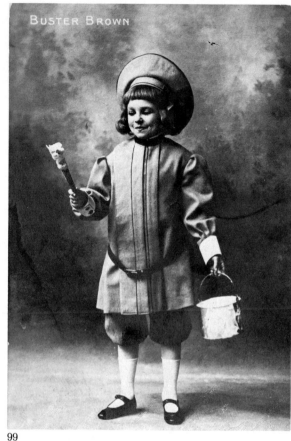

BUSTER BROWN

99

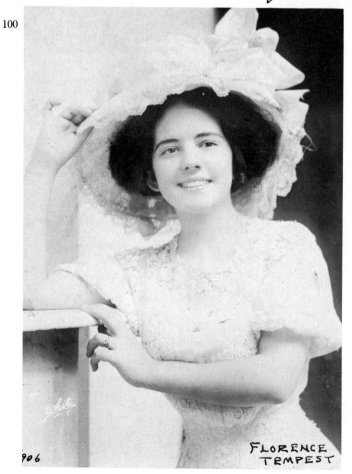

FLORENCE
TEMPEST

906

98. LOUISE GUNNING (ca. 1878–1960). Her N.Y. shows, 1897–1913, included *The Rogers Brothers in Wall Street* (1899); *Love's Lottery* (1904 , alongside Ernestine Schumann-Heink); *Tom Jones* (1907; score by Sir Edward German); and Sousa's *The American Maid* (1913). **99. MASTER GABRIEL** (born ca. 1877). Midget; starred in the musicals *Buster Brown* (1905, shown here); *Little Jack Horner* (Philadelphia, 1906); and *Little Nemo* (1908; Victor Herbert score). **100. FLORENCE (Florenz) TEMPEST** (no dates available). In N.Y. shows from the first *Ziegfeld Follies* (1907) to Berlin's *Stop! Look! Listen!* (1915), including Herbert's *Little Nemo* (1908). Also in vaudeville in team Tempest & Sunshine. (Photo: 1906.)

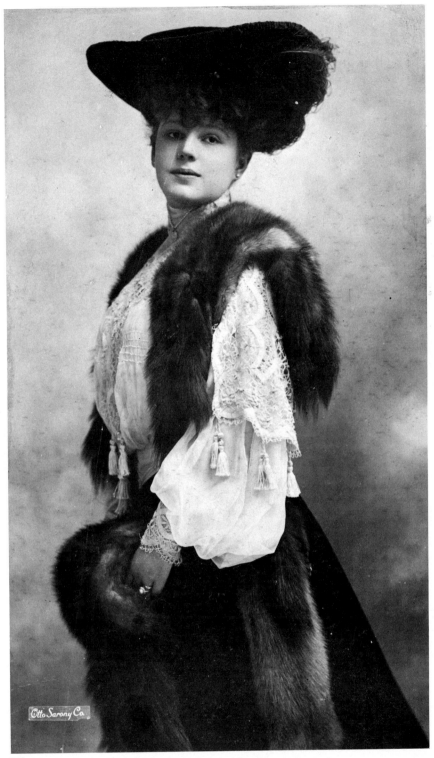

101

101. FRITZI SCHEFF (1876–1954; born in Austria). Operatic debut 1897 in Germany. At Metropolitan Opera 1901–03, then entered operetta. First show: Herbert's *Babette* (1903). Greatest success: Herbert's *Mlle. Modiste* (1905; introduced "Kiss Me Again"). Very extensive stage career, including many revivals, up to at least 1950. (Photo: Otto Sarony Co., N.Y.)

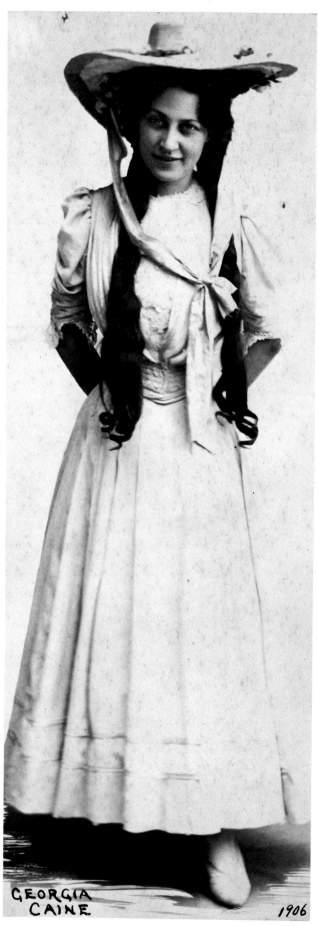

GEORGIA
CAINE

1906

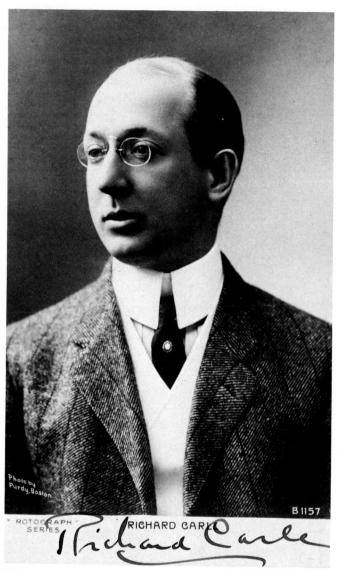

Photo by
Purdy, Boston

B 1157

"ROTOGRAPH" SERIES RICHARD CARLE

Richard Carle

103

102. GEORGIA CAINE (1876–1964). First N.Y. show: *The Rogers Brothers in Wall Street* (1899). In shows with George Ade books: *Peggy from Paris* (1903) and *The Sho-Gun* (1904). Introduced some early Kern hits, such as "How'd You Like to Spoon with Me?" (in *The Earl and the Girl*, 1905). Important later shows: *Mary* (1920); *Little Nellie Kelly* (1922; Cohan); *Smiles* (1930; last musical). Appeared in N.Y. play 1935. **103. RICHARD CARLE** (1871–1941; real name Charles Carleton). On stage from 1892; in N.Y. (in a James T. Powers show) 1893. The first show he wrote (besides performing in it) was *Mam'selle Awkins* (1900). His 1911 show *Jumping Jupiter* had Jeanne Eagels, Ina Claire and Helen Broderick in its cast. Last N.Y. show appearance: *The New Yorkers* (1930; Porter score).

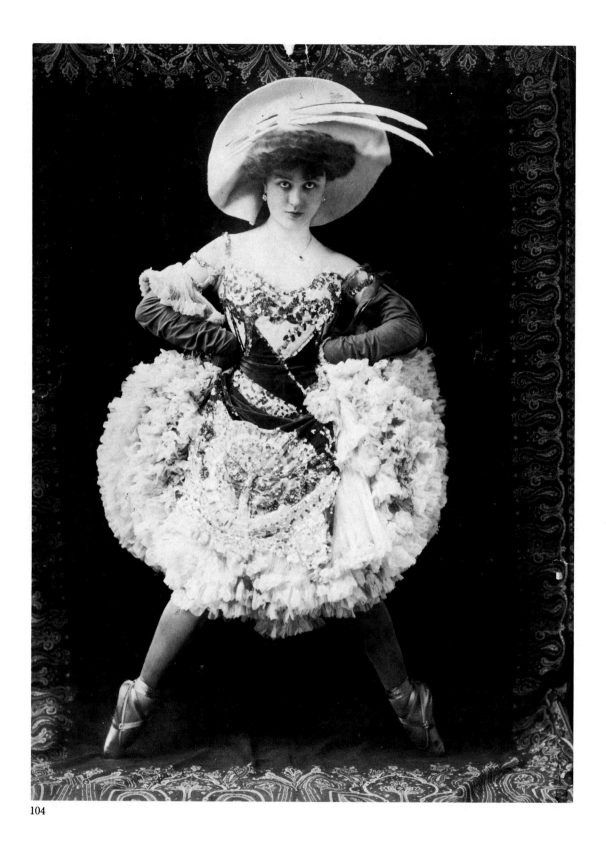

104

104. DAZIE (1884–1952; real name Daisy Peterkin). A dancer with classical training, she began to appear in N.Y. shows in 1900, and was active in vaudeville. Featured in *Buster Brown* (1905), she danced with Oscar Hammerstein's famed Manhattan Opera Company in its 1907–08 season, and was the "stellar attraction" of the first two editions of the *Ziegfeld Follies* (1907 & 1908). In 1911 she was in *La Belle Paree*.

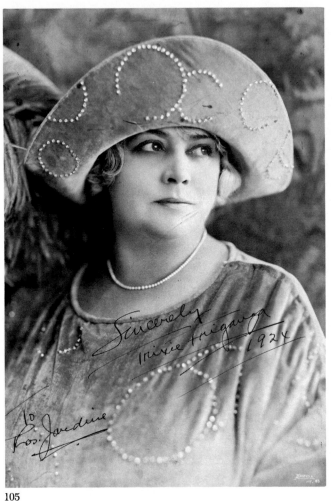

105

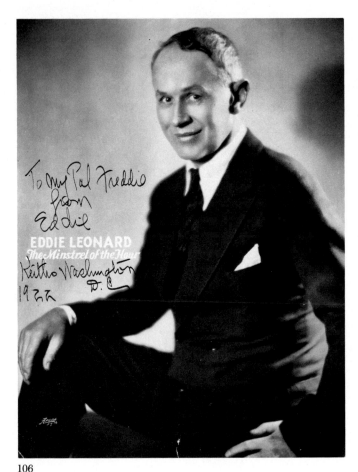

106

105. TRIXIE FRIGANZA (1870–1955; real name Delia O'Callahan). On stage 1889; in N.Y. 1892. She was in *Higgledy-Piggledy* (1904, with Joe Weber) and *The Passing Show of 1912*, among many other productions. Also performed in Chicago and London. Last N.Y. show: *Murray Anderson's Almanac* (1929). USO entertainer. (Photo: Apeda, N.Y.; signed 1924.) **106. EDDIE LEONARD** (1870–1941; real name Lemuel Toney). Minstrel man, chief inspiration for Eddie Cantor (who adopted Leonard's "Ida, Sweet as Apple Cider"). N.Y. shows: *The Southerners* (1904); *Lifting the Lid* (1905); *Cohan and Harris Minstrels* (1908); *Roly-Boly Eyes* (1919). (Photo signed 1922.) **107. CONNIE EDISS** (1871–1934; English) & **GEORGE GROSSMITH, JR.** (1874–1935; English). Connie Ediss was the leading comedienne in the great Gaiety Theatre musicals in turn-of-the-century London. N.Y. appearances 1895, 1907, 1910, 1913, 1914. Grossmith, son of the leading Gilbert &

Sullivan comedian, was very active in British musicals as a writer and producer as well as a performer. N.Y. appearances 1895, 1904, 1908, 1913, 1914, 1930. (Photo: Foulsham & Banfield, London; scene from *The Girl on the Film*, 1913.) **108. LINA ABARBANELL** (1880–1963; born in Germany). In European opera from 1898, she was brought to N.Y. from Berlin in 1905 by Heinrich Conried. At the Metropolitan Opera 1905–06. Into musicals 1906. Biggest hit: *Madame Sherry* (1910). Last N.Y. musical 1930; last N.Y. play appearance 1934; then active in producing. (Photo: White, N.Y., 1917.) **109. CHRISTIE MacDONALD** (1875–1962; born in Canada). In 1892 she was in N.Y. in a Pauline Hall company; then, with Francis Wilson. Stardom from 1900. Biggest hits: *The Spring Maid* (1910) and Herbert's *Sweethearts* (1913). Last N.Y. appearance in *Florodora* revival (1920).

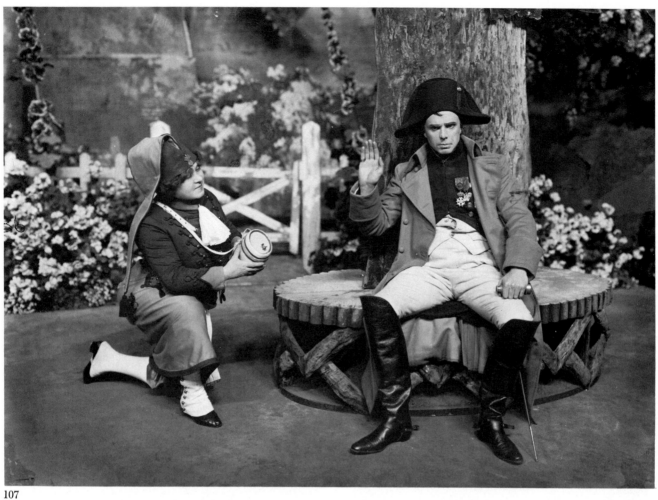

107

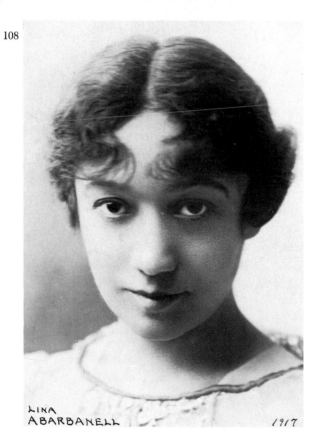

108

LINA
ABARBANELL 1917

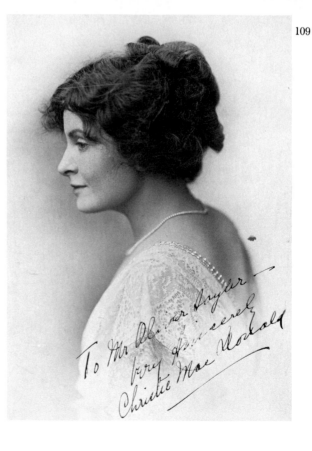

109

To Mr Oliver Taylor
Very sincerely
Christie Mac Donald

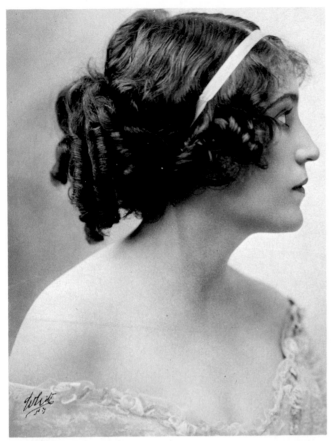

110

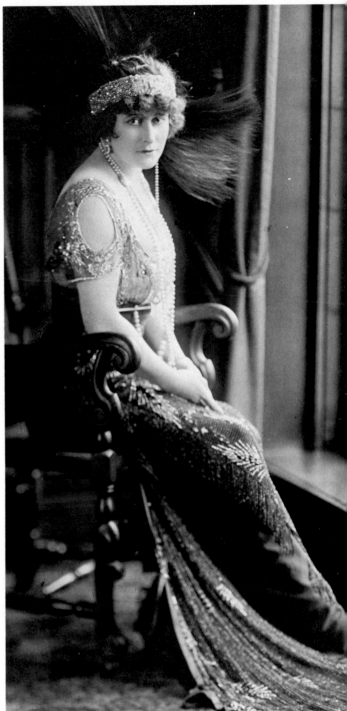

111

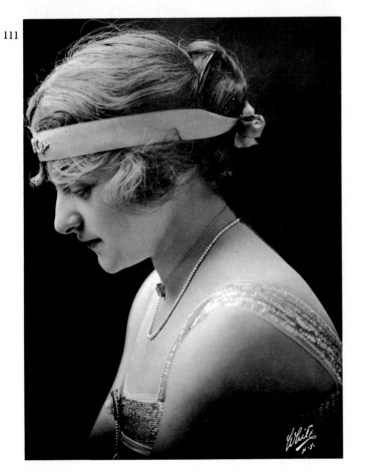

112

46

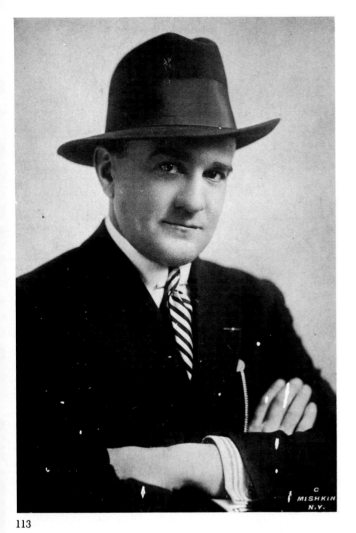

113

114

Great operetta stars of the 1910s. **110. ELEANOR PAINTER** (1890–1947). In at least 6 N.Y. shows from 1914 to 1927, especially *The Princess Pat* (1915; Herbert) and *The Last Waltz* (1921). (Photo: White, N.Y., 1916.) **111. MITZI (Magdalena) HAJOS** (born 1891 in Hungary; also billed as simply Mitzi). On stage 1908; in musicals in Vienna 1909; to N.Y. 1910. Numerous musicals and operettas to 1920, including *La Belle Paree* (1911); *Sari* (1914); and *Pom-Pom* (1916). Appeared in nonmusical plays in N.Y. to 1942. (Photo: White, N.Y. 1916.) **112. KITTY GORDON** (ca. 1877–1974; English). N.Y. appearances, 1905–15, included *Veronique* (1905); *Alma, Where Do You Live?* (1910); *La Belle Paree* (1911); and Herbert's *The Enchantress* (1911; introduced "To the Land of My Own Ro-

mance"). **113. ORVILLE HARROLD** (ca. 1878–1933). Tenor of operatic caliber, at the Metropolitan Opera 1919–24. Broadway shows: *The Belle of London Town* (1907); Herbert's *Naughty Marietta* (1910; "Tramp, Tramp, Tramp Along the Highway," "I'm Falling in Love with Someone," "Ah, Sweet Mystery of Life"); *Hip Hip Hooray* (1915); and *Holka Polka* (1925). (Photo: Mishkin, N.Y.) **114. EMMA TRENTINI** (1878–1959; born in Italy). Sang at La Scala by 1904; at Oscar Hammerstein's Manhattan Opera House 1906–09. Broadway shows: *Naughty Marietta* (1910, shown here; title song, "Italian Street Song"); Friml's *The Firefly* (1912; "Giannina Mia"); and *The Peasant Girl* (1915). (Photo: Mishkin, N.Y.)

To Beatrice —
Very Best love
from
Marilyn Miller

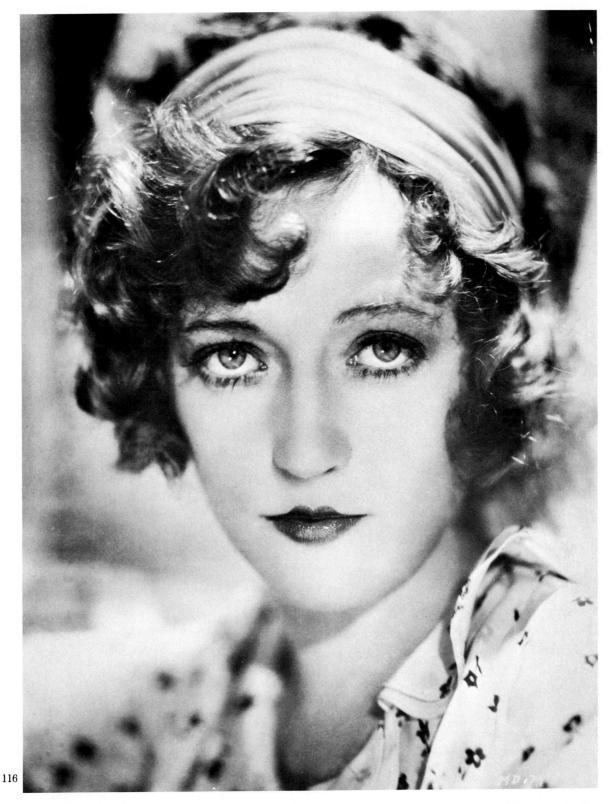

116

Ziegfeld stars of the 1910s. **115. MARILYN MILLER** (1898–1936; real name Mary Ellen Reynolds). In vaudeville 1903–13; then became a Shubert attraction: *The Passing Show(s) of 1914* and *1915*; *The Show of Wonders* (1916). Her magnificent Ziegfeld career as dancer and singer began with the *Follies of 1918*, and led to stardom in *Sally* (1920; Kern; "Look for the Silver Lining"); *Sunny* (1925; Kern; "Who?"); *Rosalie* (1928; Gershwin & Romberg); *Smiles* (1930; Youmans; "Time on My Hands"); and *As Thousands Cheer* (1933; Berlin; her last show). (Photo: Strauss Peyton, N.Y.) **116. MARION DAVIES** (1897–1961; real surname Douras). On stage (and in N.Y.) as dancer 1914, appearing that year in the Montgomery & Stone show *Chin-Chin*. Between 1915 and 1920, when she turned exclusively to film work under the aegis of William Randolph Hearst, she was in such shows as *Nobody Home* (1915; Kern); *Stop! Look! Listen!* (1915; Berlin); *Ziegfeld Follies of 1916*; *Oh, Boy!* (1917; Kern); and *The Ed Wynn Carnival* (1920).

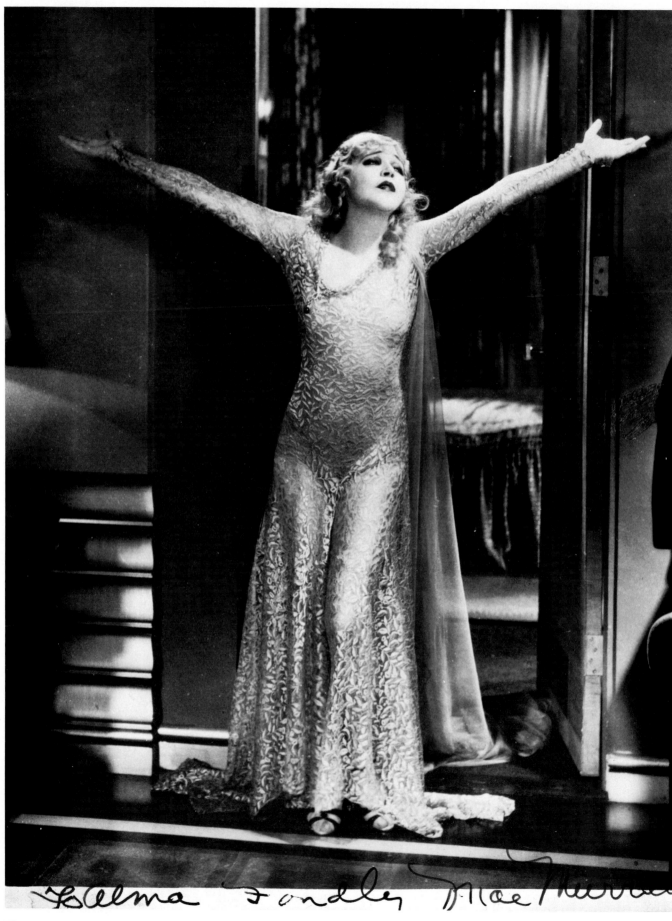

To Alma Fordley Mae Murray

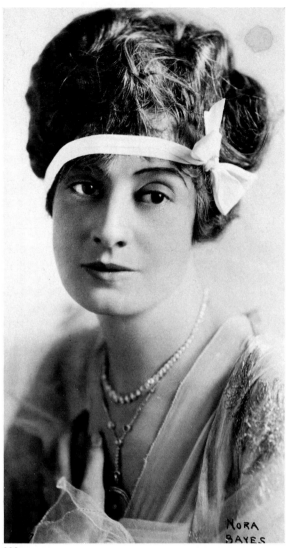

118

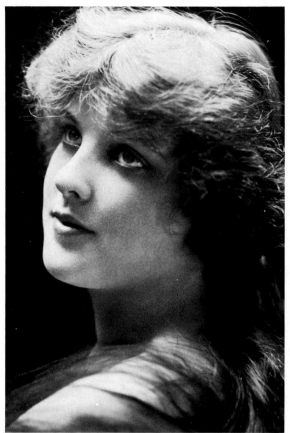

119

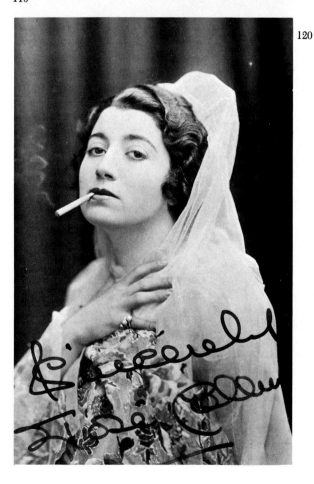

120

More Ziegfeld stars of the 1910s. **117. MAE MURRAY** (1890–1965; real name Marie Koenig). Dancer in N.Y. shows from at least 1904 (*The Sho-Gun*). In *Ziegfeld Follies of 1908, 1909* and *1915* (her last show). Danced in vaudeville with Clifton Webb (No. 140). Major film career to 1931. **118. NORA BAYES** (1880–1928; real name Dora Goldberg). Extensive vaudeville and numerous N.Y. shows, 1901–22, including *The Rogers Brothers in Washington* (1901); *Ziegfeld Follies of 1907, 1908* ("Shine On, Harvest Moon") and *1909; The Jolly Bachelors* (1910; introduced in U.S. "Has Anybody Here Seen Kelly?"). Popularized "Over There" in 1917. (Photo 1917.) **119. JUSTINE JOHNSTONE** (born 1899). On stage in vaudeville 1914; that year, in *Watch Your Step* (Berlin). In *Ziegfeld Follies of 1915* and *1916; Stop! Look! Listen!* (1915; Berlin); *Oh, Boy!* (1917; Kern); and *Over the Top* (1917). Later, films and more vaudeville. **120. JOSÉ COLLINS** (1887–1958; English). Daughter of Lottie Collins (see No. 44). Appeared with Harry Lauder as a child. In N.Y. shows 1911–15, including *Vera Violetta* (1911); *Ziegfeld Follies of 1913; The Passing Show of 1914*. Vast success in London musicals during World War I. In U.S. vaudeville 1926. Became regular actress, appeared as such in N.Y. 1937.

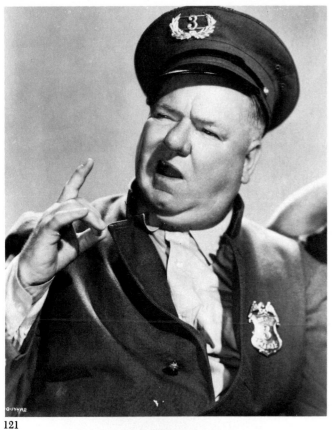

121

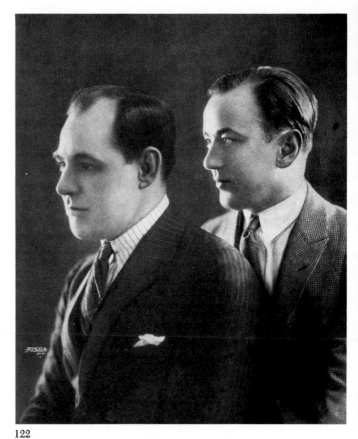

122

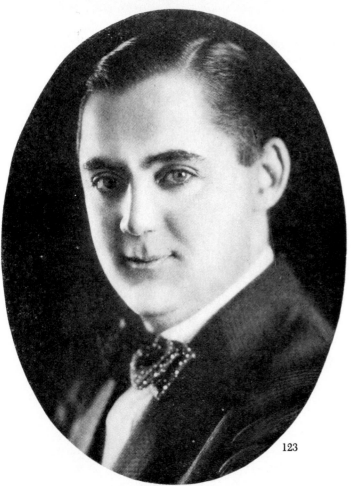

123

Ziegfeld stars of the 1910s and 1920s. **121. W. C. FIELDS** (1879–1946; real name William Claude Dukenfield). Vaudeville juggler from 1897; in N.Y. from 1898. Comedian in the shows: *The Ham Tree* (1905); *Watch Your Step* (1914; Berlin); *Ziegfeld Follies* (1915–21 & 1925); *George White's Scandals* (1922); *Poppy* (1923); *Earl Carroll Vanities of 1928; Ballyhoo* (1930). Splendid film career. **122. GUS VAN** (1888–1968) & **JOE SCHENCK** (died 1930). Singing team, together from 1911. In *The Century Girl* (1916); *Miss 1917* (1917); *Ziegfeld Follies of 1920* and *1921; Nifties of 1923.* In vaudeville, introduced "Who's Sorry Now?" (1923) and "I Wonder What's Become of Sally" (1924). Van appeared on his own in *Toplitzky of Notre Dame* (1946). **123. FRANK TINNEY** (1878–1940). Comedian; in vaudeville at age 4. Important shows: *Ziegfeld Follies of 1910* and *1913; Watch Your Step* (1914; Berlin); *Music Box Revue* (1923; Berlin); *Earl Carroll Vanities of 1925* and *1926* (his last show).

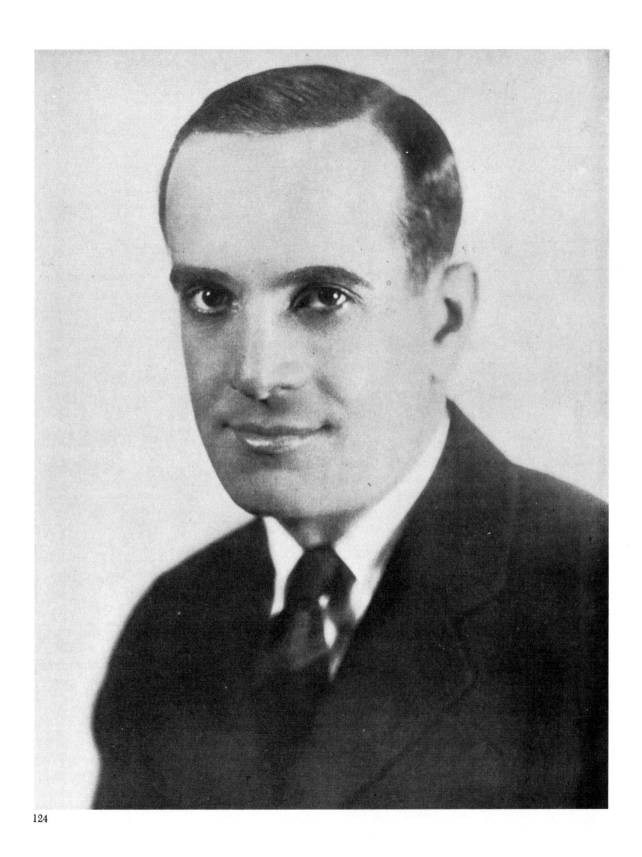

124

124. AL JOLSON (1886–1950; real name Asa Yoelson; born in Russian Lithuania). One of the most dynamic figures in show-business history. On N.Y. stage from 1899; vaudeville and minstrelsy (with Lew Dockstader). Shows: *La Belle Paree* (1911); *Vera Violetta* (1911); *The Whirl of Society* (1912); *The Honeymoon Express* (1913; "You Made Me Love You"); *Dancing Around* (1914); *Robinson Crusoe, Jr.* (1916); *Sinbad* (1918; "Rock-a-Bye Your Baby with a Dixie Melody"); *Bombo* (1920; "April Showers"; "California, Here I Come"; "Toot, Toot, Tootsie"); *Big Boy* (1925; "It All Depends on You"; "If You Knew Susie"; "Keep Smiling at Trouble"); *The Wonder Bar* (1931); *Hold On to Your Hats* (1940). Extensive USO tours in World War II and Korean War. Greatest popularizer of early talking pictures.

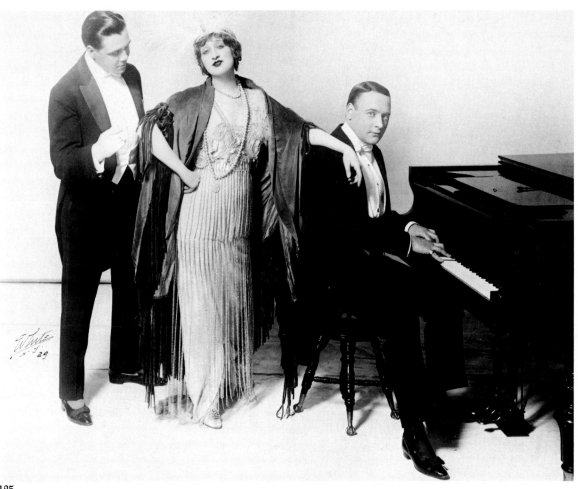

125

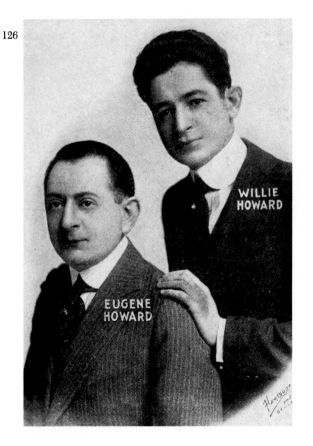

126

WILLIE
HOWARD

EUGENE
HOWARD

Stars of Shubert shows in the 1910s. **125. GABY (Gabrielle) DESLYS** (1884–1920; French). Parisian music-hall star who starred in 5 N.Y. shows from 1911 to 1915, including *Vera Violetta* (1911); *The Honeymoon Express* (1913); and *Stop! Look! Listen!* (1915; Berlin; "Take Off a Little Bit"). At the left in the photo is the actor **ERNEST GLENDINNING** (1884–1936; born in England; in U.S. from 1900; on N.Y. stage from 1903 to 1935; in only 2 or 3 other musicals). At the right is **MELVILLE ELLIS** (1878–1917; in some 9 N.Y. musicals between 1899 and 1914, including *The Rogers Brothers in London*, 1903; in vaudeville with Irene Bordoni, 1916). (Photo: White, N.Y.; scene from *The Honeymoon Express*.) **126. EUGENE & WILLIE HOWARD** (real surname Levkowitz; born in Germany). Eugene (actually Isidore; 1880–1965); Willie (1883–1949). Comedians and singers in vaudeville (partners from 1903) and a vast number of shows (Eugene as early as 1897, Willie as late as 1948), including the (Shubert) *Passing Show(s) of 1912, 1915, 1918, 1921 and 1922;* and *George White's Scandals of 1926, 1928, 1929 and 1931* (in the last-named, they did the sketch "Pay the Two Dollars"). Willie was on his own in *Girl Crazy* (1930; Gershwin) and *Ziegfeld Follies of 1934*. (Photo: Hartsook, San Francisco & Los Angeles, 1918.)

127

128

129

127. VALESKA SURATT (ca. 1881–1962). Much vaudeville, and a few shows between 1906 and 1922. (Photo: Apeda, N.Y.; signed 1914; in costume for the vaudeville act "Black Crepe and Diamonds.") **128. GERTRUDE HOFFMAN(N)** (late 1880s?–1955; born in Canada; birth year usually given, 1898, is absurd). Dancer, choreographer, trainer of precision dance troupes. Danced the "Mattchiche" in *A Parisian Model* (1906); produced and starred in *Broadway to Paris* (1912). Stole some of Diaghilev and Bakst's thunder by copying the Ballets Russes before their arrival in N.Y. (Photo: Apeda, N.Y.) **129. ANNETTE KELLERMAN(N)** (ca. 1888–1975; born in Australia). Swimming star; popularized one-piece bathing suit. In "Undine" section of show *Vera Violetta* (1911); briefly in *Ziegfeld Follies of 1914;* and in two Hippodrome shows: *The Big Show* (1916; replacing Pavlova) and *Cheer Up* (1917). (Photo: White, N.Y.)

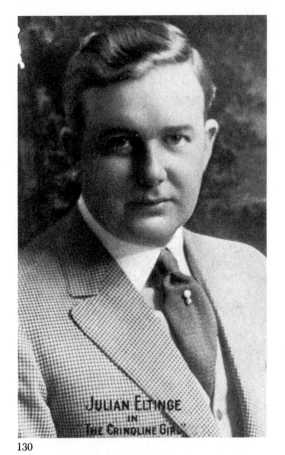

JULIAN ELTINGE
IN
THE CRINOLINE GIRL

130

131

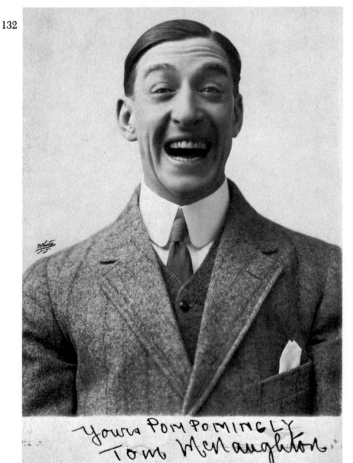

Yours POMPOMINGLY
Tom McNaughton

132

130. JULIAN ELTINGE (1883–1941; real name William Dalton). Foremost American female impersonator. N.Y. shows: *Cohan and Harris Minstrels* (1908); *The Fascinating Widow* (1911); *The Crinoline Girl* (1914); *Cousin Lucy* (1915; Kern). He also appeared in a revue in Hollywood in 1931. (Photo 1914.) **131. RAYMOND HITCHCOCK** (1870–1929). Singing comedian and producer; on the professional stage from 1890; in N.Y. from 1894. Milestones in his career: with May Irwin in *Courted into Court* (1896); in shows with Luders scores (*The Burgomaster*, 1900; *King Dodo*, 1902); stardom in *The Yankee Consul* (1903; N.Y., 1904); Cohan's *The Man Who Owns Broadway* (1909); in his own *Hitchy-Koo* shows (1917–20); *Ziegfeld Follies of 1921*. Last show 1927; last appearance 1928. **132. TOM McNAUGHTON** (1867–1923; English). Comedian, husband of Alice Lloyd (see No. 84). In the N.Y. shows: *The Spring Maid* (1910); *Sweethearts* (1913; Herbert); *Suzi* (1914); *Fads and Fancies* (1915); *Pom-Pom* (1916). (Photo 1916.)

133

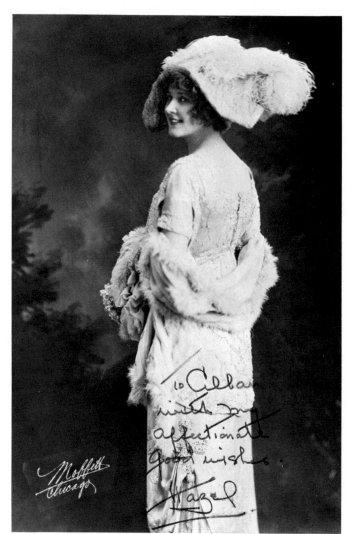

134

133. FRANCES DEMAREST (dates unavailable). N.Y. shows from 1910 to 1919, including *Madame Sherry* (1910; "Every Little Movement Has a Meaning of Its Own"); *Gypsy Love* (1911); *The Passing Show(s) of 1914, 1915* and *1916; The Blue Paradise* (1915, shown here; Romberg). (Photo: White, N.Y.) **134. HAZEL DAWN** (born 1891; real name Hazel Dawn Tout). Started career in England 1909. In N.Y. shows from 1911 (*The Pink Lady*; introduced "My Beautiful Lady" waltz) to *The Great Temptations* (1926; introduced "Valencia" in U.S.). In straight plays to 1931. (Photo: Moffett, Chicago.)

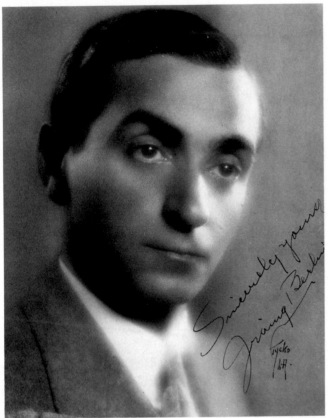

135

136

137

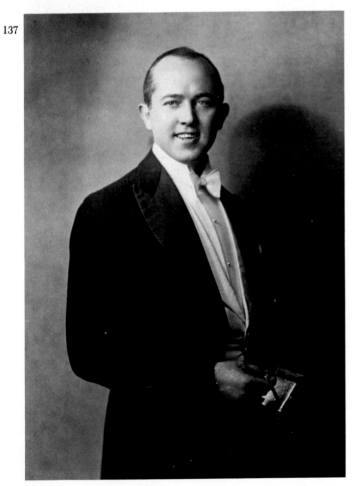

On this page and the next are some stars of earlier Irving Berlin shows. **135. IRVING BERLIN** (born 1888 in Russia; real name Israel Baline). Superb songwriter and show producer; appeared himself in *Up and Down Broadway* (1910); *Yip Yip Yaphank* (1918; soldier show; "Oh, How I Hate to Get Up in the Morning"); *Music Box Revue* (1921); and *This Is the Army* (1942; soldier show). (Photo: Tycko, Los Angeles.) **136. JOSEPH SANTLEY** (1886–1962). On stage at age 3, in N.Y. musicals from 1910 to 1933, including Lew Fields's *The Never Homes* (1911); Berlin's *Stop! Look! Listen!* (1915; "The Girl on the Magazine Cover"); Kern's *She's a Good Fellow* (1910); Berlin's *Music Box Revue* (1921, 1923). Also a songwriter and a writer, producer and director of films. **137. JOHN STEEL** (1900??–1971). Fine tenor. In *The Maid of the Mountains* (1918) and the following shows with Berlin songs: *Ziegfeld Follies of 1919* ("A Pretty Girl Is Like a Melody") and *1920*; *Music Box Revue* (1922; "Lady of the Evening"; & 1923).

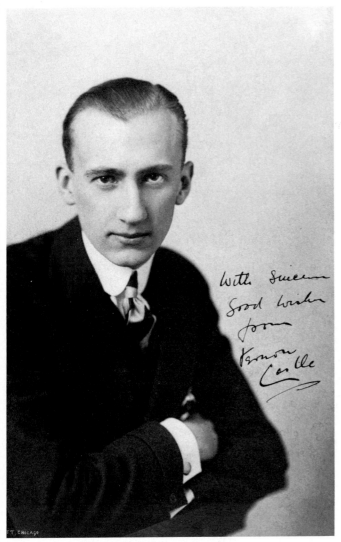

138

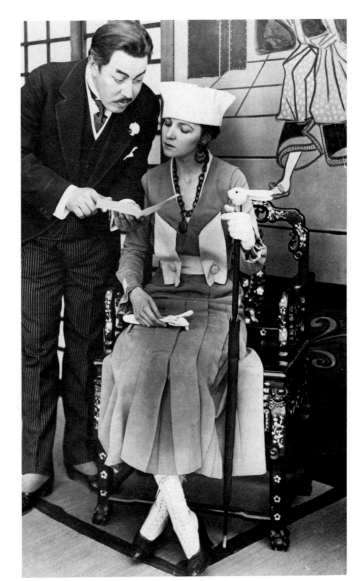

139

138. VERNON CASTLE (1887–1918; real name Vernon Castle Blythe; born in England). Great ballroom dancer and show comedian. In Lew Fields shows from 1906 to 1911, then in *The Lady of the Slipper* (1912); *The Sunshine Girl* (1913); and *Watch Your Step* (1914; Berlin). Killed while in service in World War I. (Photo: Mof-fett, Chicago, 1913.) **139.** His wife and dancing partner, **IRENE CASTLE** (1893–1969; née Foote). She was in his shows from 1910 to 1914, and also in *Miss 1917* (1917); she made a public appearance in 1939. (Photo: International Film Service, Inc., 1917; scene from the film serial *Patria*, also showing Warner Oland.)

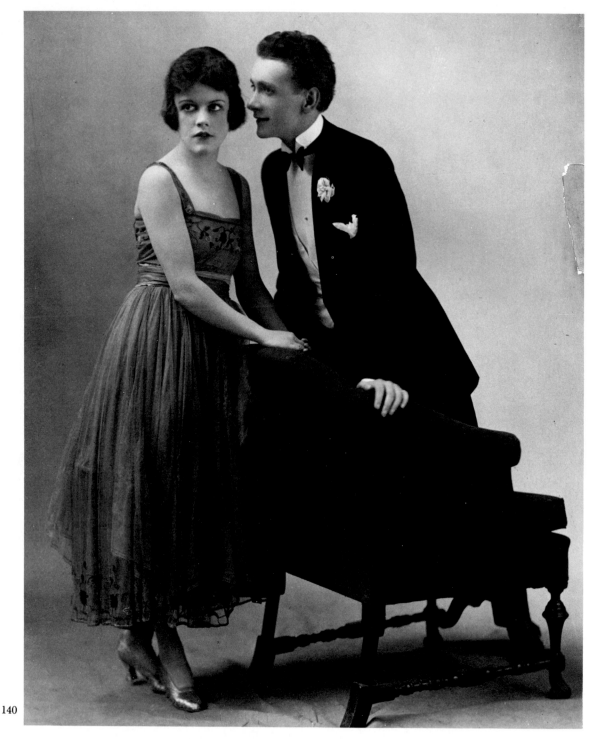

140

140. CLIFTON WEBB (ca. 1889–1966; real name Webb Parmelee Hollenbeck). Actor, singer, dancer; on stage 1902; member of Boston Opera Company 1911 ff.; to N.Y. 1913. Major shows: *See America First* (1916; first show with Porter score); *Love o' Mike* (1917; Kern); *Sunny* (1925; Kern); *She's My Baby* (1928; Rodgers & Hart); *Treasure Girl* (1928; Gershwin; "I've Got a Crush on You"); *The Little Show* (1929; Schwartz; "I Guess I'll Have to Change My Plan"); *Three's a Crowd* (1930; Schwartz); *Flying Colors* (1932; Schwartz; "Louisiana Hayride"); *As Thousands Cheer* (1933; Berlin; "Easter Parade"); *You Never Know* (1938; Porter). Straight appearances to 1946, then films. (Photo: scene from *Love o' Mike*, with Leone Morgan, who had a brief minor career to 1923.) **141. JOSEPH CAWTHORN(E)** (1867–1949) & **JULIA SANDERSON** (1887–1975; real surname Sackett). Singing comedian Cawthorne was in variety (and in N.Y.) by the early 1870s and in a vast number of N.Y. musicals from 1895 to 1925, including: *The Fortune Teller* (1898; Herbert); *The Freelance* (1906; Sousa); *Little Nemo* (1908; Herbert); four shows with Julia Sanderson (1914–18; Donald Brian was also in two of these); *Sunny* (1925; Kern). Julia Sanderson quickly moved up from N.Y. show choruses (1902–03) to larger roles in the 1900s and stardom in the 1910s. In *The Girl from Utah* (1914) she introduced Kern's "They Didn't Believe Me." Last N.Y. appearance 1928; then radio to 1943. (Photo: White, N.Y.; scene from *Rambler Rose*, 1917.)

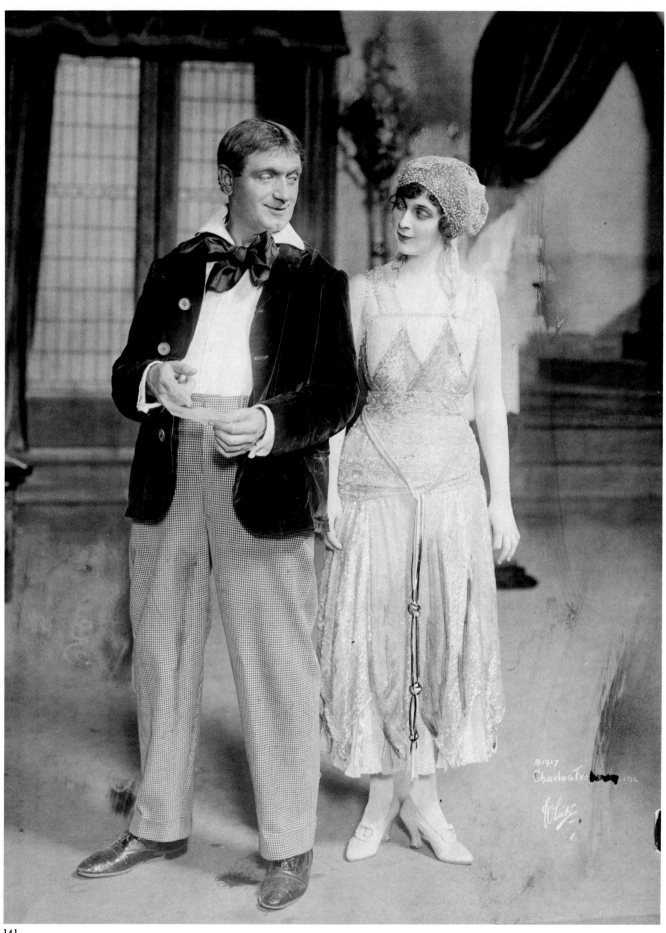

141

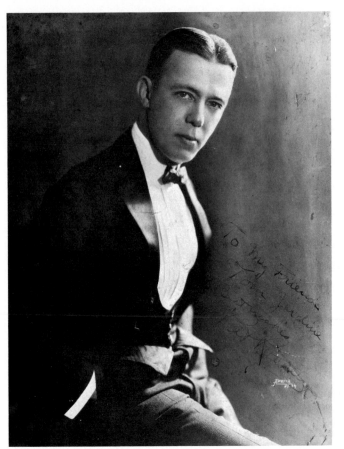

142

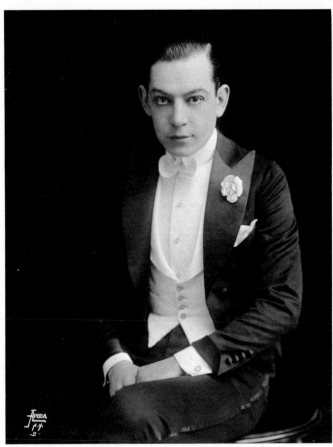

143

142. PAT ROONEY (JR.) (1880–1962). Much vaudeville, and N.Y. shows from 1898 to 1903, including *The Rogers Brothers in Washington* (1901) and *The Rogers Brothers in Harvard*; then again in 1921, 1944 and in the 1950 *Guys and Dolls* (Loesser). (Photo: Apeda, N.Y.) **143. CARTER DE HAVEN** (1886–1977). In vaudeville 1896–1903; then in N.Y. shows, 1903–17, including: *Whoop-Dee-Doo* (1903; Weber & Fields); *Miss Dolly Dollars* (1905; Herbert); and two Lew Fields shows, *Hanky-Panky* (1912) and *All Aboard* (1913). In the 1920s he was a Hollywood producer. Father of Gloria De Haven. (Photo: Apeda, N.Y.)

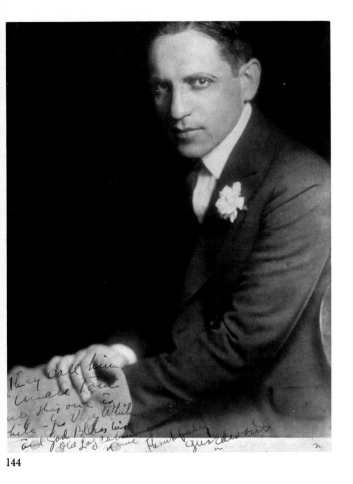

144

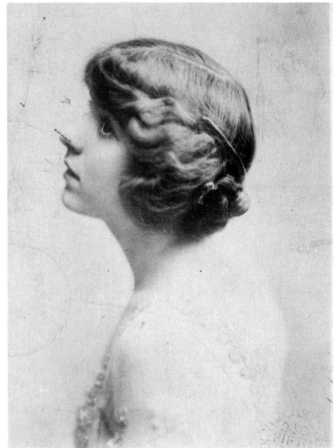

145

146

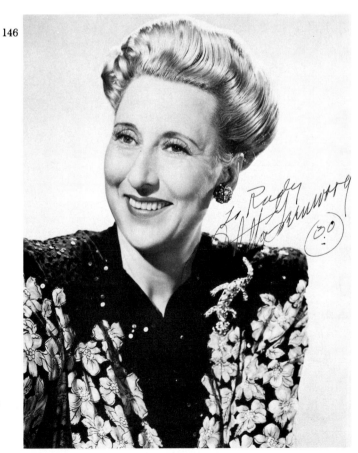

144. GUS EDWARDS (1878–1945; real surname Simon; born in Germany). Great impresario and developer of young talent (Eddie Cantor, George Jessel, Lila Lee and many others). Appeared in vaudeville and films, not in regular Broadway shows. **145. INA CLAIRE** (born 1892; real surname Fagan). Started in vaudeville 1907 as an impersonator; then into half a dozen N.Y. musicals, including *Ziegfeld Follies of 1915* ("Hello, Frisco") and *1916*, and one in London. From 1917, straight plays, becoming the leading comedienne of manners of the American stage. (Photo 1911, in *The Quaker Girl.*) **146. CHARLOTTE GREENWOOD** (ca. 1891–1978). In N.Y. show chorus 1905. Her many N.Y. shows (she also appeared in London) included: *The Rogers Brothers in Panama* (1907); *The Passing Show(s) of 1912* and *1913*; the very popular musicals built around the character Letty (*So Long, Letty*, 1916; *Linger Longer Letty*, 1919); *Music Box Revue* (1922; Berlin); and her brilliant return to the stage in *Out of This World* (1950; Porter; "Nobody's Chasing Me"). (Photo: publicity shot for the 1943 film *The Gang's All Here.*)

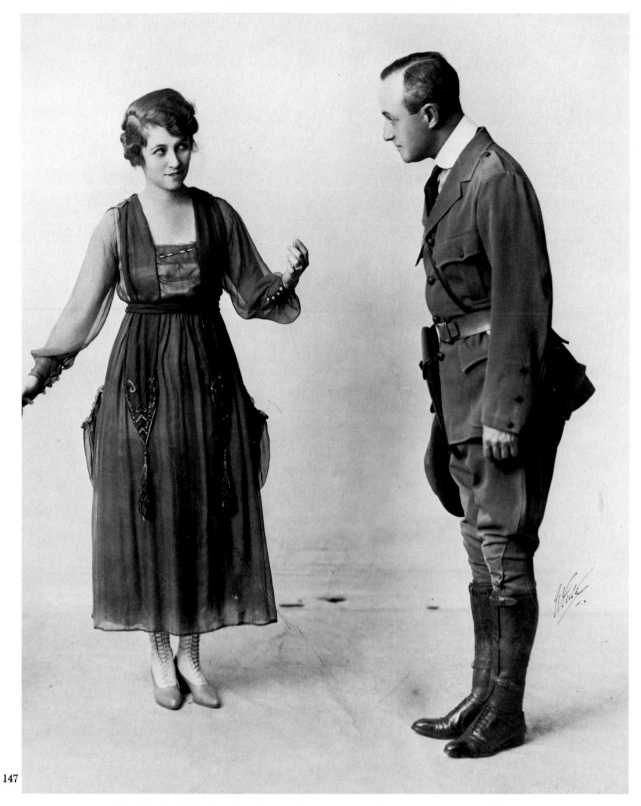

147

147. ADELE ROWLAND (no dates available) **& CLIFTON CRAWFORD** (ca. 1875–1920; born in Scotland). Adele Rowland was in numerous N.Y. musicals from 1904 to 1922, then concentrated on vaudeville. Her most interesting shows were: *The Only Girl* (1914; Herbert); *Nobody Home* (1915; Kern's first Princess Theatre show); and *Katinka* (1915; Friml). Among Crawford's many shows between 1901 and 1918 were *Three Twins* (1908) and *The Quaker Girl* (1911). (Photo: White, N.Y.; scene from *Her Soldier Boy*, 1916.) **148. EDITH DAY** (1896–1971). On stage 1915; in N.Y. 1916. Major N.Y. shows: *Going Up* (1917); *Irene* (1919; title song, "In My Sweet Little Alice Blue Gown"); *Orange Blossoms* (1922; Herbert; "A Kiss in the Dark"); *Wildflower* (1923; Youmans; "Bambalina"). From 1925 she starred in London productions of major American operettas by Friml, Romberg, Kern and others. (Photo: Underwood & Underwood. N.Y.; in *Follow Me*, 1916.)

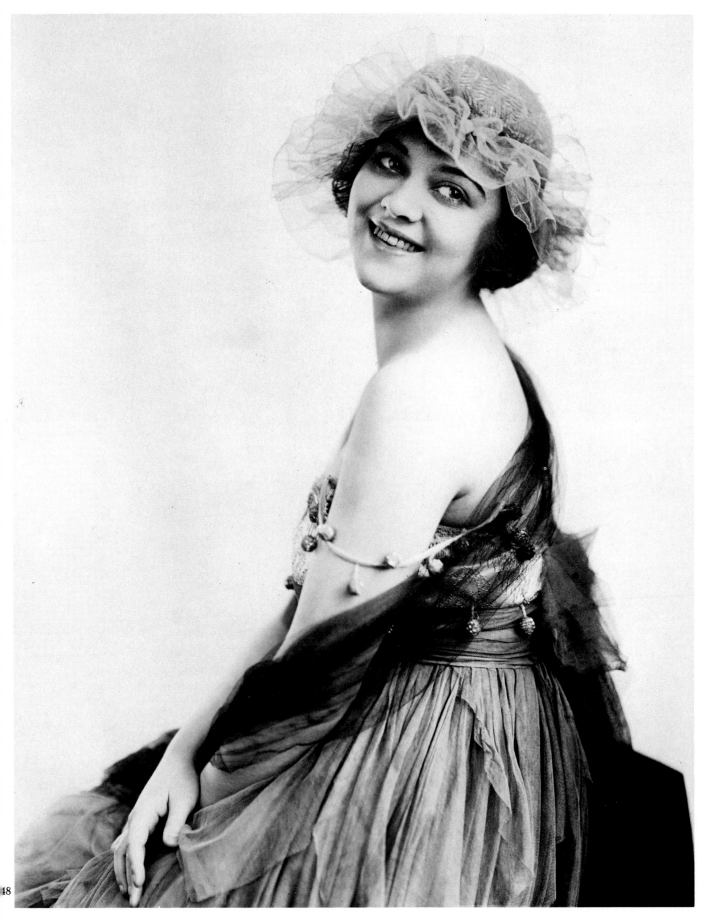

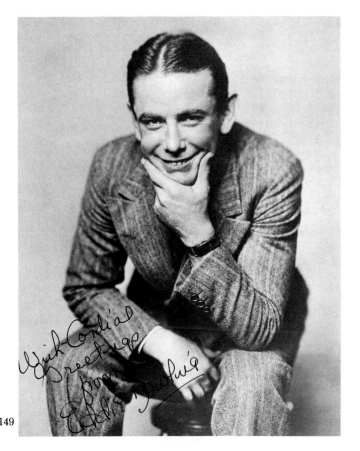

149

150

151

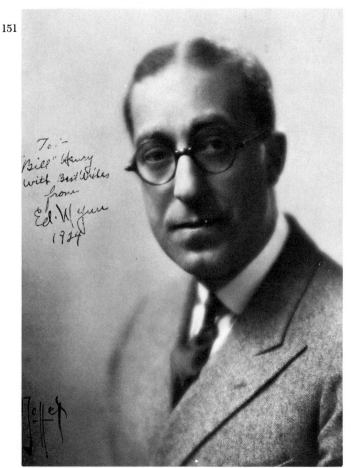

149. EDDIE DOWLING (1894–1976). On stage from 1909; in N.Y. from 1917. Musical appearances included *Ziegfeld Follies of 1919*; *Sally, Irene and Mary* (1922; also co-writer of show); *Honeymoon Lane* (1926; also co-writer); *Thumbs Up* (1934). Later, actor in, and producer of, major straight plays. Husband of Ray Dooley (see No. 202). **150. EVELYN HERBERT** (born 1898; real surname Houstellier). Brilliant operetta soprano. Opera in N.Y. and Chicago; then 8 N.Y. shows, especially *The New Moon* (1928; Romberg; "One Kiss," "Wanting You," "Lover, Come Back to Me"). **151. ED WYNN** (1886–1966; real name Edward Leopold). Outstanding comedian, producer of some of his shows. Vaudeville from 1901; N.Y. musicals from 1910 to 1942, including *Ziegfeld Follies of 1914* and *1915*; *The Ed Wynn Carnival* (1920); *The Perfect Fool* (1921); *Manhattan Mary* (1927); *Simple Simon* (1930; Rodgers & Hart); and *Hooray for What!* (1937). (Photo: Moffett, Chicago; signed 1924.) **152. VIVIENNE SEGAL** (born 1897). Highlights of fabulous career: opera in Philadelphia 1914; in N.Y.: *The Blue Paradise* (1915, shown here; Romberg); *Oh, Lady! Lady!* (1918; Kern); *Ziegfeld Follies of 1924*; *The Desert Song* (1926; Romberg); *The Three Musketeers* (1928; Friml); *I Married an Angel* (1938; Rodgers & Hart); *Pal Joey* (1940; Rodgers & Hart; "Bewitched, Bothered and Bewildered"; also 1952 revival, her last show).

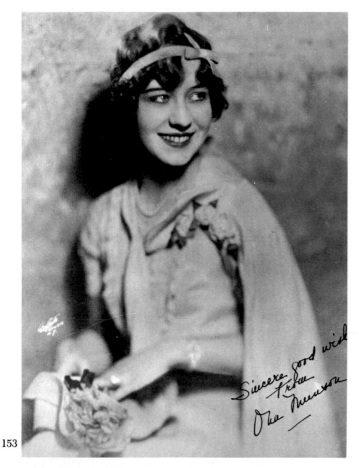

153

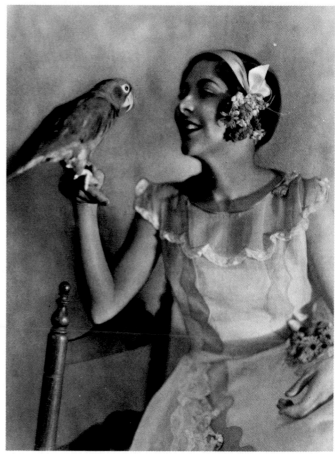

154

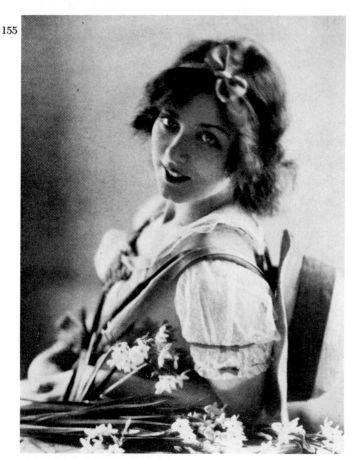

155

153. ONA MUNSON (1903–1955). In N.Y. musicals 1919–33, including *George White's Scandals of 1919; Manhattan Mary* (1927); *Hold Everything* (1928; "You're the Cream in My Coffee"); *Pardon My English* (1933; Gershwin); and *Hold Your Horses* (1933). Straight plays in N.Y. to 1952. (Photo: White, N.Y.) **154. LOUISE GROODY** (1897–1961). Cabaret dancer in N.Y. 1915; musicals 1915–27, including *The Night Boat* (1920; Kern); *Good Morning, Dearie* (1921; Kern); *No, No, Nanette* (Chicago, 1924; N.Y., 1925; Youmans; "Tea For Two," "I Want to Be Happy"); *Hit the Deck* (1927, shown here; Youmans; "Sometimes I'm Happy"). Plays to 1933. (Photo: Nicholas Hay.) **155. MARY ELLIS** (born 1899; real surname Elsas). At Metropolitan Opera 1918–22 (in world premiere of Puccini's *Suor Angelica*, 1918). N.Y. shows from 1922. Title role of *Rose-Marie* (1924, shown here; Friml; "Indian Love Call"). In England 1932–54 in American musicals and Ivor Novello shows. Also straight actress. **156. IRENE BORDONI** (before 1895–1953; born in Corsica). In Parisian music halls 1909–11; N.Y. shows from 1912 to 1940, including *Hitchy-Koo* (1917 & 1918); *As You Were* (1920); *The French Doll* (1922; "Do It Again"); *Paris* (1928; Porter; "Let's Do It"); *Louisiana Purchase* (1940; Berlin). In Chicago *South Pacific* company ca. 1950. (Photo: in 1917 or 1918 *Hitchy-Koo*.)

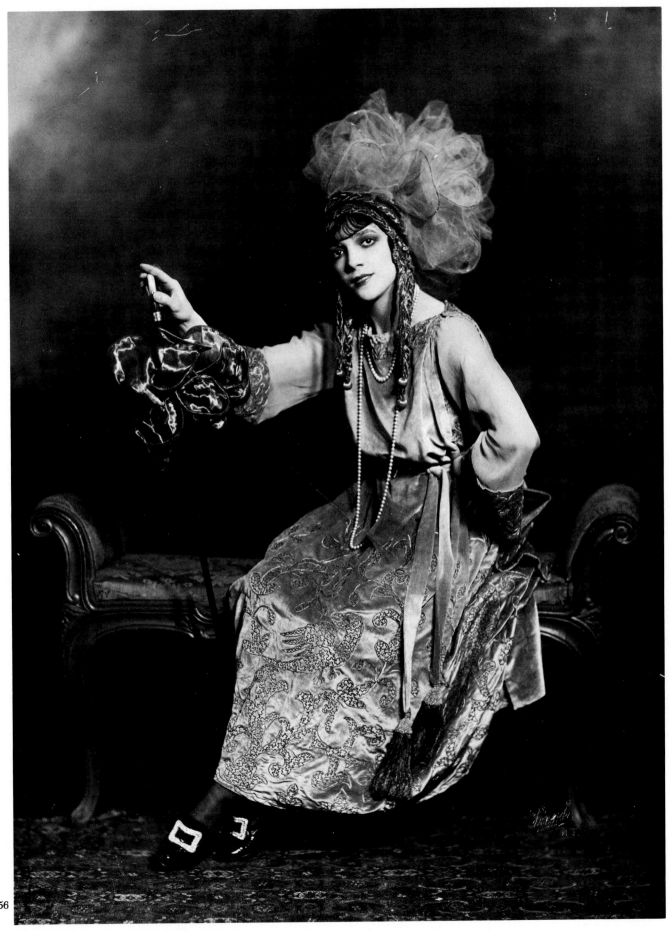

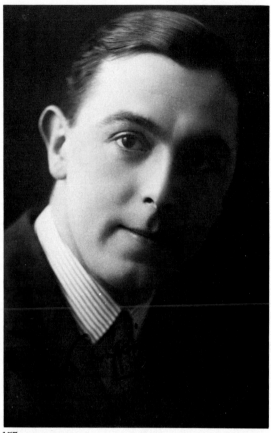

157

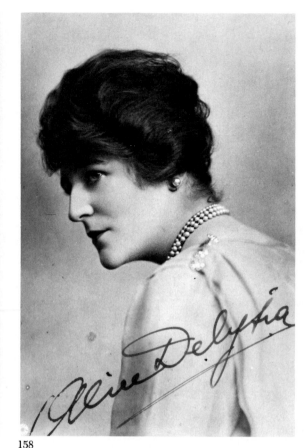

158

159

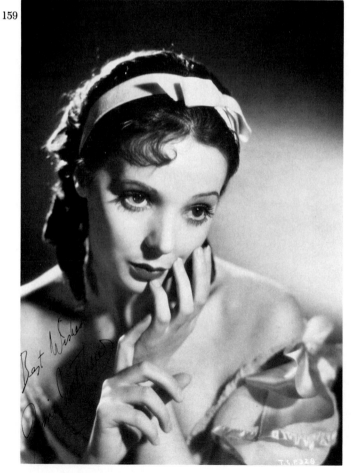

Two pages of distinguished visitors from Britain. **157. LUPINO LANE** (1892–1959; actually Henry George Lupino). Member of great English theatrical dynasty; on stage at age 4; in London from 1903 in music halls and shows. N.Y. musicals: *Afgar* (1920); *Ziegfeld Follies of 1924*. Important film career. (Photo: Fielding, Leeds; signed 1921.) **158. ALICE DELYSIA** (1888–1979; real surname Lapize; French). On stage 1903 (in chorus at Moulin Rouge in Paris); many shows in Paris and London up to at least 1939. N.Y. appearances: *The Catch of the Season* (1905; as Elise Delisia); *Afgar* (1920); *Topics of 1923* (1923). (Photo: Foulsham & Banfield, London.) **159. JESSIE MATTHEWS** (1907–1981). Top star of English movie musicals as actress, singer and dancer; also on London stage. N.Y. appearances: *Charlot's Revue* (1924; chorus and understudy to Gertrude Lawrence); *Earl Carroll Vanities of 1927*; *Wake Up and Dream* (1929; Porter). (Photo: Gaumont-British Picture Corp.)

160

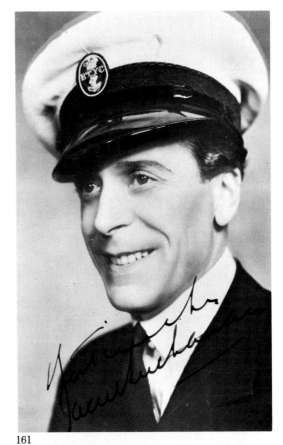

161

162

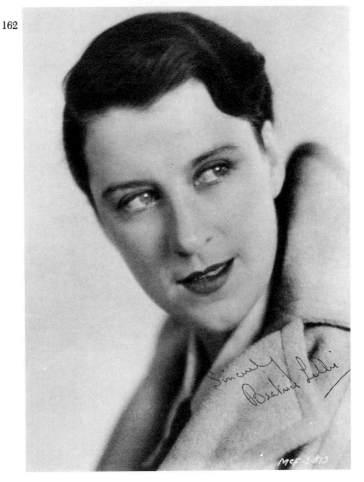

160. GERTRUDE LAWRENCE (ca. 1898–1952; real surname Klasen). On stage 1908, steady London show work from 1916. Also straight actress. Among her N.Y. musicals: *Charlot's Revue* (1924; "Limehouse Blues"; & 1926); *Oh, Kay!* (1926; Gershwin; "Do, Do, Do," "Someone to Watch Over Me"); *The International Revue* (1930); *Lady in the Dark* (1941; Weill); *The King and I* (1951; Rodgers & Hammerstein; "Whistle a Happy Tune," "Hello, Young Lovers," "Getting to Know You"). (Photo mid-1920s.) **161. JACK BUCHANAN** (1891–1957; born in Scotland). On stage 1912; in many London shows. In N.Y.: *Charlot's Revue* (1924 & 1926); *Wake Up and Dream* (1929; Porter); *Between the Devil* (1937; Schwartz; "By Myself"). **162. BEATRICE LILLIE** (born early 1890s in Canada). On stage in London from 1914. Numerous N.Y. musicals, 1924–64, included: *Charlot's Revue* (1924 & 1926); *Oh, Please* (1926; Youmans; "I Know That You Know"); *Walk a Little Faster* (1932); *At Home Abroad* (1935; Schwartz; "Get Yourself a Geisha"); *The Show Is On* (1936); *Inside U.S.A.* (1948); *High Spirits* (1964).

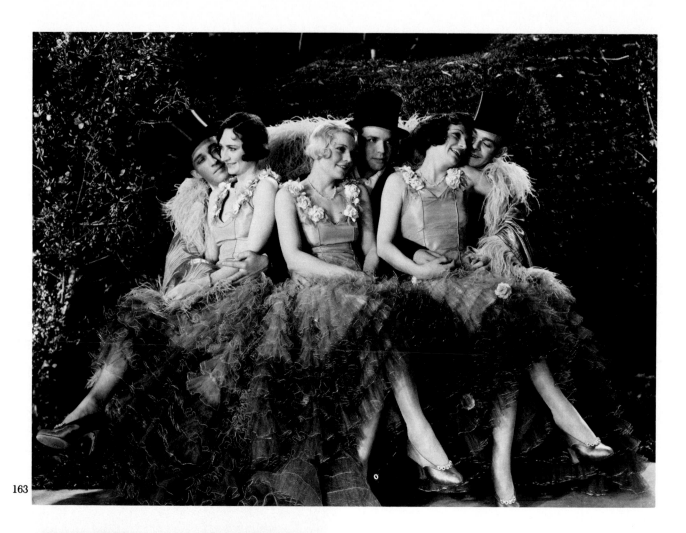

163

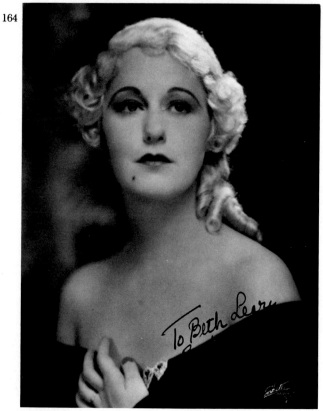

164

Two pages of stars of 1920s Irving Berlin shows. **163. BROX SISTERS** (Lorraine, Patsy & Bobbie; no dates available). Peppy vocal team in these shows (all with Berlin scores): *Music Box Revue* (1921; "Everybody Step"; 1923; 1924); *The Cocoanuts* (1925; with Marx Bros.); *Ziegfeld Follies of 1927*. (Photo: in 1930 film *King of Jazz*, with Paul Whiteman's Rhythm Boys: left to right, Bing Crosby, Al Rinker and Harry Barris.) **164. GRACE MOORE** (1901–1947). On stage (and in N.Y.) from 1920. Among her shows: *Music Box Revue* (Berlin; 1923; "What'll I Do?"; 1924; "All Alone"); *The Du Barry* (1932; shown here). At Metropolitan Opera 1927–32, 1935–36, 1937–46; also sang at Opéra-Comique and Covent Garden. Films. (Photo: White, N.Y.)

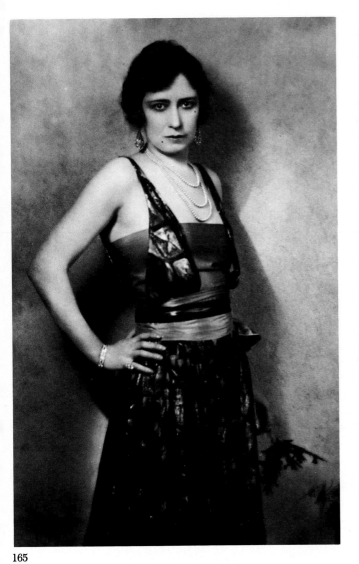

165

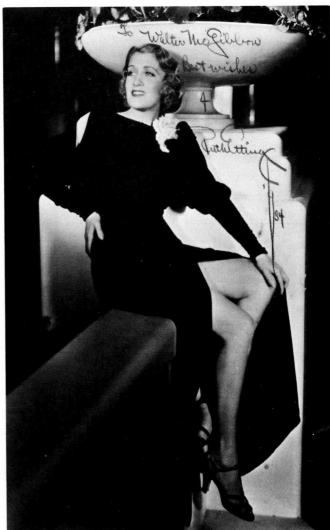

166

165. GRACE LA RUE (1881–1956). Her N.Y. musicals, 1906–29, included: *Ziegfeld Follies of 1907* and *1908*; *Hitchy-Koo* (1917); *Music Box Revue* (1922; Berlin); *Greenwich Village Follies of 1928*. (Photo: Victor Georg, N.Y.) **166. RUTH ETTING** (ca. 1897–1978). Supreme song stylist; important club and film work. In chorus of Chicago revue 1925. N.Y. shows: *Ziegfeld Follies of 1927* (Berlin; "Shaking the Blues Away") and *1931*; *Whoopee* (1928; "Love Me or Leave Me"); *9:15 Revue* (1930; "Get Happy"); and *Simple Simon* (1930; Rodgers & Hart; "Ten Cents a Dance"). In London show *Transatlantic Rhythm* (1936). (Photo taken & signed 1934.)

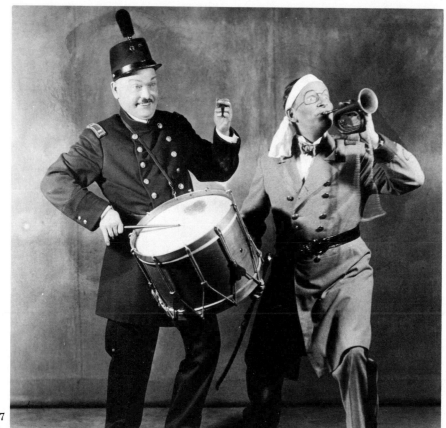

167

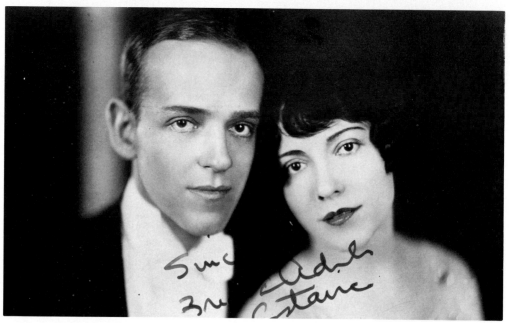

168

Through page 78: stars of Gershwin shows, 1924–30. **167. PAUL McCULLOUGH** (left; 1883–1936) **& BOBBY CLARK** (1888–1960). McCullough on stage 1900; Clark, 1902; team from 1905. Major shows together: *Music Box Revue* (1922 & 1924; Berlin); *Strike Up the Band* (1930, shown here; Gershwin); *Walk a Little Faster* (1932); *Thumbs Up* (1934). Clark continued on his own from *Ziegfeld Follies of 1936*, through *Mexican Hayride* (1944; Porter), to *As the Girls Go* (1948). **168. FRED** (eric; born 1899) **& ADELE** (1898–1981) **ASTAIRE** (real surname Austerlitz). Brother-and-sister song-and-dance team; in vaudeville 1906–16; in N.Y. shows together 1917–31, including: *The Passing Show of 1918; Lady, Be Good!* (1924; Gershwin); *Funny Face* (1927; Gershwin); and *The Band Wagon* (1931; Schwartz; "I Love Louisa"). Then Adele retired; Fred did *The Gay Divorce* (1932; Porter; "Night and Day") and entered films.

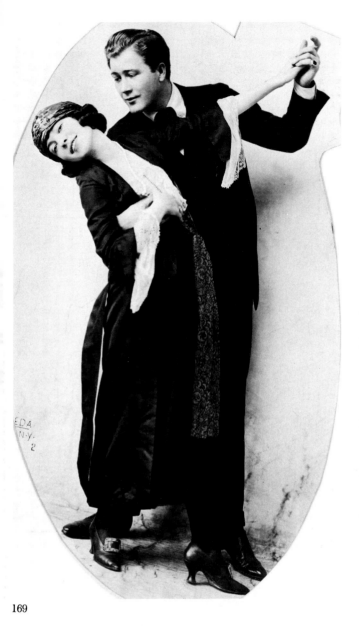

169

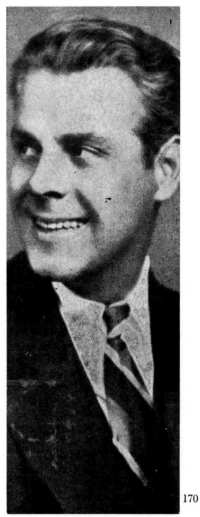

170

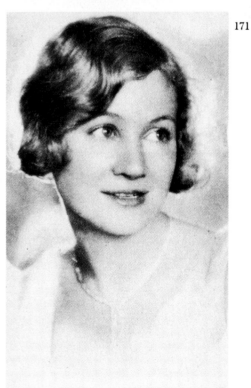

171

169. Adele Astaire with **JOHN CHARLES THOMAS** (ca. 1891–1960). Baritone in opera from 1924; at Metropolitan Opera 1933–34, 1935–43. Earlier in N.Y. shows, 1913–20, including *The Passing Show(s) of 1913* and *1915*. (Photo: Apeda, N.Y.; in *Apple Blossoms*, 1919.) **170. OSCAR SHAW** (1891–1967; real surname Schwartz). On stage (N.Y.) 1908–41. Most important shows: *The Passing Show of 1912; Very Good Eddie* (1915; Kern); *Leave It to Jane* (1917; Kern); *Music Box Revue* (1924; Berlin); *Oh, Kay!* (1926; Gershwin); *The Five O'Clock Girl* (1927; "Thinking of You"). (Photo ca. 1927.) **171. QUEENIE SMITH** (ca. 1900–1978). Dancer at Metropolitan Opera 1916–19; in N.Y. musicals 1919–32, including: *Orange Blossoms* (1922; Herbert); *Tip-Toes* (1925; Gershwin; "Looking for a Boy"); *Hit the Deck* (1927; Youmans). (Photo: G. Maillard Kesslère; mid-1930s.)

To- H.C. BRANCH —
With All Our Well Wishes That This
May Always Give You A Laugh —
Best
Lou Clayton
Eddie Jackson
Jimmie Durante

173

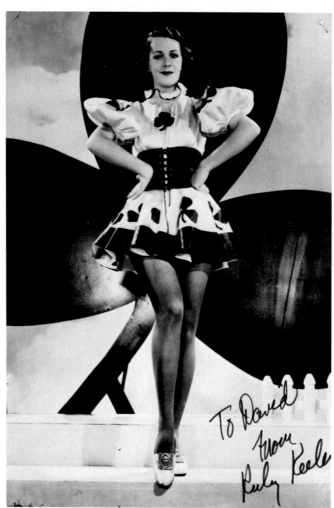

174

172. The team of **LOU CLAYTON** (1887–1950), **EDDIE JACK-SON** (ca. 1896–1980) & **JIMMY DURANTE** (1893–1980) were to-gether in the N.Y. shows *Show Girl* (1929; Gershwin) and *The New Yorkers* (1930; Porter). Clayton (who had been a vaudeville partner of Sammy White, No. 221), also appeared on his own in *The Show of Wonders* (1916) and *The Passing Show of 1918.* Durante on his own also appeared in *Strike Me Pink* (1933); *Jumbo* (1935; Rodgers & Hart); *Red, Hot and Blue!* (1936; Porter); *Stars in Your Eyes* (1939; Schwartz); and *Keep Off the Grass* (1940). (Photo: Mitchell, N.Y.) **173. TESSA KOSTA** (1893–1981). On stage ca. 1911; in N.Y.

from 1914. Important shows: *Nobody Home* (1915; first Kern show at Princess Theatre); *Chu Chin Chow* (1917); *The Rose of Stamboul* (1922); *The Song of the Flame* (1925, shown here; Gershwin). Last N.Y. appearance in revival of Herbert's *The Fortune Teller* (1929). (Photo: Vandamm, N.Y.) **174. RUBY KEELER** (born 1909 in Can-ada). Danced in clubs with Patsy Kelly; then, into N.Y. show cho-ruses from 1923; roles from 1927. In *Whoopee* (1928) and—as bride of Al Jolson—in *Show Girl* (1929; Gershwin; "Liza"). Films in 1930s. In old-timer revival of *No, No, Nanette* (1971).

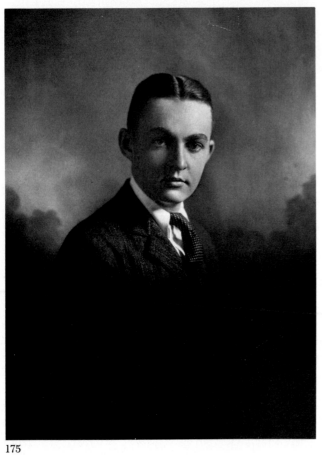

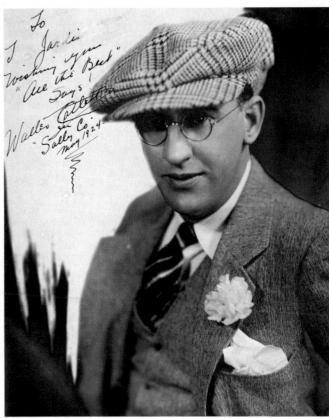

175

176

175. ALLEN KEARNS (1893–1956; born in Canada). On stage from 1910; in N.Y. shows and plays 1914–44. Most important: *Little Jessie James* (1923); *Mercenary Mary* (1925); *Tip-Toes* (1925; Gershwin); *Funny Face* (1927; Gershwin); *Girl Crazy* (1930; Gershwin; "Embraceable You"). Also on London stage. (Photo: Rollinson.) **176. WALTER CATLETT** (1889–1960). On stage 1906 in San Francisco; tours; minstrelsy; in N.Y. 1910. Major N.Y. shows: *So Long, Letty* (1916); *Ziegfeld Follies of 1917*; *Sally* (1920; Kern); *Lady, Be Good!* (1924; Gershwin; title song); *Treasure Girl* (1928; Gershwin; his last N.Y. show). Long film career; voice of the Fox in Disney's *Pinocchio* (1940). (Photo signed 1924.)

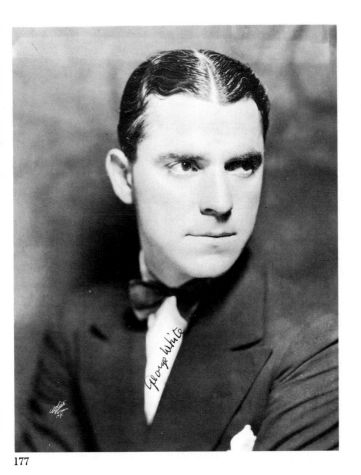

177

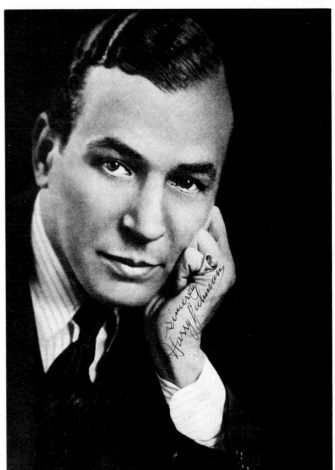

178

Through page 81: 1920s stars of the *Scandals*. **177. GEORGE WHITE** (1890–1968; real surname Weitz). On stage from childhood; important early shows: *The Echo* (1910; Deems Taylor); *Ziegfeld Follies of 1915*. In 1919 founded the great revue series *George White's Scandals*, danced himself in the editions from 1919 to 1925. Also appeared in his shows *Manhattan Mary* (1927) and *George White's Scandals Cavalcade* (1941). (Photo: White, N.Y.)

178. HARRY RICHMAN (1895–1972; real surname Reichman). Brilliant popular singer in shows, films and clubs; club owner; songwriter. In vaudeville ca. 1907; in N.Y. vaudeville from 1920; shows 1922–42, including: *George White's Scandals of 1926* ("The Birth of the Blues"), *1927* and *1928; The International Revue* (1930; "Exactly Like You," "On the Sunny Side of the Street"); and *Ziegfeld Follies of 1931*.

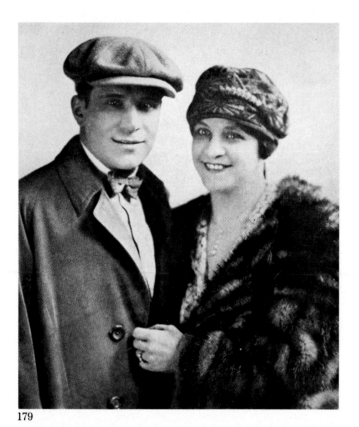

179

180

179. TOM PATRICOLA (1891–1950; real surname Patricolo). In vaudeville with his family from 1901 (at Pastor's). In *George White's Scandals* from 1923 to 1928, helping to create the popular new dances introduced in those editions. Also in *George White's Music Hall Varieties* (1932) and *Hold Your Horses* (1933). Appeared to 1938. Also in photo: his sister **ISABELLE** (ca. 1886–1965), a vaudeville headliner billed as Miss Patricola. **180. WINNIE LIGHT-NER** (1901–1971; née Hanson). Lively singer; big in vaudeville 1919–23; in the N.Y. shows: *George White's Scandals of 1922* ("I'll Build a Stairway to Paradise"); *1923* and *1924* ("Somebody Loves Me"); *Gay Paree* (1925 & 1926); *Delmar's Revels* (1927). Films 1928–34. (Photo: in film *Gold Dust Gertie*, 1931.) **181. ANN PEN-NINGTON** (1892–1971). Preeminent show dancer; on stage 1911; in N.Y. musicals 1911–43. Career highlights: *Ziegfeld Follies* (1913–18, 1924); *George White's Scandals* (1919–21; 1926; "Black Bottom"; 1928); *The New Yorkers* (1930; Porter); *Everybody's Welcome* (1931). Also in Chicago shows.

181

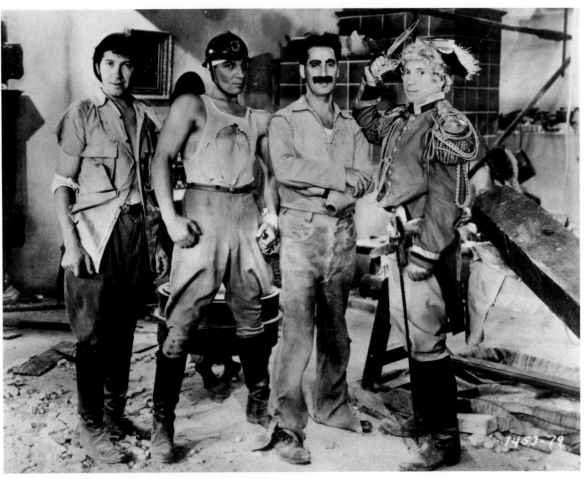

182

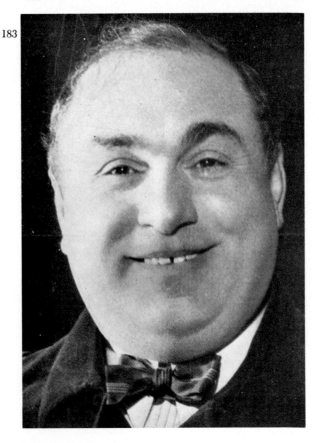

183

182. MARX BROTHERS. Left to right: **Chico** (Leonard; 1891–1961), **Zeppo** (Herbert; 1901–1979), **Groucho** (Julius; 1895–1977), **Harpo** (Adolf → Arthur; 1893–1964). In vaudeville from 1909. Shows: *I'll Say She Is* (1924); *The Cocoanuts* (1925; Berlin); *Animal Crackers* (1928); Chico on his own in *Take a Bow* (1944). Fabulous film career. Subject of musical *Minnie's Boys* (1970). (Photo: in 1933 film *Duck Soup*.) **183. NIKITA BALIEFF** (1877–1936; born in Russia). Founder, producer, director and comic M.C. of Chauve-Souris (Bat Theatre), originally a cabaret offshoot of the Moscow Art Theatre, after the Revolution transferred to Paris, London, N.Y. (1922 ff., 1931). He also appeared in *Continental Varieties* (1934). (Photo: Delphi.) **184. DOLLY SISTERS** (the twins Jenny = Jancsi = Janszieka, 1892–1941, & Rosie = Roszicka, 1892–1970; real surname Deutsch; born in Hungary). In N.Y. vaudeville from 1909. N.Y. shows together included: *The Echo* (1910; Deems Taylor); *Ziegfeld Follies of 1911*; *Greenwich Village Follies of 1924*. Between 1913 and 1915 they were in separate shows, Jennie, for instance, in *The Honeymoon Express* (1913). From 1919 to 1921 they appeared as a team in London shows. In Chicago Kern show *Sitting Pretty* (1924).

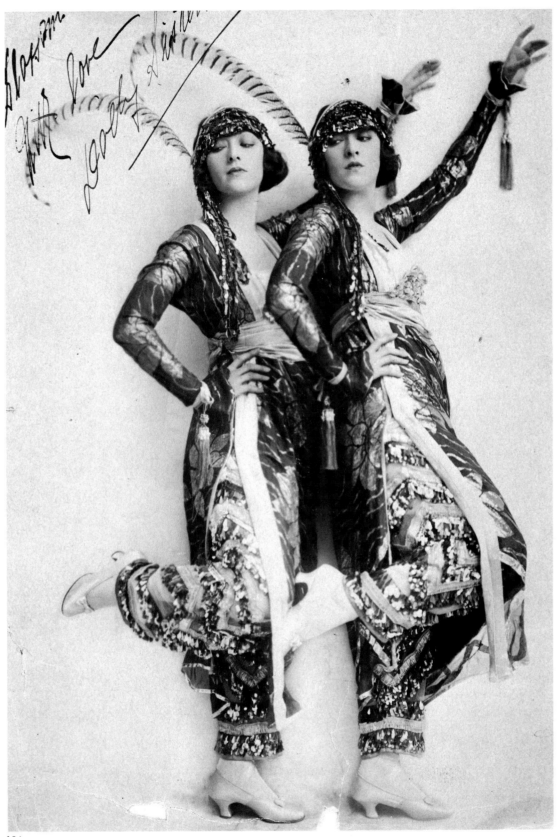

184

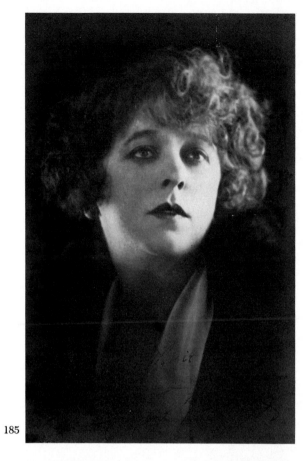

185

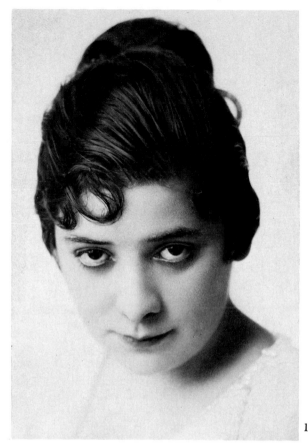

186

187

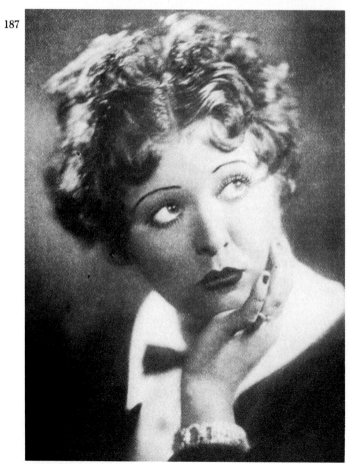

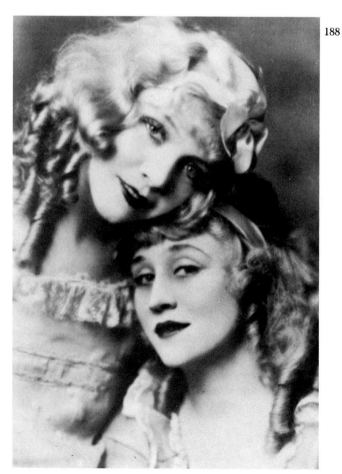

188

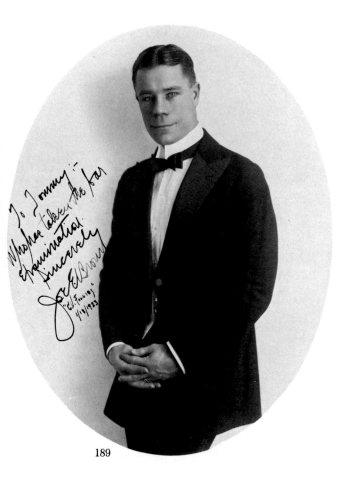

189

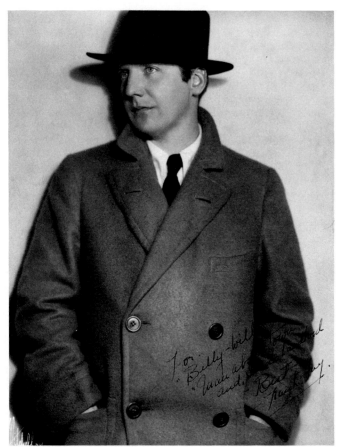

190

185. JOBYNA HOWLAND (1880–1936). Statuesque comedienne was model for artist Charles Dana Gibson, appeared in all kinds of plays from 1899 to 1936. Major N.Y. musicals: *Miss Prinnt* (1900); *The Ham Tree* (1905); *The Passing Show of 1912; Kid Boots* (1923). **186. BELLE BAKER** (1895–1957; real surname Becker). Magnificent vaudeville career as dramatic singer (popularized "Eli, Eli"). In *Vera Violetta* (1911) and *Betsy* (1926; introduced Berlin's "Blue Skies"). In Chicago *Artists and Models* (1928). (Photo 1915.) **187. HELEN KANE** (1904–1966; real surname Schroeder). Popularized baby-voiced "boop-boop-a-doop" singing; inspiration for cartoon character Betty Boop. Shows: *A Night in Spain* (1927); *Good Boy* (1928; "I Wanna Be Loved by You"); *Shady Lady* (1933). Introduced "That's My Weakness Now" in live appearance, 1928. (Photo: G. Maillard Kesslère, mid-1930s.) **188. DUNCAN SIS-**

TERS: Vivian (above; born 1902) & **Rosetta** (1900–1959). In vaudeville as children with Gus Edwards. N.Y. shows: *Doing Our Bit* (1917); *She's a Good Fellow* (1910; Kern); *Tip Top* (1920); *Topsy and Eva* (1924; Chicago 1923 & 1933). Appearances to 1936; also in other Chicago shows. **189. JOE E. BROWN** (ca. 1891–1973). On stage at age 7; vaudeville acrobat. N.Y. musical career from 1918 to 1923 (in *Greenwich Village Follies*, 1921–23), then 1951 (*Courtin' Time*) and 1961 (*Show Boat* revival). In Chicago show *Twinkle, Twinkle* (1927). (Photo signed 1923.) **190. FRANK FAY** (1894–1961). Child actor, in N.Y. vaudeville by 1906. N.Y. musicals, 1918–43, included: *The Passing Show of 1918; Frank Fay's Fables* (1922); *Artists and Models* (1923). Show producer in Hollywood. Greatest success in straight comedy *Harvey* (1944). (Photo: Mitchell, N.Y.)

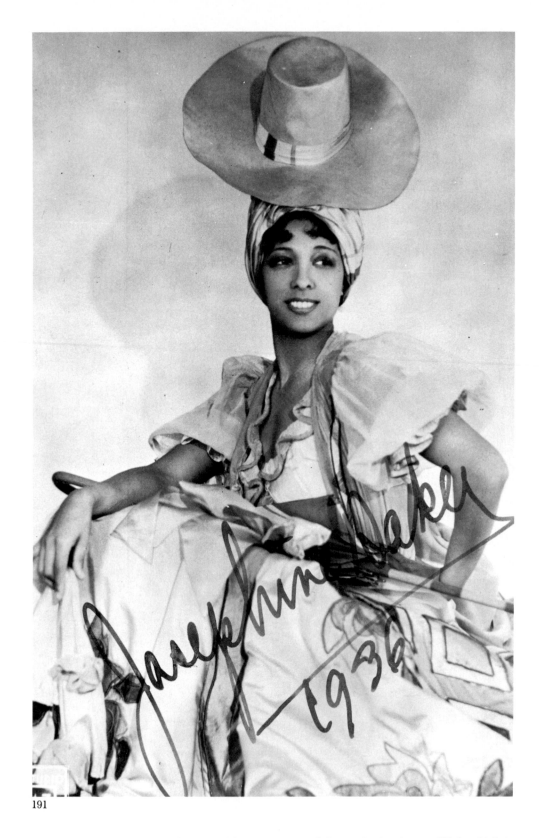

191

191. JOSEPHINE BAKER (1906–1975). Fine singer and dancer. In the chorus of Eubie Blake's show *Shuffle Along* when it reached Boston in 1922; then into his 1924 show *The Chocolate Dandies.* Created a sensation in France, which became her headquarters. Later N.Y. appearances: *Ziegfeld Follies of 1936; Josephine Baker* (1964); *An Evening with Josephine Baker* (1973). (Photo: in film *La Créole;* signed 1936.) **192. BILL ROBINSON** (1878–1949). Most celebrated tap dancer. Broadway shows: *Blackbirds of 1928; Brown Buddies* (1930); *The Hot Mikado* (1939); *All in Fun* (1940); *Memphis Bound* (1945). In the Cotton Club (Harlem) show *Rhythmania,* 1931, introduced Arlen's "Between the Devil and the Deep Blue Sea." (Photo: Nicholson, Kansas City; signed 1928.)

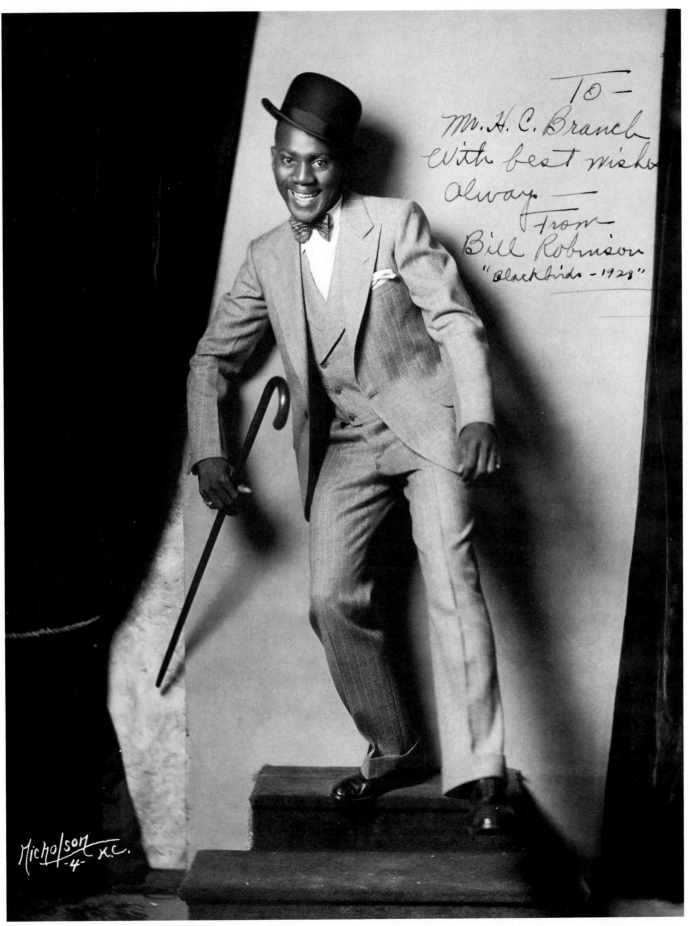

TO—
Mr. H. C. Branch
With best wishes
alway—
from
Bill Robinson
"Blackbirds - 1928"

Nicholson
-4-
X.C.

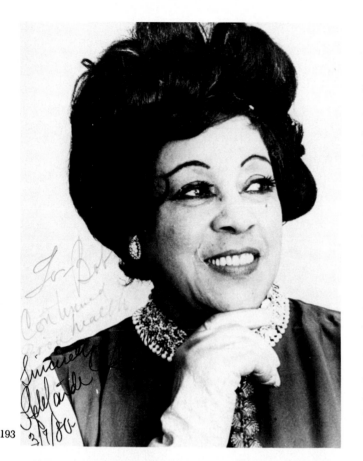

193

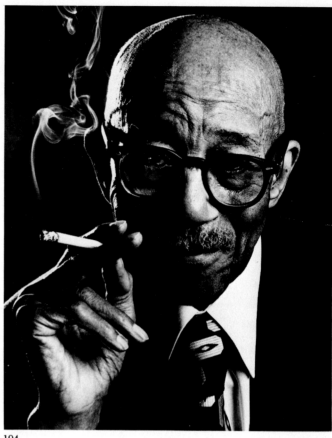

194

195

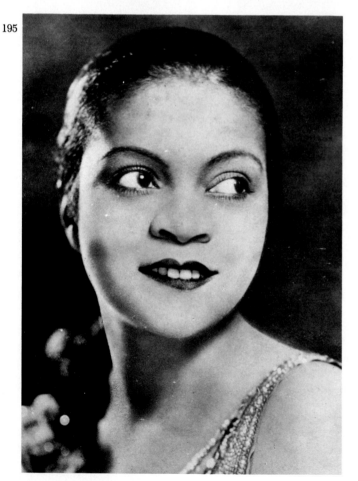

193. ADELAIDE HALL (born 1910). In chorus of Eubie Blake's *Shuffle Along* (1921); roles in: *Runnin' Wild* (1923; the show that gave us "Charleston"); *Blackbirds of 1928* ("Diga Diga Doo"); *Brown Buddies* (1930); *Jamaica* (1957). Still active 1980. (Photo: Geoff Wilding; signed 1980.) **194. EUBIE (James Hubert) BLAKE** (born 1883). Pianist, songwriter, showman. Appeared as pianist in his own shows *Shuffle Along* (1921; and revival 1952); *The Chocolate Dandies* (1924); and *Shuffle Along of 1933* (1932). Still performing 1981. (Photo: Tom Caravaglia, 1979.) **195. FLORENCE MILLS** (1895–1927). Joined cast of *Shuffle Along;* was in *Plantation Revue* (1922) and *Dixie to Broadway* (1924; N.Y. version of earlier London show in which she sang).

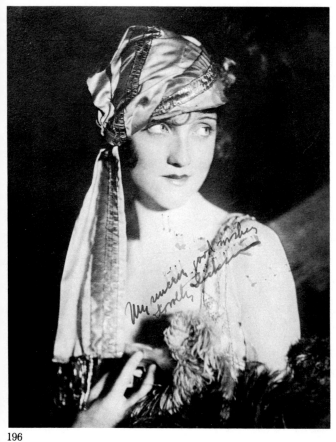

196

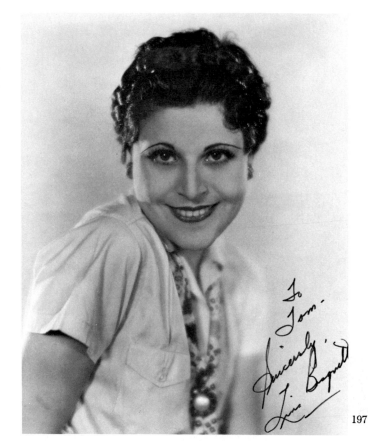

197

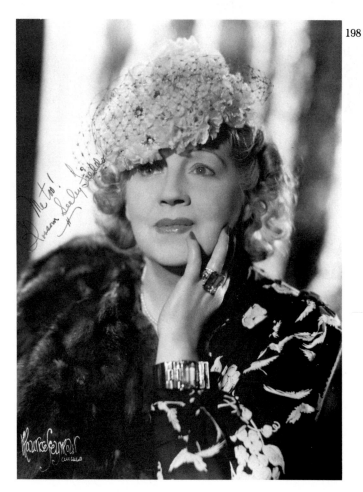

198

196. DOROTHY DICKSON (born 1896). Ballroom dancer with husband Carl Hyson. She was in N.Y. shows from 1917 to 1920 (highlights: Kern's *Oh, Boy!*, 1917, and *Ziegfeld Follies of 1918*), then went on to great London success until 1942 (London productions of N.Y. shows; Ivor Novello shows; and two Kern shows of London origin: *The Cabaret Girl*, 1922, and *The Beauty Prize*, 1923). **197. LINA BASQUETTE** (year of birth unavailable). Dancer; in N.Y. shows 1923–27, especially *Ziegfeld Follies of 1924*. In retirement, breeder of champion dogs. **198. BLOSSOM SEELEY** (ca. 1892–1974). In N.Y. shows from 1911 (Lew Fields's *The Hen Pecks*) to 1928 (*Greenwich Village Follies*). In Chicago *Girl Crazy* production (1931). Chicago TV appearance 1961. (Photo: Maurice Seymour, Chicago.)

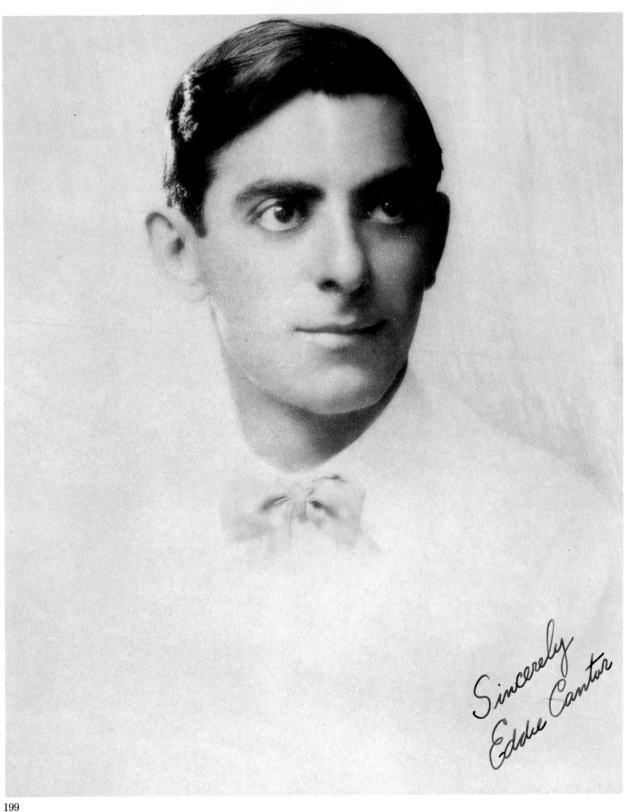

Sincerely
Eddie Cantor

199

From here through page 105: Ziegfeld stars of the 1920s. **199. EDDIE CANTOR** (1892–1964; real surname Iskowitz). Stupendous singing comedian, on stage from 1906; vaudeville, for some years as a Gus Edwards protégé. Numerous shows included: *Ziegfeld Follies of 1917, 1918, 1919* ("You'd Be Surprised") and *1927* (briefly); *Kid Boots* (1923); *Whoopee* (1928; "Makin' Whoopee"); and *Banjo Eyes* (1941; his last). Major career in films and radio.

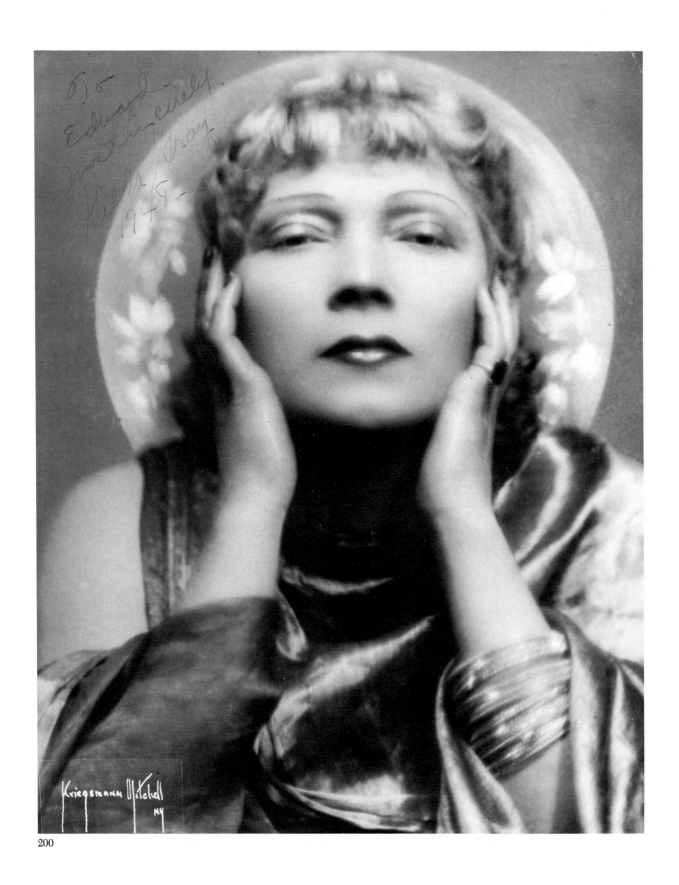

200

200. GILDA GRAY (ca. 1900–1959; real name Marianna Michalska; born in Poland). Provocative dancer, associated with the "shimmy." N.Y. shows: *Shubert Gaieties of 1919; Hello, Alexander* (1919); *Snapshots of 1921; Ziegfeld Follies of 1922.*

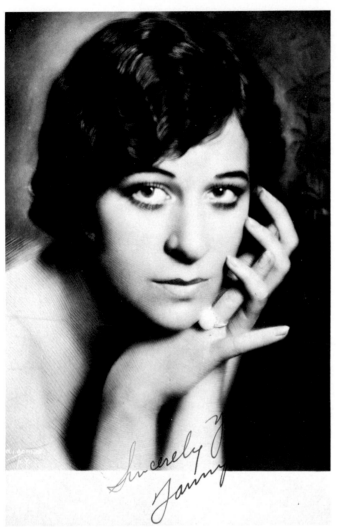

201

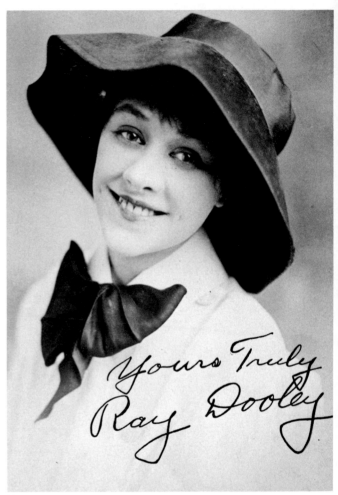

202

201. FANNY (also Fannie) BRICE (1891–1951; real surname Borach). Brilliant singing comedienne; in N.Y. shows 1910–36: *Ziegfeld Follies of 1910, 1911, 1916, 1917, 1920, 1921* ("Second Hand Rose," "My Man"), *1923, 1934* and *1936; The Honeymoon Express* (1913); *Music Box Revue* (1924; Berlin); *Fioretta* (1929); *Sweet and Low* (1930); *Crazy Quilt* (1931; "I Found A Million-Dollar Baby"). Subject of show *Funny Girl* (1964). (Photo signed 1926.) **202. RAY** (Rachel) **DOOLEY** (born 1896 in Scotland). Wife of Eddie Dowling (see No. 149). In U.S. minstrel shows as a child; N.Y. musicals, 1917–34, included: *Hitchy-Koo* (1918); four editions of the *Ziegfeld Follies* (1919–21, 1925), in which she created the obnoxious little-girl character later assumed by Fanny Brice; *Earl Carroll Vanities of 1928;* and *Thumbs Up* (1934). (Photo: Apeda, N.Y.)

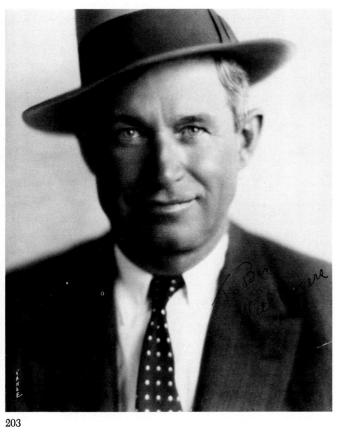

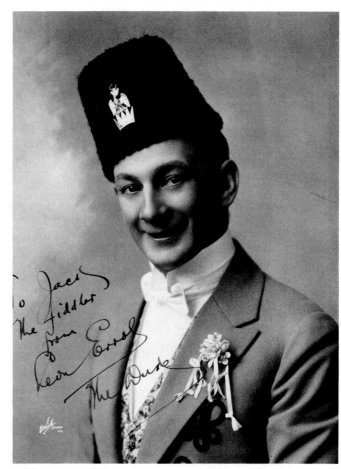

203

204

203. WILL ROGERS (1879–1935). Comic monologist, rope expert. In vaudeville by 1906; in N.Y. musicals 1912–28 (and an appearance in 1934), especially: *Ziegfeld Follies* (1916–18, 1922–24) and *The Passing Show of 1917*. Also popular in films and radio. **204. LEON ERROL** (1881–1951; born in Australia). On stage 1896 in Sydney; comedian in N.Y. shows 1910–29, especially: *Ziegfeld Follies* (1910–15); *Hitchy-Koo* (1917 & 1918); *Sally* (1920, shown here; Kern); *Louie the 14th* (1925). Long film career. (Photo: White, N.Y.)

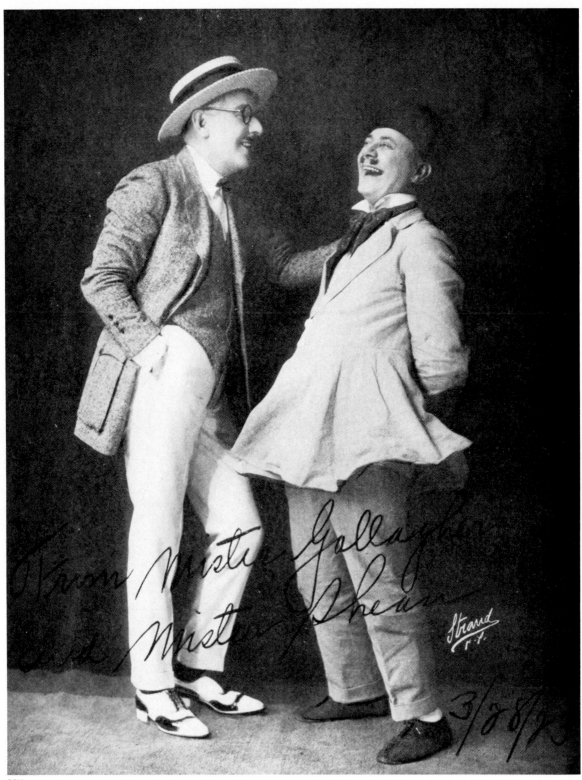

205

205. (Edward) GALLAGHER (died 1929) & **(Al) SHEAN** (1868–1949; actually Alfred Schoenberg; born in Germany; maternal uncle of Marx Bros.). Shean appeared in Chicago shows in 1903 and 1904, in N.Y. musicals from 1903 to 1932 (with straight appearances to 1948; in Chicago musical 1945/6). Together with Gallagher in vaudeville and in *The Rose Maid* (1912) and *Ziegfeld Follies of 1922* ("Mr. Gallagher and Mr. Shean"). On his own in such shows as *The Princess Pat* (1915; Herbert); *Betsy* (1926); *Music in the Air* (1932; Kern). Gallagher on his own in *Frivolities of 1920*.

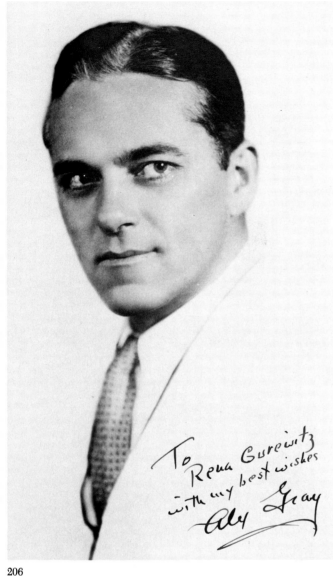

206

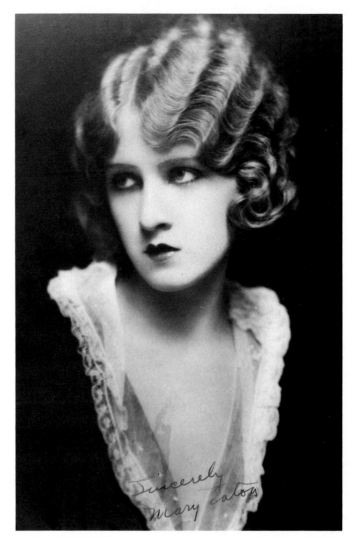

207

206. ALEXANDER GRAY (born 1902). In *Ziegfeld Follies of 1922; Annie Dear* (1924); *Tell Me More* (1925); *The Merry World* (1926); then, toured in *The Desert Song* and participated in the early years of film musicals. Back on Broadway in *John Henry* (1939) and in various revivals up to 1961. (Photo: G. Maillard Kesslère, N.Y.) **207. MARY EATON** (1901–1948). Balletic show dancer. On stage from childhood; to N.Y. 1915; in show choruses from 1916; roles from 1919. Then: *Ziegfeld Follies* (1920–22); *Kid Boots* (1923); *Lucky* (1927); *The Five O'Clock Girl* (1927).

208

209

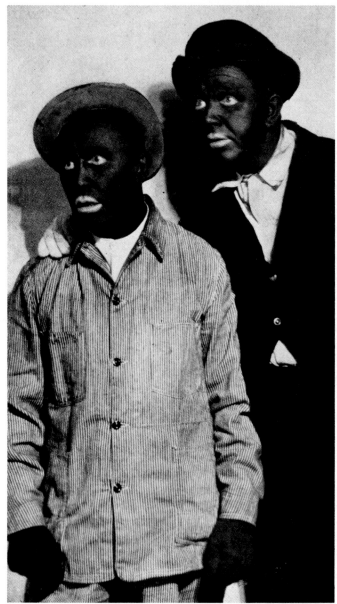

210

208–210. MORAN & MACK, extremely popular, relatively taste-ful vaudeville blackface comedians. 208: George Moran (died 1949). 209: Charles E. Mack (died 1934). 210: in their 1933 film *Hypno-tized*. Their N.Y. shows: *Ziegfeld Follies of 1920; Greenwich Village Follies of 1924; No Foolin'* (1926; a Ziegfeld revue); *Earl Carroll Vanities of 1926*. Mack, the proprietor of the act, is said to have used various "Morans" from time to time.

211

212

213

Cast members of Ziegfeld's 1928 hit *Whoopee*. **211. GEORGE OLSEN** (ca. 1893–1971). Bandleader; led his band on stage in the shows *Kid Boots* (1923); *Ziegfeld Follies of 1924*; *Good News* (1927); and *Whoopee*. (Photo: G. Maillard Kesslère, N.Y., mid-1930s.) **212. ETHEL SHUTTA** (ca. 1897–1976). Wife of George Olsen; singer and dancer. In: *The Passing Show of 1922*; *Topics of 1923*; *Marjorie* (1924); *Louie the 14th* (1925); *Whoopee*; *My Dear Public* (1943); and *Follies* (1971). Popular in radio. (Photo: G. Maillard Kesslère, N.Y., 1934.) **213. CHIEF CAUPOLICAN** (no dates available; allegedly born in Chile). Operatic baritone. By 1903 in vaudeville in San Francisco (remained important in vaudeville). At Metropolitan Opera 1920–22. In *Whoopee* (also in the 1930 film version).

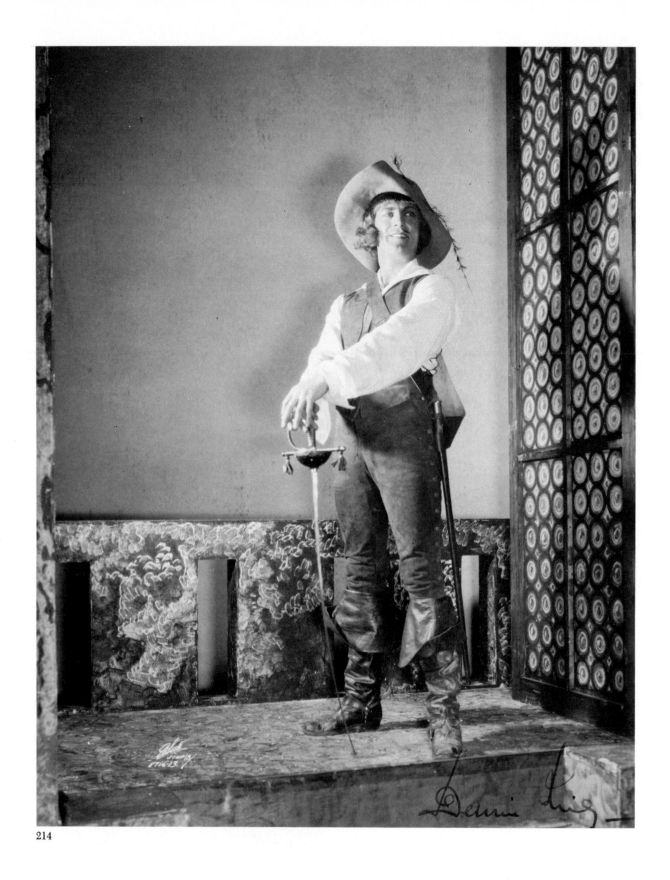

214

214. DENNIS KING (1897–1971; real surname Pratt; born in England). Equally at home in prestigious drama, operetta and musical comedy. On stage 1916 in the famed Birmingham (Eng.) Repertory Company; in London 1919. In N.Y. plays 1921–69. N.Y. musicals: *Rose-Marie* (1924; Friml; title song); *The Vagabond King* (1925; Friml; "Song of the Vagabonds"); *The Three Musketeers* (1928, shown here; Friml; "March of the Musketeers"); *Show Boat* (1932 revival); *Frederika* (1937); *I Married an Angel* (1938; Rodgers & Hart; title song); *Music in the Air* (1951 revival); *Shangri-La* (1956). (Photo: White, N.Y.)

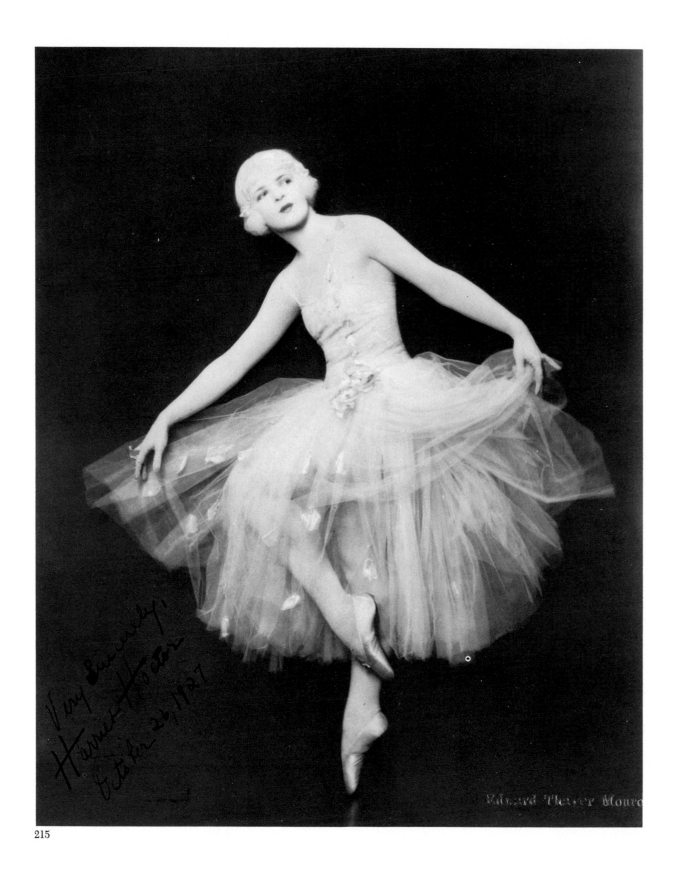

215

215. HARRIET HOCTOR (ca. 1903–1977). Balletic dancer and choreographer. In vaudeville 1923. N.Y. show appearances: *Topsy and Eva* (1924; Chicago 1923); *Sunny* (1925; Kern); *A la Carte* (1927); *The Three Musketeers* (1928; Friml); *Show Girl* (1929; Gershwin); *Simple Simon* (1930; Rodgers & Hart); *Earl Carroll Vanities of 1932; Hold Your Horses* (1933); *Ziegfeld Follies of 1936.* (Photo: Edward Thayer Monroe; signed 1927.)

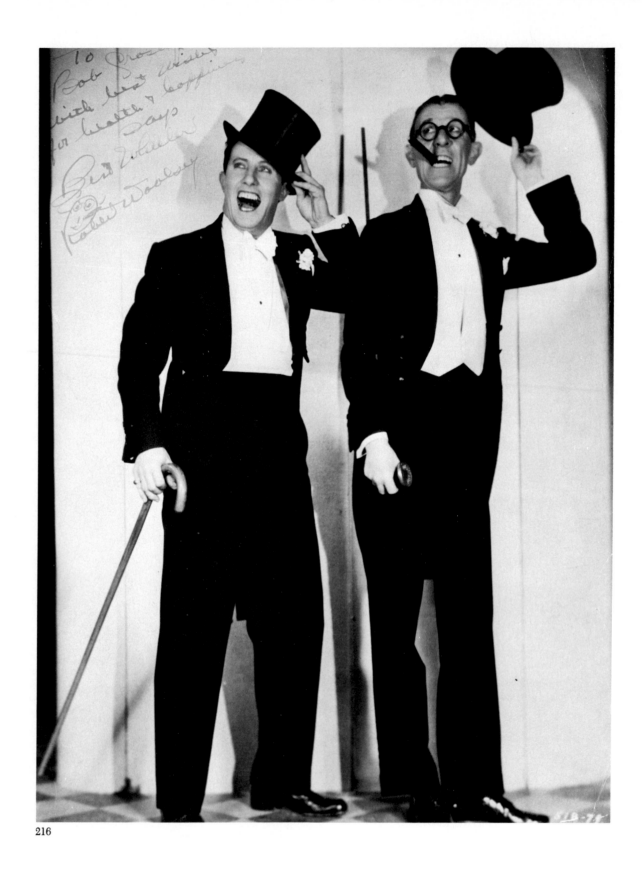

216

216. BERT (Albert) WHEELER (1895–1968) & **ROBERT WOOLSEY** (1889–1938). Wheeler was in stock and vaudeville from 1911. His N.Y. appearances, 1923–63, included: *Ziegfeld Follies of 1923; Rio Rita* (1927); and *Three Wishes for Jamie* (1952; his last musical). Woolsey, at first a jockey, entered stock in San Francisco and toured for years before appearing in a N.Y. show in 1919. He was in *Poppy* with W. C. Fields (1923). His last N.Y. musical was *Rio Rita*, his only Broadway stage team-up with Wheeler (they were together in films to 1937).

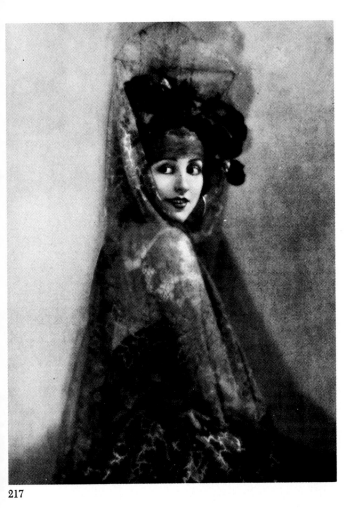

217

218

219

217. ETHELIND TERRY (born 1900). N.Y. shows: *Honeydew* (1920); *Music Box Revue* (1922; Berlin); *Kid Boots* (1923); *Rio Rita* (1927, shown here; title role); *Nina Rosa* (1930). (Photo: Hal Phyfe.) **218. J. HAROLD MURRAY** (1891–1940). N.Y. shows included: *Caroline* (1923); *Rio Rita* (1927, shown here; "The Rangers' Song," title song); *Face the Music* (1932; Berlin; "Let's Have Another Cup of Coffee," "Soft Lights and Sweet Music"); and *Thumbs Up* (his last show, 1934; "Autumn in New York"). **219. JACK DONAHUE** (1892–1930). Personable singer and dancer. In: *The Woman Haters* (1912); *Angel Face* (1919; Herbert); *Ziegfeld Follies of 1920*; *Molly Darling* (1922); *Sunny* (1925; Kern); *Rosalie* (1928; Gershwin & Romberg); and *Sons o' Guns* (1929).

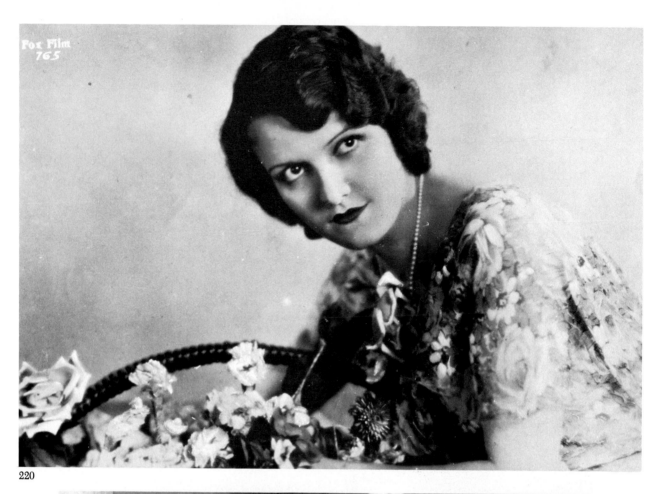

220

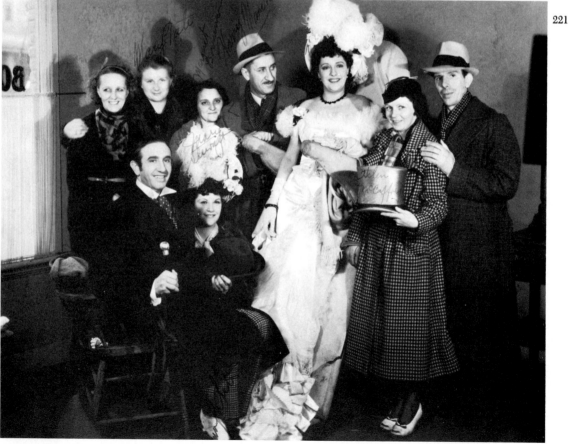

221

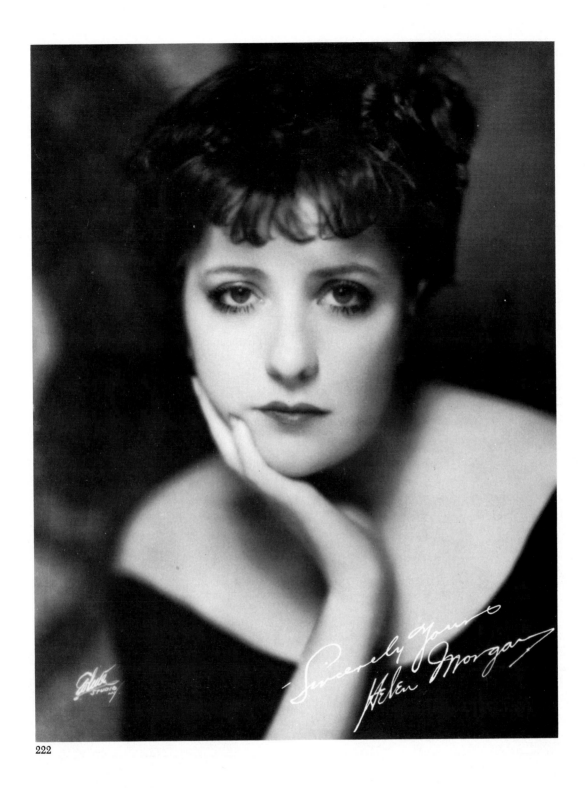

222

Pages 102–105 are devoted to Kern's landmark *Show Boat* (1927). **220.** The original Magnolia: **NORMA TERRIS** (born 1904). N.Y. debut in a Ziegfeld chorus 1920; roles from 1922; also in *Show Boat* revival of 1932; straight plays in N.Y. to 1938. (Photo: Fox Films.) **221.** The original Frank: **SAMMY WHITE** (1896–1960; in left foreground of this photo of Helen Morgan and entourage during 1936 filming of *Show Boat*). His shows, 1916–48, included *The Girl Friend* (1926; Rodgers & Hart; he and wife/partner Eva Puck sang "The Blue Room") and the *Show Boat* revivals of 1932 and 1948. **222.** The original Julie: **HELEN MORGAN** (1900–1941). On stage 1918; in N.Y. chorus of *Sally* (1920). N.Y. shows: *George White's Scandals of 1925; Americana* (1926); *Show Boat* (1927 & 1932); *Sweet Adeline* (1929; Kern; "Why Was I Born?"); *Ziegfeld Follies of 1931*. Important nightclub career. (Photo: White, N.Y.)

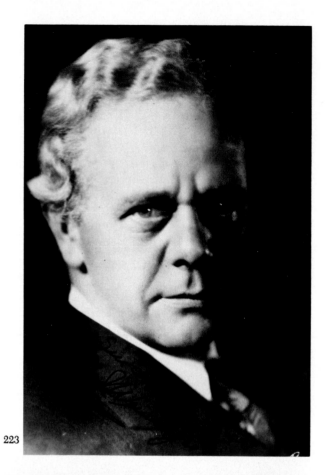

223

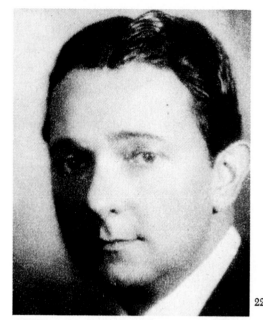

224

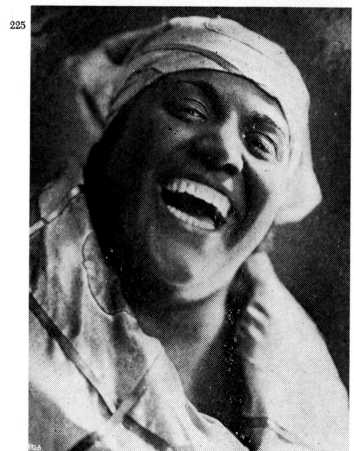

225

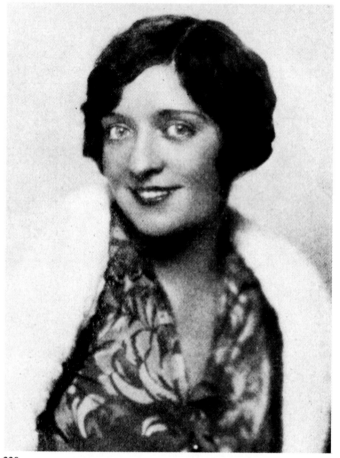

226

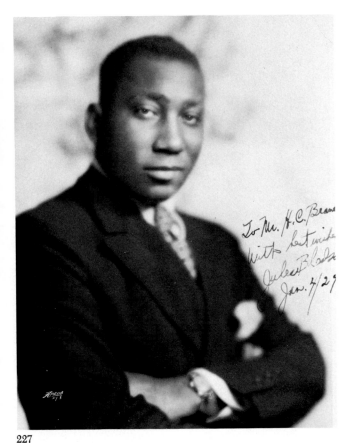

227

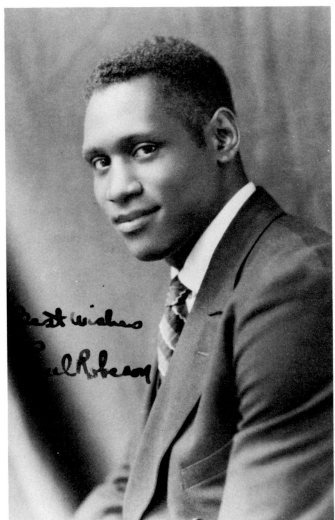

228

223. The original Captain Andy: **CHARLES WINNINGER** (1884–1969). In vaudeville 1894–1910; then to N.Y., where his shows, 1910–51, included *The Cohan Revue(s) of 1916 and 1918* (1917); *The Passing Show of 1919; Ziegfeld Follies of 1920; No, No, Nanette* (1925; also in Chicago original, 1924; "I Want to Be Happy"); *Show Boat* (1927 & 1932); *Through the Years* (1932; Youmans); *Revenge with Music* (1934; Schwartz). (Photo 1934.) **224.** The original Gaylord: **HOWARD MARSH** (died 1969). N.Y. musicals 1917–35, especially: *Greenwich Village Follies of 1920; Blossom Time* (1921); *The Student Prince in Heidelberg* (1924; Romberg; "Deep in My Heart," "Serenade"); *Show Boat* (1927); *The Du Barry* (1932). (Photo: G. Maillard Kesslère, N.Y., mid-1930s.) **225.** The original Queenie: **AUNT JEMIMA** (Tess Gardella; ca. 1898–1950).

Also in *George White's Scandals of 1921* and the *Show Boat* revival of 1932. Big in vaudeville and radio. **226.** The original Ellie: **EVA PUCK** (ca. 1892–1979). Also in *Irene* (1919); *Greenwich Village Follies of 1923; The Girl Friend* (1926; Rodgers & Hart). (Photo: De Barron, ca. 1927.) **227.** The original Joe: **JULES BLEDSOE** (1898–1943). Noted concert singer, also in the show *Deep River* (1926) and the London *Blackbirds of 1936*. (Photo: Apeda, N.Y.; signed 1929.) **228.** The Joe of the first London production (1928) and the first N.Y. revival (1932): **PAUL ROBESON** (1898–1976). Actor, athlete, superb bass; on N.Y. stage from 1921; outstanding in O'Neill plays of 1920s and in *Othello* (1942 ff.). Other N.Y. musical: *John Henry* (1939). (Photo: Sasha, London.)

229

230

229. FRANK CRUMIT (1888–1943). N.Y. shows: *Betty Be Good* (1920); *Greenwich Village Follies of 1920; Tangerine* (1921; with Julia Sanderson, whom he married and sang with in radio for years); *Nifties of 1923; Oh, Kay!* (revival of Gershwin show in 1928). **230. STERLING HOLLOWAY** (born ca. 1900). On N.Y. stage 1923–52 and in numerous films. His N.Y. musicals comprise three editions of the *Garrick Gaieties:* 1925 (Rodgers & Hart; "Manhattan"), 1926 (Rodgers & Hart; "Mountain Greenery") and 1930. (Photo: in film, mid-1930s.)

231

232

231. LILLIAN ROTH (1910–1980). Vaudeville, in N.Y. from 1917. N.Y. shows (all of the "naughty" variety in the 1920s): *Artists and Models* (1923); *Padlocks of 1927*; *Delmar's Revels* (1927); *Earl Carroll Vanities of 1928* and *1931*; *I Can Get It for You Wholesale* (1962); *70, Girls 70* (1971). (Photo: Wide World Photos, 1931; signed 1972.) **232. DOROTHY STONE** (1905–1974). Singer and dancer.

Debut (which was in N.Y.) with her father Fred Stone (see No. 86) in his show *Stepping Stones* (1923; Kern); with him again in *Criss Cross* (1926; Kern) and *Ripples* (1930). Her career largely comprised taking over leading roles during long runs (e.g., *Show Girl*, 1929; *As Thousands Cheer*, 1934), out-of-N.Y. productions, revivals. Last N.Y. appearance: 1945 revival of Herbert's *The Red Mill*.

233

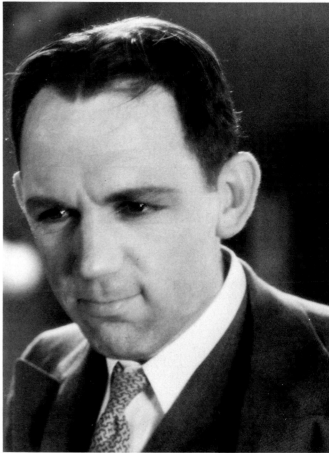

234

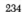

235

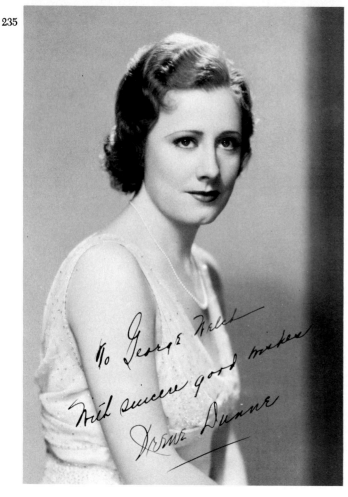

No George Welsh
With sincere good wishes
Irene Dunne

233. (Joe) **SMITH** (1884–1981, real surname Sultzer) **& (Charles) DALE** (1881–1971, real surname Marks). Comedians; with Avon Comedy Four from ca. 1900; shows included: *The Passing Show of 1919* (sketch "The Doctor's Office"); *Earl Carroll Vanities of 1926*; *Bright Lights of 1944* (1943; their last). (Photo ca. 1924.) **234. HAL (Joseph Harold) SKELLY** (1891–1934). Into circus at age 15; minstrel; N.Y. shows, 1918–34, included Kern's *The Night Boat* (1920) and two Herbert shows, *The Girl in the Spotlight* (1920) and *Orange Blossoms* (1922). (Photo: in 1929 film *The Dance of Life*.) **235. IRENE DUNNE** (born 1904). In Chicago production of *Irene* (1920); varied Broadway work 1922–28; tour in *Show Boat* (1929); Hollywood. (Photo ca. 1932.) **236.** Still from film *Hollywood Revue of 1929* with (l. to r.): **CHARLES KING** (1889–1944; N.Y. shows 1908–38, especially *The Passing Show of 1913*; *Watch Your Step*, 1914; Berlin; "Play a Simple Melody"; *George White's Scandals of 1921*; *Hit the Deck*, 1927; Youmans; "Sometimes I'm Happy"; *Present Arms*, 1928; Rodgers & Hart); Joan Crawford (1906–1977; as Lucille Le Sueur a chorine in *The Passing Show of 1924*); Conrad Nagel (1897–1970; in *Music in the Air* revival, 1951); **& CLIFF EDWARDS** (Ukulele Ike; 1895–1971; in: *The Mimic World*, 1921; *Lady, Be Good!*, 1924; Gershwin; "Fascinating Rhythm"; *Sunny*, 1925; Kern; *George White's Scandals of 1935*). **237. HELEN FORD** (born 1890s; real surname Barnett). On N.Y. stage 1918–42, especially the Rodgers & Hart shows *Dearest Enemy* (1925) and *Peggy-Ann* (1926; "Where's That Rainbow?"). (Photo: in *Champagne, Sec*, 1933.) **238. POLLY (Heather) WALKER** (born 1908). On stage 1911; vaudeville; N.Y. shows 1926–30, especially *The Merry Malones* (1927; Cohan); then, in England and Australia. (Photo: in 1930 film of *Hit the Deck*.)

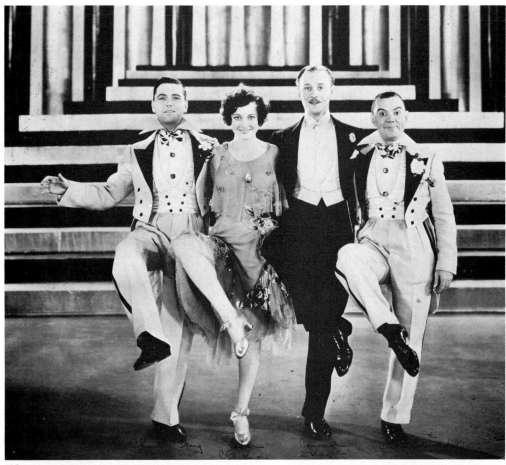

236

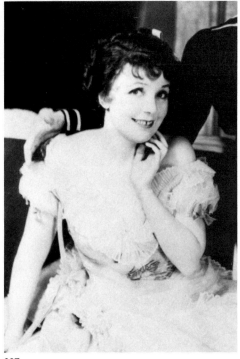

237

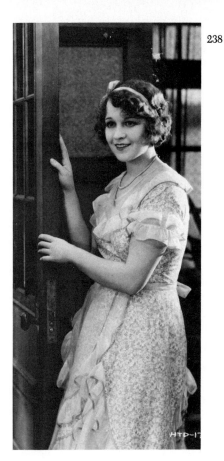

238

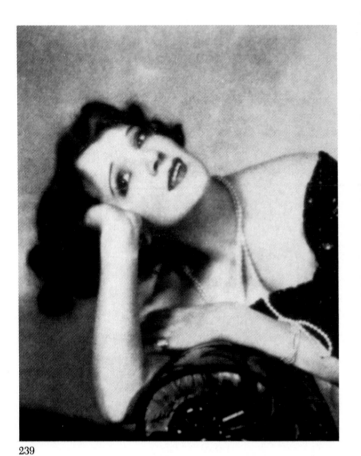

239

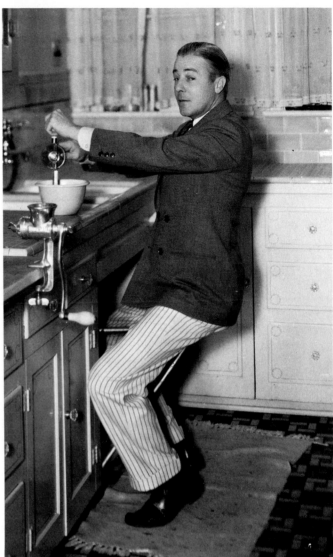

240

239. INEZ COURTNEY (ca. 1908–1975). In N.Y. shows 1926–33, including: *Good News* (1927); *Spring Is Here* (1929; Rodgers & Hart); *America's Sweetheart* (1931; Rodgers & Hart); *Hold Your Horses* (1933). (Photo ca. 1930.) **240. RICHARD "SKEET(S)" GALLAGHER** (1891–1955). After vaudeville, in N.Y. musicals from 1922 to 1927 (and straight appearance 1945). In original Chicago *No, No, Nanette* (1924). (Photo: Hollywood publicity shot, ca. 1930.) **241. ZELMA O'NEAL** (born 1907; real surname Schroeder). Energetic dancer and singer. In: *Good News* (1927; title song, "The Varsity Drag"); *Follow Thru* (1929; "Button Up Your Overcoat"); *The Gang's All Here* (1931). Starred in London musicals in the 1930s. (Photo: Mitchell, N.Y., 1930.)

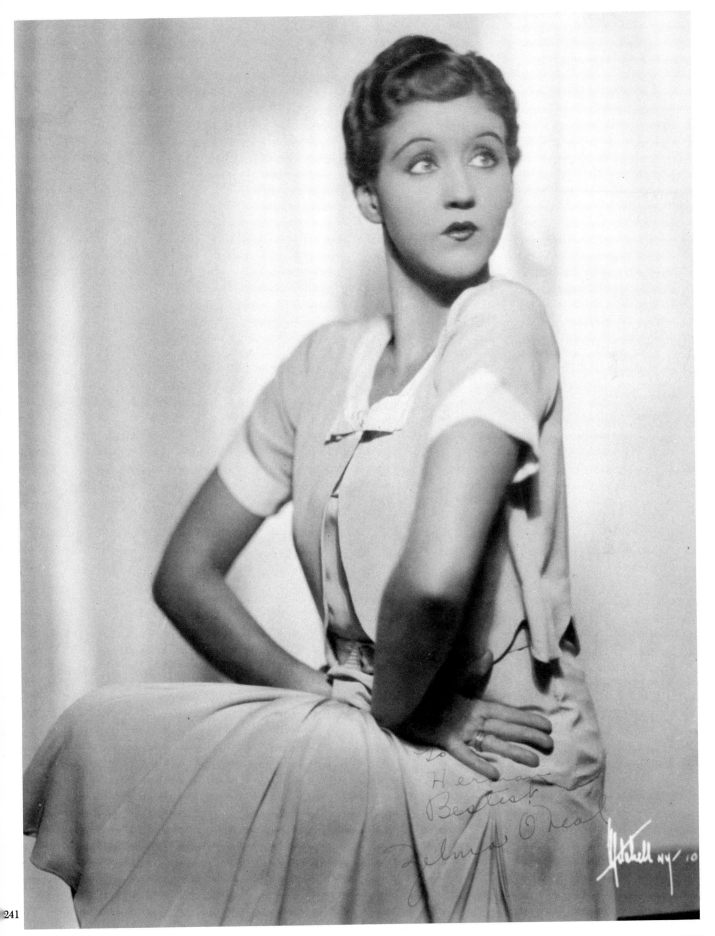

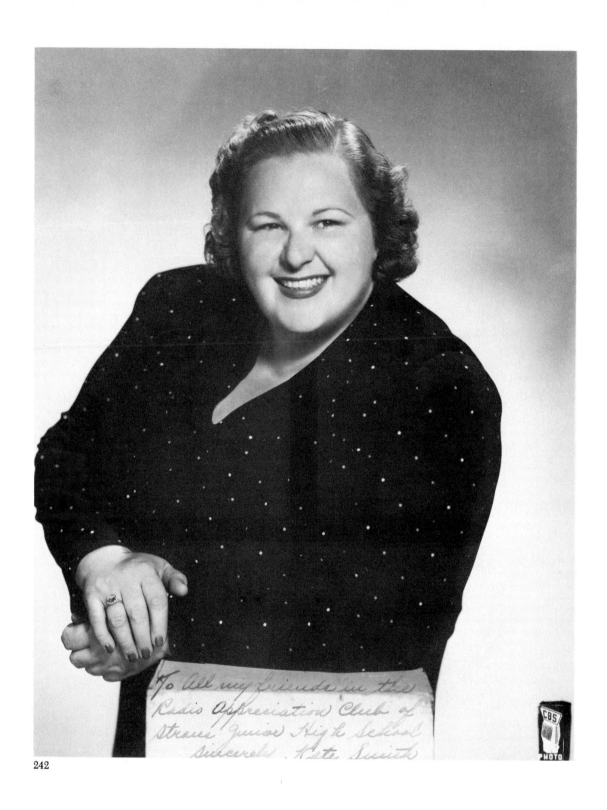

242

242. **KATE SMITH** (born 1909). Before becoming smash radio star, sang in the N.Y. shows *Honeymoon Lane* (1926) and *Flying High* (1930). (Photo: CBS.) 243. **TED HEALY** (1896–1937). Comedian. In: *Earl Carroll Vanities of 1925; A Night in Venice* (1929); *The Gang's All Here* (1931); and *Crazy Quilt* (1931). (Photo: MGM, 1934.) 244. **CHARLES PURCELL** (1883–1962). On stage in London 1904; U.S. 1905; N.Y. 1908. Highlights of long career (to 1946): *Ziegfeld Follies of 1915; Maytime* (1917; Romberg); *Poor Little Ritz Girl* (1920; Rodgers & Hart); *Dearest Enemy* (1925; Rodgers & Hart; "Here in My Arms"); *Oh, Please* (1926; Youmans). (Photo: Apeda, N.Y., mid-1920s.) 245. **BORRAH MINEVITCH** (ca. 1904–1955; born in Russia) with his Harmonica Rascals. His shows (to 1940) included *Sunny* (Kern; 1925, year of his first band); *Good Boy* (1928); and *Sweet and Low* (1930). (Photo 1934.)

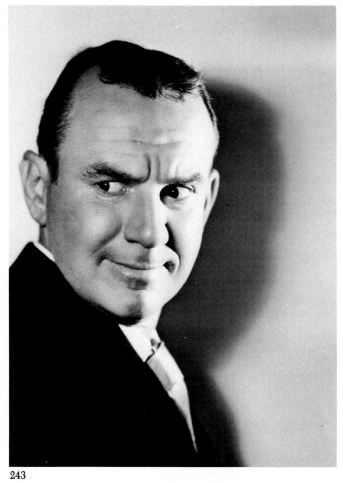

243

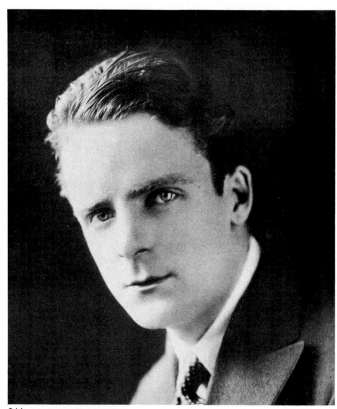

244

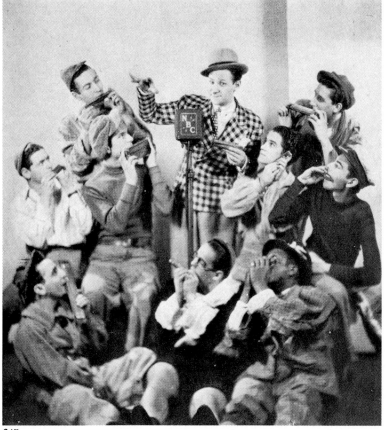

245

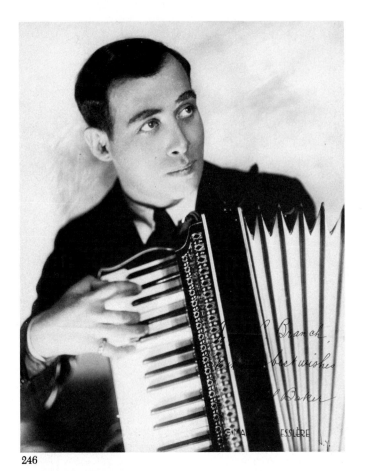

246

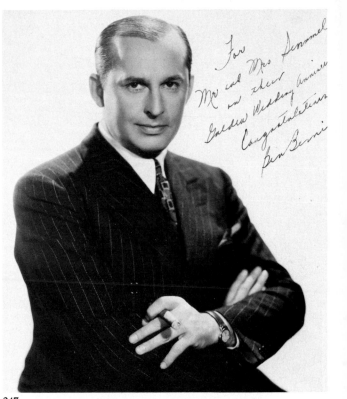

247

246. PHIL BAKER (1898–1963). Comedian/accordionist. Shows, 1923–42, included: *Music Box Revue* (1923; Berlin); *Artists and Models of 1925*; and *Crazy Quilt* (1931; sang "I Found a Million-Dollar Baby" with Fanny Brice and Ted Healy). (Photo: G. Maillard Kesslère, N.Y.) **247. BEN BERNIE** (ca. 1891–1943; real name Bernard Anzelevitz). In vaudeville with Phil Baker; later, major bandleader. In the show *Here's Howe* (1928) he introduced "Crazy Rhythm." (Photo: in 1937 film *Wake Up and Live.*) **248. RUDY (Hubert Prior) VALLÉE** (born 1901). Amazingly successful bandleader and vocalist; in his radio years, an exemplary producer and fosterer of talent. N.Y. shows: *George White's Scandals of 1931* ("This Is the Missus") and *1935; How to Succeed in Business Without Really Trying* (1961). **Still performing 1981.**

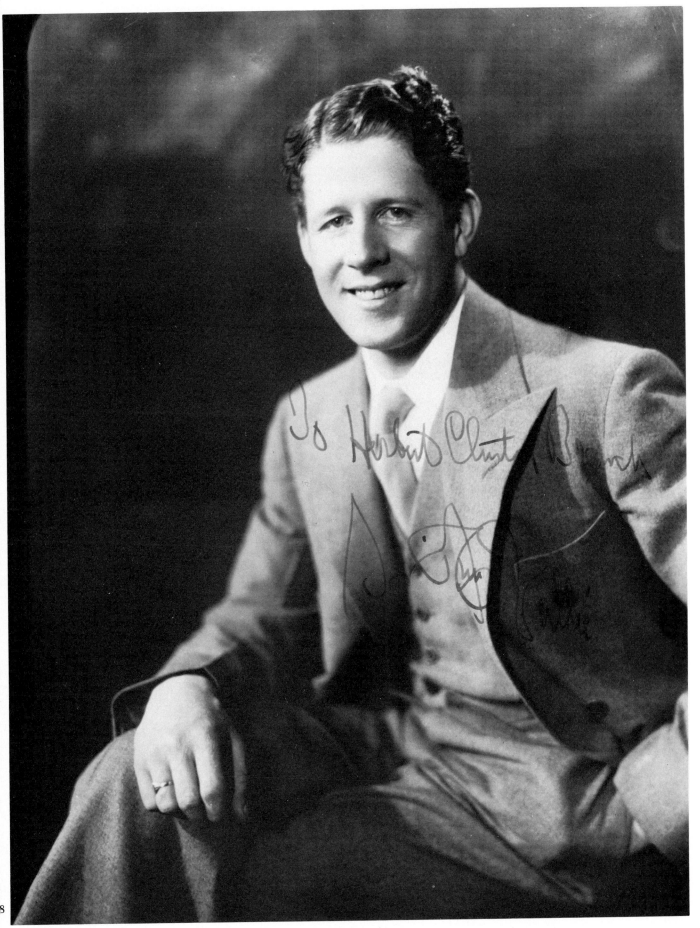

249

250

249. GINGER ROGERS (born 1911; real name Virginia McMath). In show business since 1924, her N.Y. show appearances flanking her long film career: *Top Speed* (1929), *Girl Crazy* (1930; Gershwin; "But Not for Me"); *Hello, Dolly!* (1965, taking over from Carol Channing); *Mame* (1969 revival). (Photo: from a film, ca. 1930.) **250 & 251. ETHEL MERMAN** (born 1909; real surname Zimmerman). Our greatest female lead in book shows. Just a few highlights: *Girl Crazy* (1930; Gershwin; her first show; "I Got Rhythm"); *George White's Scandals of 1931* ("Life Is Just a Bowl of Cherries"); *Take a Chance* (1932; "Eadie Was a Lady," "You're an Old Smoothie"); *Anything Goes* (1934; Porter; title song, "I Get a Kick Out of You," "You're the Top"); *Red, Hot and Blue!* (1936; Porter; "It's De-Lovely"); *Stars in Your Eyes* (1939; Schwartz); *Du Barry Was a Lady* (1939; Porter; "Friendship"); Panama Hattie (1940; Porter; "Let's Be Buddies"); *Annie Get Your Gun* (Berlin; 1946, & 1966 revival; "Doin' What Comes Natur'lly," "You Can't Get a Man with a Gun," "[I've Got the] Sun in the Morning"); *Call Me Madam* (1950; Berlin; "The Hostess with the Mostes' on the Ball"); *Gypsy* (1959; "Everything's Coming Up Roses").

252

252. VERA ZORINA (born 1917 in Germany; real name Brigitta Hartwig). Ballerina, stage from 1923. In the London production of Rodgers & Hart's *On Your Toes* in 1937. N.Y. shows: *I Married an Angel* (1938; Rodgers & Hart); *Louisiana Purchase* (1940; Berlin); *Dream with Music* (1944). From 1976, briefly director of Oslo Opera; still a consultant for Columbia Records. (Photo: Ray Jones, for Universal Pictures, 1943.)

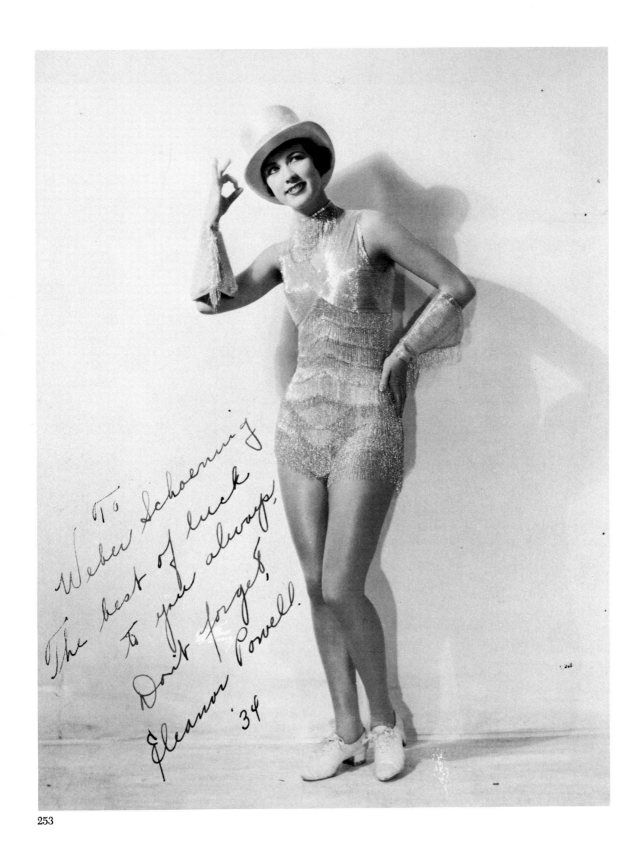

The best of luck,
To you always,
Don't forget,
To
Weber Schoening
Eleanor Powell
'34

253

253. ELEANOR POWELL (born 1912). Dancer; on stage from 1925. N.Y. shows: *The Optimists* (1928); *Follow Thru* (1929); *Fine and Dandy* (1930); *Hot-Cha* (1932; joined cast during run); *George White's Music Hall Varieties* (1935); and *At Home Abroad* (1935; Schwartz). Then left Broadway to become leading female popular dancer in Hollywood. (Photo signed 1934.)

254

255

254. TILLY (Ottilie) LOSCH (1902–1975; born in Austria). Exotic dancer; on stage 1912; in N.Y. from 1927, with appearances to 1947. Chief N.Y. show credits: *Wake Up and Dream* (1929; Porter; "What Is This Thing Called Love?") and *The Band Wagon* (1931; Schwartz; "Dancing in the Dark"). **255.** Lineup from *Flying Colors* (1932; Schwartz). Left to right: **TAMARA GEVA,** Clifton Webb (see No. 140), **PATSY KELLY & CHARLES BUTTERWORTH.** Tamara Geva (born ca. 1900 in Russia; real surname Gevergeva) danced for Diaghilev in the 1920s. Other N.Y. shows: *Chauve-Souris* (1927);

Whoopee (1928); *Three's a Crowd* (1930); and *On Your Toes* (1936; Rodgers & Hart; "Slaughter on Tenth Avenue"); varied appearances to 1965. Patsy (really Bridget) Kelly (born 1910) was in vaudeville and in N.Y. shows 1927–73, including: *Earl Carroll's Sketch Book* (1929); *Earl Carroll Vanities of 1930; The Wonder Bar* (1931) and two old-timer revivals: *No, No, Nanette* (1971) and *Irene* (1973). Charles Butterworth (1896–1946) was a much-liked comedian on Broadway from 1926 to 1945; two other big shows were *Good Boy* (1928) and *Sweet Adeline* (1929; Kern).

256

256. ODETTE MYRTIL (1898–1978; real surname Quignard; born in France). Long, varied international career. Began as violinist 1911. In N.Y. shows from 1914 to 1959, including: *Ziegfeld Follies of 1915*; *Countess Maritza* (1926); and *The Cat and the Fiddle* (1931; Kern). In major London musicals between 1916 and 1923. Los Angeles dress designer in 1930s and 1940s. Chicago appearances 1935, 1947. Toward end of life, ran popular restaurant in New Hope, Pa.

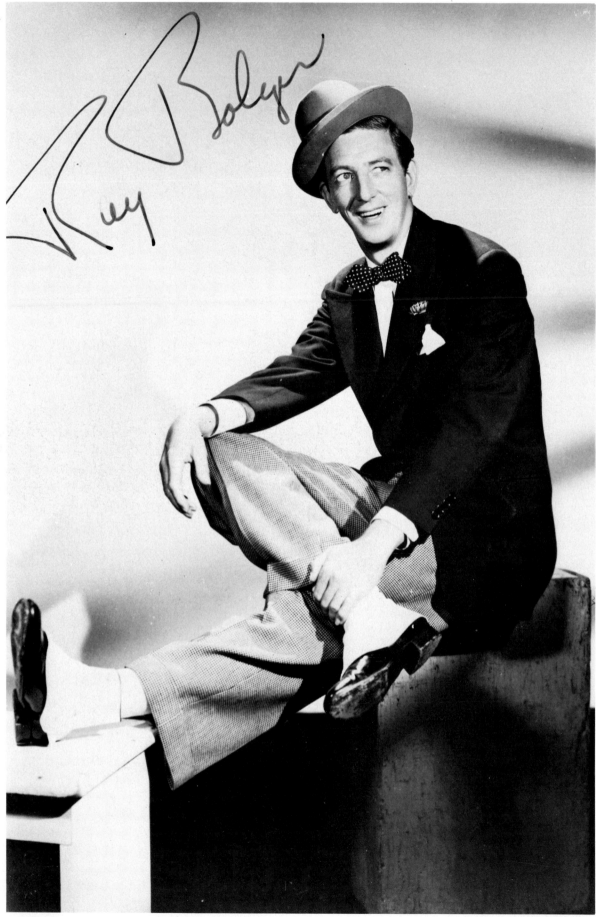

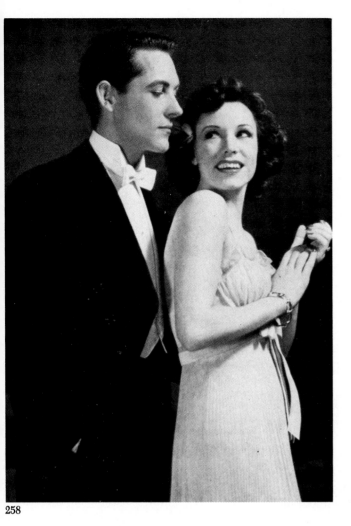

258

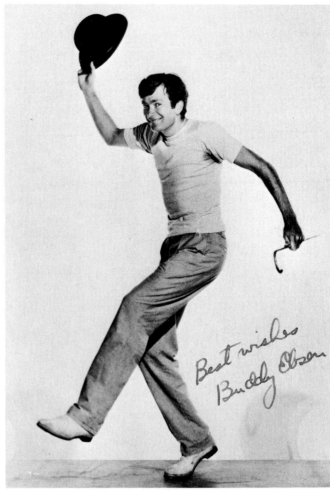

259

257. RAY BOLGER (born 1904). Dancer and singer from 1922; in N.Y. from 1925; in shows 1926–69, including: *Heads Up* (1929; Rodgers & Hart), *George White's Scandals of 1931; Life Begins at 8:40* (1932); *On Your Toes* (1936; Rodgers & Hart; "There's a Small Hotel," "Slaughter on Tenth Avenue"); *By Jupiter* (1942); *Where's Charley?* (1948; Loesser; "Once in Love with Amy"). Perhaps best remembered as Scarecrow in 1939 film *The Wizard of Oz.*
258. CHARLES WALTERS & AUDREY CHRISTIE in *I Married an Angel* (1938; Rodgers & Hart). Walters (born 1911), a dancer, was in the 1933 West Coast revue *Lo and Behold*, turning up in N.Y. in the first *New Faces* (1934). Other N.Y. shows: *Parade* (1935); *Jubilee* (1935; Porter; "Begin the Beguine," "Just One of Those Things"); *The Show Is On* (1936); *Between the Devil* (1937; Schwartz); and *Du Barry Was a Lady* (1939; Porter). Later a director of MGM musicals. Audrey Christie (born 1912) went on stage in 1926 and in the late 1920s and 1930s had excellent roles in Chicago productions of N.Y. musical hits. Her other N.Y. musicals included *Banjo Eyes* (1941) and *The Duchess Misbehaves* (1946). She was married to Guy Robertson (see No. 264). **259. BUDDY (Christian Rudolf) EBSEN** (born 1908). Dancer; in chorus of *Whoopee* (1928); then in *Flying Colors* (1932; "A Shine on Your Shoes"); *Ziegfeld Follies of 1934; Yokel Boy* (1939); and the 1946 revival of *Show Boat.* Also films and TV.

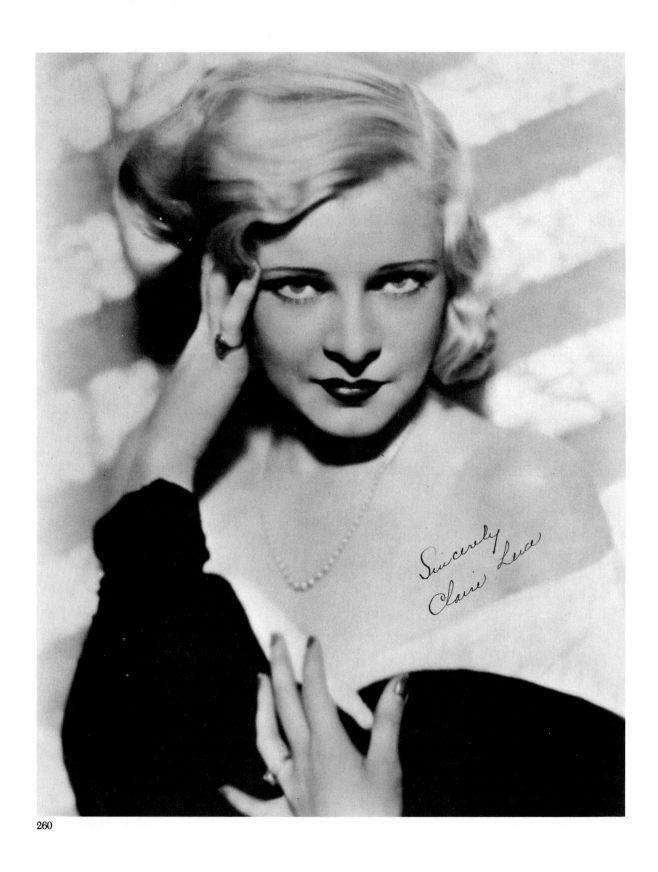

260

260. CLAIRE LUCE (born 1901). Dancer, singer, actress. Her first public appearance was in a dance troupe managed by Texas Guinan. Important musicals included: *No Foolin'* (1926); *Ziegfeld Follies of 1927* (Berlin); and *The Gay Divorce* (1932; Porter). Significant nonmusical career extended to 1963.

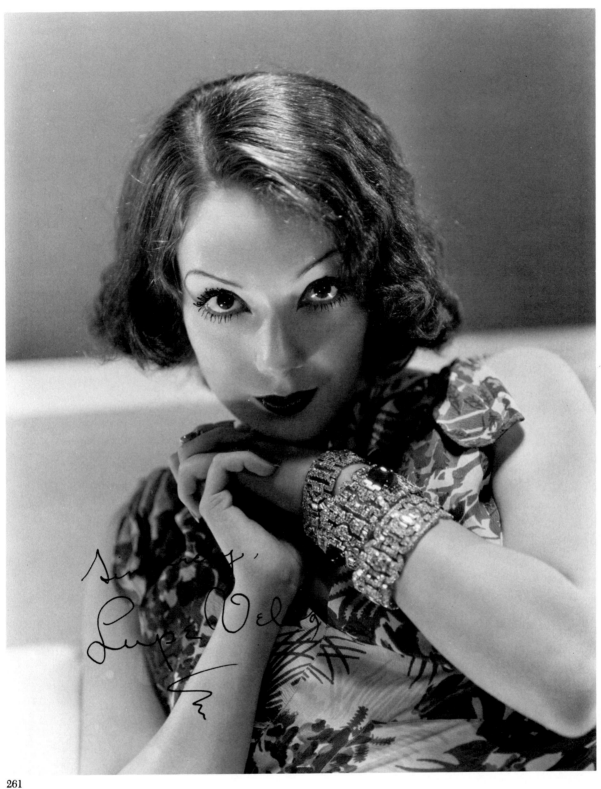

261

261. LUPE (Guadelupe) VELEZ (de Villalobos; 1908–1944; born in Mexico). Very important in films. In N.Y.: *Hot-Cha* (1932); *Strike Me Pink* (1933); and *You Never Know* (1938; Porter). (Photo: Clarence Sinclair Bull, for MGM.)

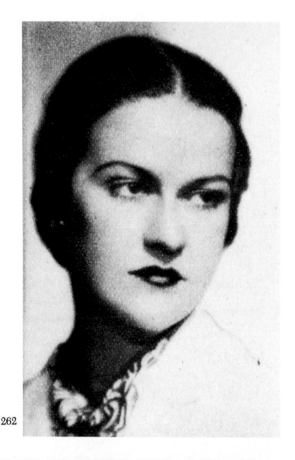

262

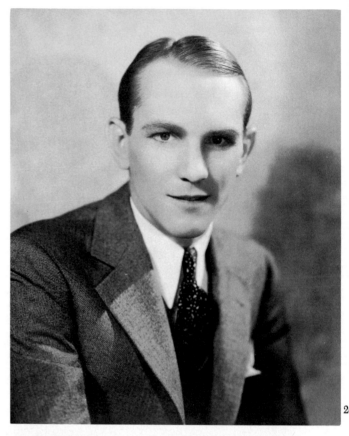

2●

264

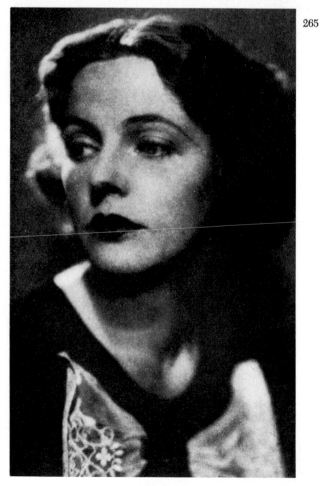

265

266

267

262. GLORIA GRAFTON (dates unavailable). In *The Second Little Show* (1930) and *Jumbo* (1935; Rodgers & Hart; "Little Girl Blue"). **263. DONALD NOVIS** (ca. 1906–1966; born in Wales). Important radio singer. Shows: *Luana* (1930) and *Jumbo* (1935; "The Most Beautiful Girl in the World"). **264. GUY ROBERTSON** (born 1892). Long, distinguished career in N.Y. musicals, 1919–38, including *Wildflower* (1923; Youmans); *The Song of the Flame* (1925; Gershwin); *The Great Waltz* (1934); and *Right This Way* (1938). **265. BETTINA HALL** (born 1906). On stage (in N.Y.) 1926 in a Gilbert & Sullivan chorus; roles from 1927 to 1939, in such shows as: *The Little Show* (1929; Schwartz); *The Cat and the Fiddle*

(1931; Kern; "She Didn't Say Yes"); and *Anything Goes* (1934; Porter; "All Through the Night"). (Photos 262, 264 & 265: G. Maillard Kesslère, N.Y., mid-1930s.) (Two fine English visitors:) **266. ADÈLE DIXON** (born 1908). On stage in England, mainly in nonmusical plays, from 1921. In N.Y. musical *Between the Devil* (1937; Schwartz). **267. EVELYN LAYE** (born 1900). On stage 1915; in London 1916; revues and operetta; leading role in London production of *The New Moon* (1929). In N.Y.: *Bitter Sweet* (1929; Coward; "I'll See You Again," "Zigeuner") and *Between the Devil* (1937; Schwartz). (Photo: Bassano.)

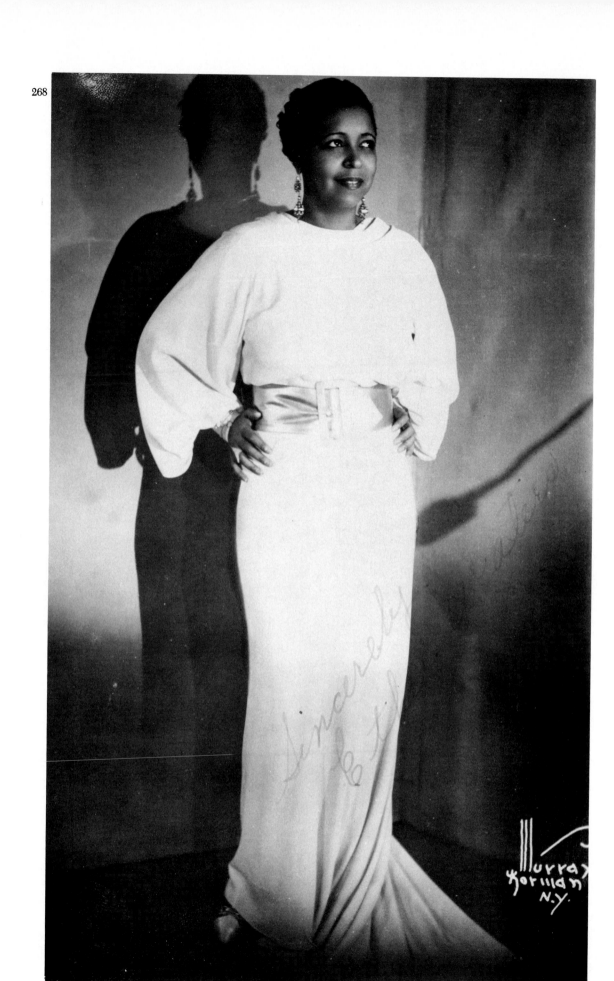

269

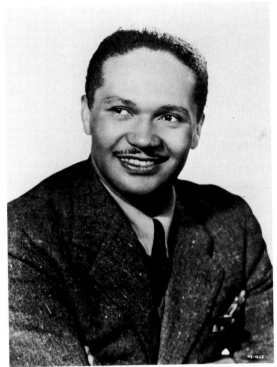

270

268. ETHEL WATERS (1896–1977). One of the very greatest American popular singers. Vaudeville 1917–27. In Chicago show *Miss Calico* (1926). Broadway shows and appearances 1927–59, including: *Rhapsody in Black* (1931); *As Thousands Cheer* (1933; Berlin; "Heat Wave," "Harlem on My Mind"); *At Home Abroad* (1935; Schwartz; "Thief in the Night"); *Cabin in the Sky* (1940; title song, "Taking a Chance on Love"). (Photo: Murray Korman, N.Y.)
269. JOHN BUBBLES (born 1902; real surname Sublett). Singer, dancer, drummer, long teamed with pianist Buck Washington ("Buck & Bubbles"). N.Y. shows: *Lew Leslie's Blackbirds* (1930); *Ziegfeld Follies of 1931; Porgy and Bess* (1935; Gershwin; created role of Sportin' Life; "It Ain't Necessarily So," "There's a Boat Dat's

Leavin' Soon for New York"); *Virginia* (1937); *Laugh Time* (1943); *Carmen Jones* (1946 revival); *Judy Garland at Home at the Palace* (1967). In London show *Transatlantic Rhythm* (1936). Still making personal appearances 1980. (Photo: in the 1943 film of *Cabin in the Sky*.) **270. (Robert) TODD DUNCAN** (born 1903). Operatic baritone who made theatrical history in his three N.Y. shows: *Porgy and Bess* (1935; Gershwin; created title role; "I Got Plenty o' Nuthin'," "Buzzard Song," "Bess, You Is My Woman Now," "Where's My Bess?," "Oh, Lord, I'm on My Way"); also in 1942 and 1943 N.Y. revivals); *Cabin in the Sky* (1940); and *Lost in the Stars* (1949; Weill; title song).

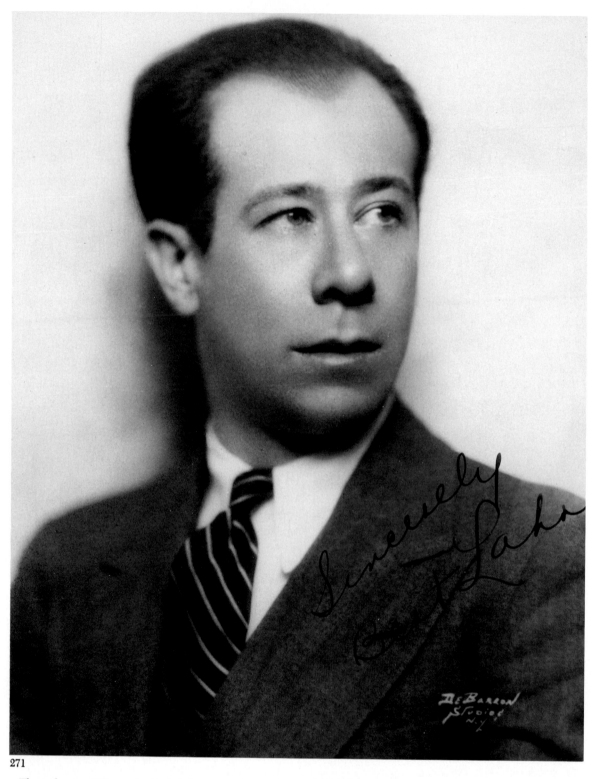

271

Through page 136: a selection of show comedians of the 1930s. **271. BERT LAHR** (1895–1967; real name Irving Lahrheim). On Broadway 1927–66; shows included: *Hold Everything* (1928); *Hot-cha* (1932); *George White's Scandals of 1935*; *The Show Is On* (1936; "Song of the Woodman"); *Du Barry Was a Lady* (1939; Porter); *Foxy* (1964; last musical). Unforgettable Cowardly Lion in 1939 *Wizard of Oz* film. (Photo: De Barron, N.Y.) **272. FRED ALLEN** (1894–1956; real name John Florence Sullivan). N.Y. shows: *The Passing Show of 1922*; *Vogues of 1924*; *Rufus Le Maire's Affairs* (1926); *The Little Show* (1929; Schwartz; his wife Portland Hoffa, shown in photo, also in cast); *Three's a Crowd* (1930; Schwartz). Then, finest radio comedian. (Photo: NBC, 1935.) **273. JACK BENNY** (1894–1974; real name Benny Kubelsky). N.Y. shows: *The Great Temptations* (1926); *Earl Carroll Vanities of 1930*; *Jack Benny* (1963). Major radio star. (Photo: Maurice Seymour, Chicago.) **274. REGINALD GARDINER** (1903–1980; born in England). On London stage 1923–35. N.Y. shows: *At Home Abroad* (1935; Schwartz); *The Show Is On* (1936); *An Evening with Bea Lillie* (1952); revival of *My Fair Lady* (1964).

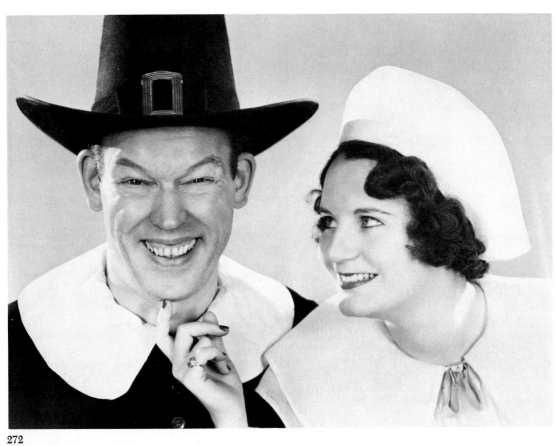

272

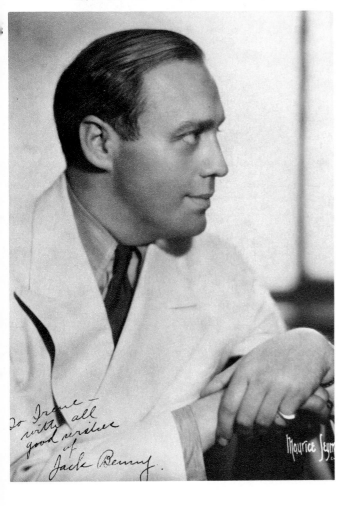

To Irene —
with all
good wishes
of
Jack Benny.

Maurice Seym[...]

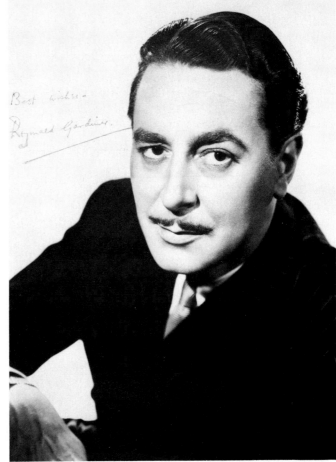

Best wishes —
Reginald Gardiner.

274

275

276

275. VICTOR MOORE & HELEN BRODERICK. Moore (1876–1962) began as a super in Boston in 1893. After touring shows and vaudeville, N.Y. shows 1906–57, including: *Forty-five Minutes from Broadway* (1906; Cohan; title song); *Oh, Kay!* (1926; Gershwin); *Funny Face* (1927; Gershwin); *Hold Everything* (1928); *Heads Up* (1929; Rodgers & Hart); and a major group of shows alongside William Gaxton, from *Of Thee I Sing* (1931; Gershwin), through *Let 'Em Eat Cake* (1933; Gershwin), *Anything Goes* (1934; Porter), *Leave It to Me* (1938; Porter) and *Louisiana Purchase* (1940; Berlin), to *Nellie Bly* (1946). Helen Broderick (1891–1959) began in the chorus of the first *Ziegfeld Follies* (1907). Important later appearances: *Oh, Please* (1926; Youmans); *Fifty Million Frenchmen* (1929; Porter); *The Band Wagon* (1931; Schwartz); *Earl Carroll Vanities of 1932*; *As Thousands Cheer* (1933; Berlin; her last N.Y. show). Mother of actor Broderick Crawford. (Photo: in 1937 film *Meet the Missus*.) **276. MARY BOLAND** (1880–1965). Brilliant comedienne; on stage 1900; in N.Y. straight plays 1905–54. In the two great musicals *Face the Music* (1932; Berlin) and *Jubilee* (1935; Porter). (Photo: Paramount Pictures.)

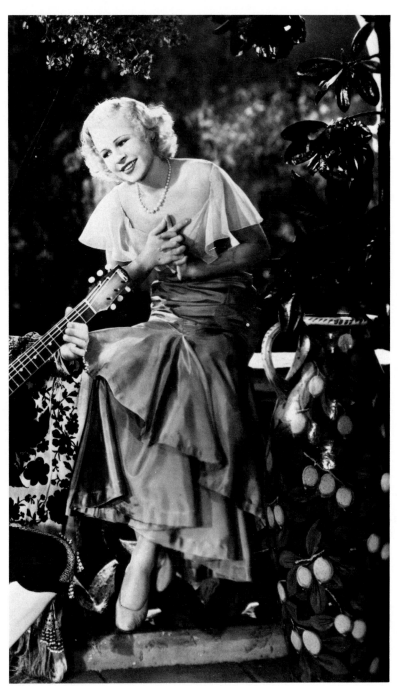

277

278

277. JIMMY SAVO (1896–1960; real surname Sava). In the N.Y. shows: *Vogues of 1924; Murray Anderson's Almanac* (1929; "I May Be Wrong But I Think You're Wonderful"); *Earl Carroll Vanities of 1930; Parade* (1935); *The Boys from Syracuse* (1938; Rodgers & Hart); *Wine, Women and Song* (1942); *What's Up* (1943). **278. LYDA**

ROBERTI (1909–1938; born in Poland). Daughter of a clown, she did circus work as a child. Into American vaudeville; then, in the N.Y. shows: *You Said It* (1931); *Pardon My English* (1933; Gershwin); *Roberta* (1933; Kern); *George White's Scandals of 1935*. (Photo: in 1932 film *The Kid from Spain*.)

279

280

279. JAMES BARTON (1890–1962). Singer, actor, excellent eccentric dancer. On stage from infancy; much early stock and repertory; in N.Y. straight plays and musicals 1919–57. Musicals included: *The Passing Show(s) of 1919* and *1924; The Last Waltz* (1921); *Artists and Models of 1925; No Foolin'* (1926); *Sweet and Low* (1930); *Paint Your Wagon* (1951; "Wand'rin' Star"). **280. DAVE CHASEN** (ca. 1899–1973). In *Earl Carroll Vanities of 1925;* then, in three Joe Cook shows as Cook's sidekick: *Rain or Shine* (1928); *Fine and Dandy* (1930); *Hold Your Horses* (1933). Later, a major Hollywood restaurateur. (Photo: G. Maillard Kesslère, N.Y.) **281. JOE COOK** (1890–1959; real surname Lopez). Joined a traveling show at 12; long in vaudeville as comic juggler. His N.Y. shows were: *Hitchy-Koo* (1919); *Earl Carroll Vanities of 1923* and *1924;* the three shows alongside Dave Chasen (see just above); and *It Happens On Ice* (1940). (Photo: De Mirjian, N.Y.)

To
my old friend
Louis Moscone
With sincere regards
from
Joe Cook

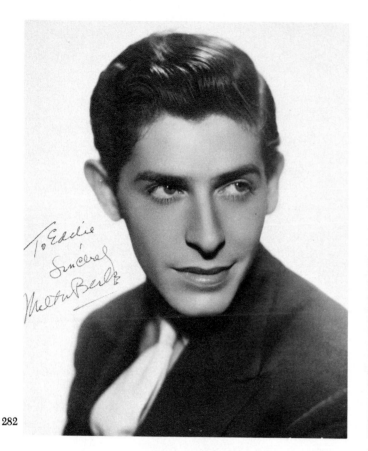

282

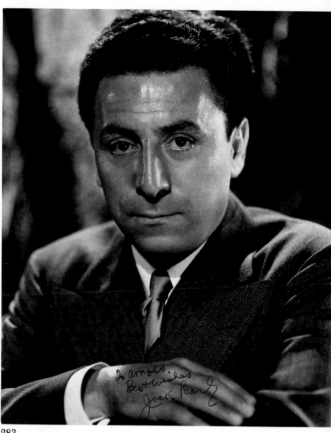

283

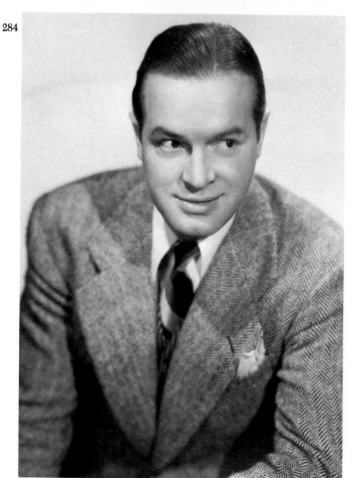

284

282. MILTON BERLE (born 1908; real surname Berlinger). Much vaudeville. N.Y. shows were; revival of *Florodora* (1920); *Earl Carroll Vanities of 1932*; *Saluta* (1934); *Ziegfeld Follies of 1943*. In Chicago *Spring in Brazil* (1945). Enormously popular on television as comedian, producer and talent developer. (Photo: Maurice Seymour, Chicago.) **283. JACK PEARL** (born 1895; real name Jake Perlman). On stage from 1911; in vaudeville and burlesque. N.Y. shows included: *Hitchy-Koo* (1920); *Artists and Models of 1927*; *The International Revue* (1930); *Ziegfeld Follies of 1931*; *Everybody's Welcome* (1931); and *Pardon My English* (1933; Gershwin; his last musical). Other appearances to 1943. Important radio career. (Photo: MGM, ca. 1933.) **284. BOB (Lester Townes) HOPE** (born 1903 in England). Vaudeville; in N.Y. by 1927. Small roles and chorus work 1928–30; then, in the shows: *Ballyhoo of 1932*; *Roberta* (1933; Kern); *Say When* (1934); *Ziegfeld Follies of 1936* ("I Can't Get Started with You"); and *Red, Hot and Blue!* (1936; Porter). Later, highly successful film and radio career. Memorable USO service throughout World War II. (Photo: Paramount Pictures, late 1930s.)

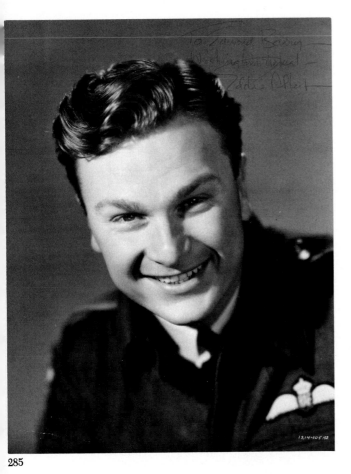

285

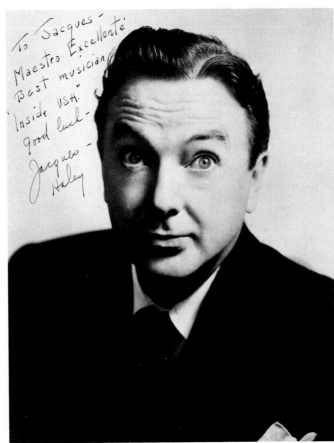

286

285. EDDIE ALBERT (born 1908; real name Edward Albert Heimberger). On stage 1933; in N.Y. 1936. His musicals were: *The Boys from Syracuse* (1938; Rodgers & Hart; "This Can't Be Love"); *Miss Liberty* (1949; Berlin; "Let's Take an Old Fashioned Walk"); and *The Music Man* (replacing Robert Preston, 1960, in this 1957 show). (Photo: Universal Pictures, 1942.) **286. JACK HALEY** (1899–1979). Vaudeville; N.Y. shows 1924–48: *Round the Town* (1924, with his vaudeville partner Charles Crafts); *Follow Thru* (1929; "Button Up Your Overcoat" in duet with Zelma O'Neal); *Take a Chance* (1932; "You're an Old Smoothie" in duet with Ethel Merman); *Higher and Higher* (1940; Rodgers & Hart); *Show Time* (1942); and *Inside U.S.A.* (1948; Schwartz). He was also in the Chicago *Good News* Company (1928). Played the Tin Man in the 1939 film *The Wizard of Oz*; much other film work. (Photo ca. 1948.)

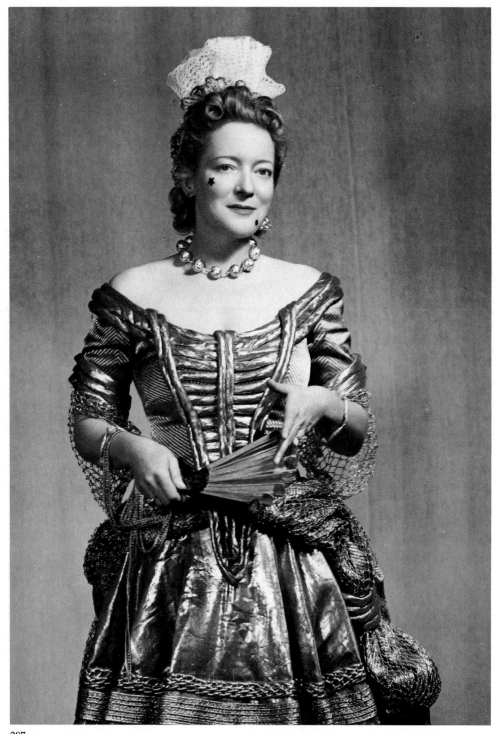

287

287. PEGGY (Margaret) WOOD (1892–1978). Extensive N.Y. and London career—1910 to at least 1970—chiefly in straight plays. In N.Y. musicals: chorus of *Naughty Marietta* (1910; Herbert); *The Lady of the Slipper* (1912); *Love o' Mike* (1917; Kern); *Maytime* (1917; Romberg; "Will You Remember?"); *Buddies* (1919); *Champagne, Sec* (1933). (Photo: Vandamm; in costume for Players Club production of *Love for Love*, 1940.) **288. KITTY CARLISLE** (born 1915; real name Catherine Conn). In N.Y. shows: *Champagne, Sec* (1933); *White Horse Inn* (1936); *Three Waltzes* (1937); *Walk with Music* (1940); revival of *Kiss Me, Kate* (1956). (Photo: MGM, ca. 1935.) **289. MITZI MAYFAIR** (year of birth unavailable; real name Evelyn Pique). In: *Ziegfeld Follies of 1931*; *Take a Chance* (1932); *Calling All Stars* (1934); and *The Show Is On* (1936).

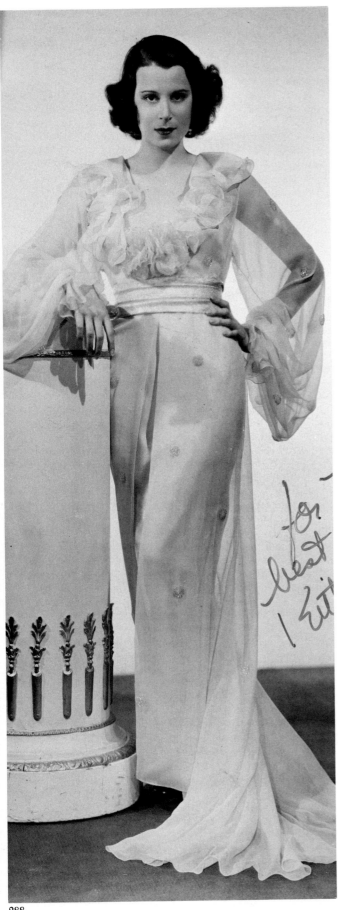

288

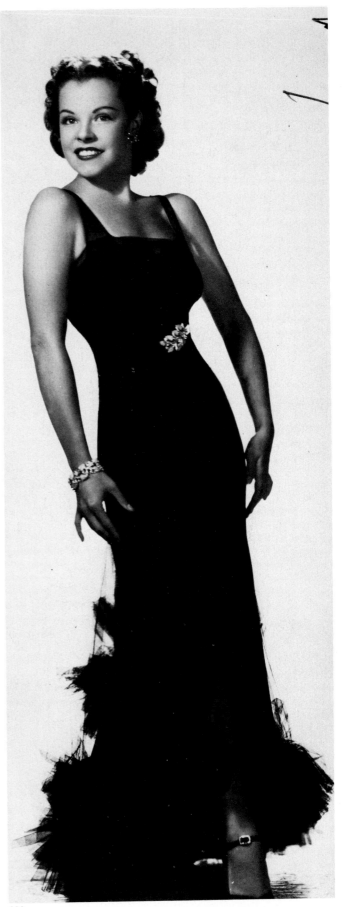

289

290

291

292

290. DIXIE (Christina Elizabeth) DUNBAR (born ca. 1919). In N.Y. shows: *Life Begins at 8:40* (1934) and *Yokel Boy* (1939). Retired very young. (Photo: Universal Pictures.) **291. HAL LE ROY** (born 1913; real name John LeRoy Schotte). Dancer; N.Y. shows, 1931–56, included: *Ziegfeld Follies of 1931*; *Thumbs Up* (1934; "Zing, Went the Strings of My Heart"); and *Too Many Girls* (1939; Rodgers & Hart). (Photo: Richter.) **292. LUELLA GEAR** (1897–1980). Fine comedienne, on N.Y. stage 1917–57. Musicals included: *Love o' Mike* (1917; Kern); *Poppy* (1923); *The Gay Divorce* (1932; Porter); *Life Begins at 8:40* (1934); *On Your Toes* (1936; Rodgers & Hart). Last musical: *My Romance* (1948). (Photo: G. Maillard Kesslère, N.Y., mid-1930s.)

293

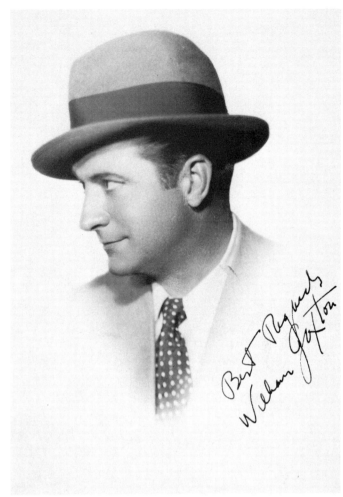

294

295

293. GERTRUDE NIESEN (ca. 1913–1975). Understudied Ethel Merman in *Take a Chance* (1932). In shows: *Calling All Stars* (1934); *Ziegfeld Follies of 1936*; and *Follow the Girls* (1944). Extensive radio and nightclub work. (Photo: Apeda, N.Y., ca. 1933.) **294. WILLIAM GAXTON** (1893–1963; real name Arturo Gaxiola). One of the great Broadway musical leading men, 1922–46 (further appearances to 1962). Partial credits: *Music Box Revue* (1922; Berlin); *A Connecticut Yankee* (1927; Rodgers & Hart; "My Heart Stood Still" [introduction to U.S.] & "Thou Swell"); *Fifty Million Frenchmen* (1929; Porter; "You Do Something to Me"); *Of Thee I Sing* (1931; Gershwin; title song, "Who Cares?"); *Anything Goes* (1934; Porter); *White Horse Inn* (1936); *Leave It To Me* (1938; Porter); and *Louisiana Purchase* (1940; Berlin). **295. JACK WHITING** (1901–1961). Impressive N.Y. show career, 1922–58. Highlights: *Stepping Stones* (1923; Kern); *Hold Everything* (1928; "You're the Cream in My Coffee"); *Heads Up* (1929; Rodgers & Hart); *America's Sweetheart* (1931; Rodgers & Hart); *Take a Chance* (1932); *Hooray for What!* (1937); *Very Warm for May* (1939; Kern). (Photo ca. 1930.)

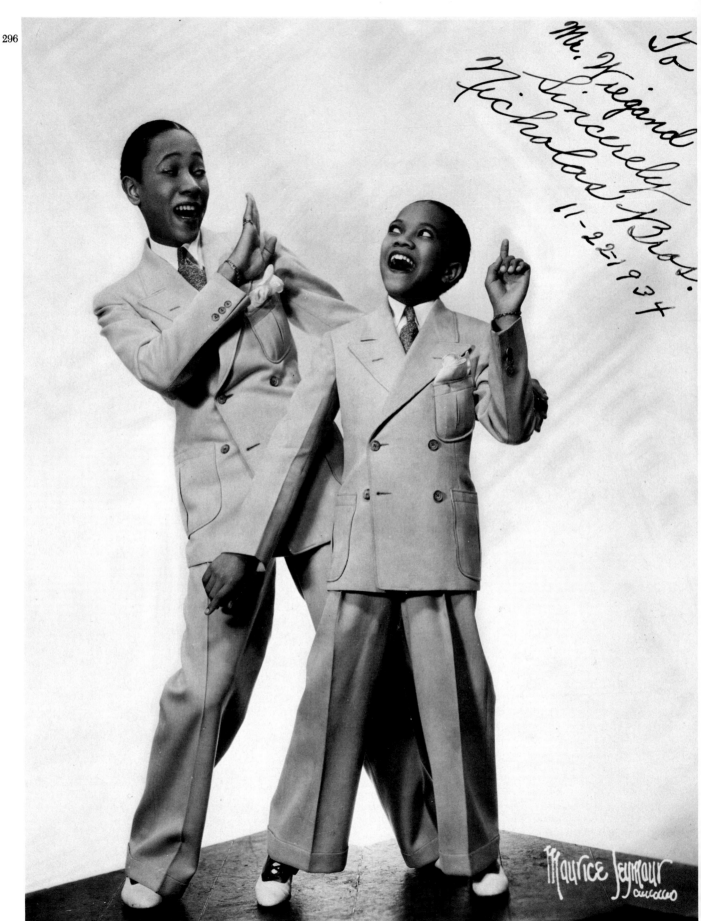

To
Mr. Wiegand
Sincerely
Nicholas Bros.
11-22-1937

Maurice Seymour
studio

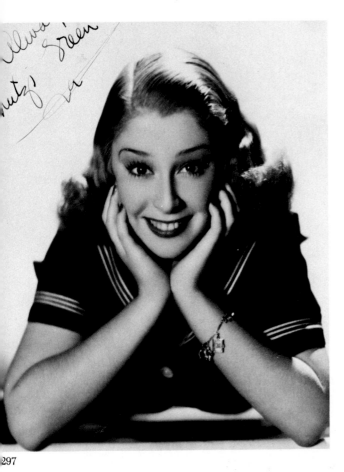

297

298

299

296. NICHOLAS BROTHERS (Fayard, born ca. 1918, & Harold, born ca. 1924). Acrobatic dancers in films and in the N.Y. shows: *Ziegfeld Follies of 1936; Babes in Arms* (1937; Rodgers & Hart); *St. Louis Woman* (1946; Arlen); and *Sammy* (1974). In London *Blackbirds of 1936*. Still making personal appearances 1980. (Photo: Maurice Seymour, Chicago; signed 1934.) **297. MITZI GREEN** (1920–1969). In films from 1929, on Broadway 1935–57, especially in *Babes in Arms* (1937; "Where or When," "The Lady Is a Tramp," "My Funny Valentine"). (Photo ca. 1937.) **298. JUNE PREISSER** (born ca. 1920). On stage at age 2. With sister Cherry in *Ziegfeld Follies of 1934* and *1936*. On her own in *You Never Know* (1938; Porter) and *Count Me In* (1942). (Photo: Universal Pictures, 1944.) **299. RAY HEATHERTON** (born 1910). In *Garrick Gaieties* (1930) and *Babes in Arms* (1937; "Where or When" with Mitzi Green); also revivals and stock. In television as The Merry Mailman. (Photo ca. 1937.)

301

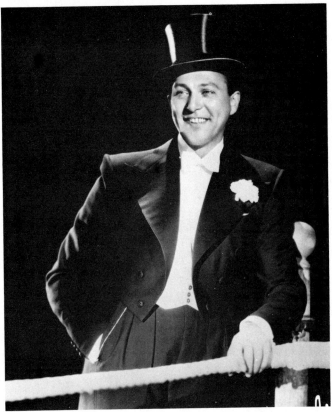

302

300. GYPSY ROSE LEE (1914–1970; real name Rose Louise Hovick). Burleycue queen; on stage from 1917 in vaudeville. In chorus of N.Y. show *Melody* (1933); then, in the second edition of *Ziegfeld Follies of 1936*; in the N.Y. World's Fair edition of *The Streets of Paris* (1940); and in *Star and Garter* (1942). Subject of musical *Gypsy* (1959). (Photo: Maurice Seymour, Chicago.) **301. YVONNE PRINTEMPS** (1895–1977; real surname Wigniolle). Vast career in France from 1908 in music hall, revue, operetta and drama: a national institution. In N.Y. in Sacha Guitry's *Mozart*

(1926; performed in French) and in Noël Coward's *Conversation Piece* (1934; "I'll Follow My Secret Heart"). (Photo 1934.) **302. CARL BRISSON** (1893–1958; real name Carl Brisson Petersen; Danish). Began as boxer; on stage 1916 as dancer; cabaret work; into Stockholm revues; active in London from 1921 (especially in the first English-language version of *The Wonder Bar* in 1930). Much film work. In the N.Y. show *Forbidden Melody* (1936). (Photo signed Hollywood, 1934.)

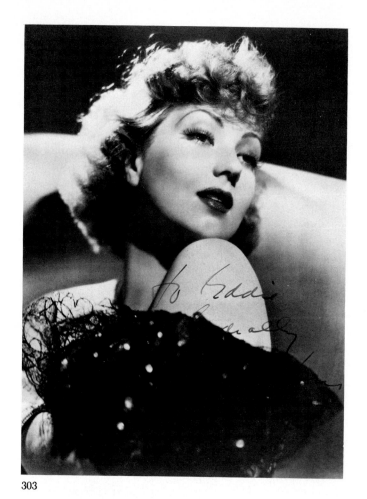

303

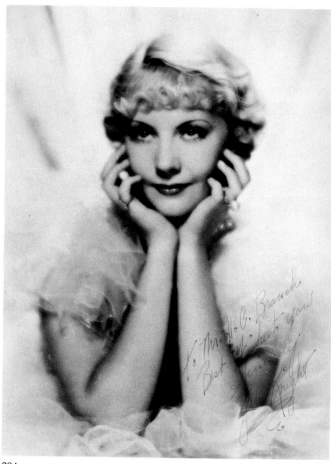

304

303. ANN SOTHERN (born 1909). Her name, on stage and screen, up to 1933 was Harriette Lake. In light opera companies 1930–31. N.Y. shows: *America's Sweetheart* (1931; Rodgers & Hart; "I've Got Five Dollars"); *Everybody's Welcome* (1931); succeeded Lois Moran, 1933, in 1931 Gershwin show *Of Thee I Sing*. Then, film popularity. **304. JUNE KNIGHT** (born 1911; real name Margaret Rose Valliquietto). Began as dancer in live movie-house pres-

entations; on regular stage 1925; in California shows; then N.Y. cabaret and small roles. In *Nine O'Clock Revue* (1931) in Hollywood and San Francisco. Real N.Y. career: *Hot-Cha* (1932); *Take a Chance* (1932); *Jubilee* (1935; Porter; "Begin the Beguine" & "Just One of Those Things" with Charles Walters); *The Would-Be Gentleman* (1946); and the 1947 revival of Herbert's *Sweethearts*.

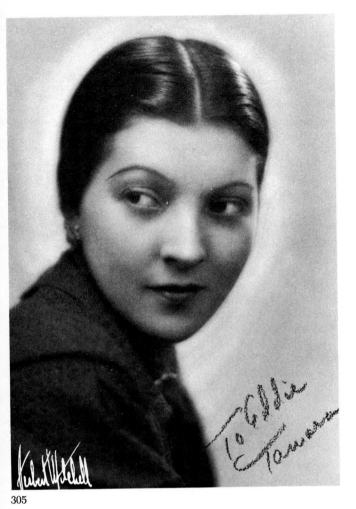

305

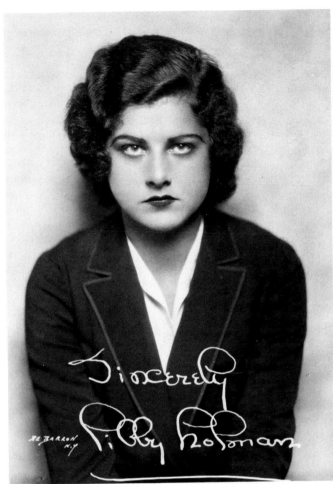

306

305. TAMARA (1907–1943; surname Drasin; born in Russia). Singer and guitarist. N.Y. show work 1922–38, especially: *Roberta* (1933; Kern; "Smoke Gets in Your Eyes," "The Touch of Your Hand"); *Right This Way* (1938; "I'll Be Seeing You," "I Can Dream, Can't I?"); *Leave It to Me* (1938; Porter; "Get Out of Town"). Also in *Cochran's 1930 Revue* in London. (Photo: Herbert Mitchell.) **306. LIBBY HOLMAN** (1906–1971; real name Elizabeth Holtzman). On stage 1924, on Broadway 1925–54. Major shows: *Garrick Gaieties* (1925; Rodgers & Hart); *The Little Show* (1929; Schwartz et al.; "Can't We Be Friends?" and "Moanin' Low"); *Three's a Crowd* (1930; Schwartz et al.; "Body and Soul" first time in U.S., and "Something to Remember You By"); *Revenge with Music* (1934; Schwartz; "You and the Night and the Music"); *You Never Know* (1938; Porter). Also in straight plays and concerts. (Photo: De Barron, ca. 1934.)

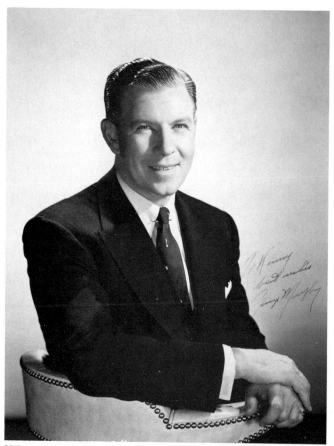

307

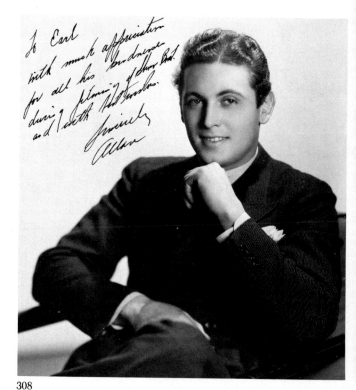

308

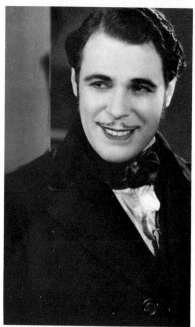

309

307. GEORGE MURPHY (born 1902). In London and Chicago productions of late-1920s Broadway musicals. On Broadway: *Shoot the Works* (1931); *Of Thee I Sing* (1931; Gershwin; "Love Is Sweeping the Country"); *Roberta* (1933; Kern). Films; politics. (Photo: MGM.) **308. ALLAN JONES** (born 1907). Much operetta and club work outside of N.Y.; many films. N.Y. credits: revival of *Bitter Sweet* (1934); revival of *The Chocolate Soldier* (1942); *Jackpot* (1944). Still active 1980. (Photo: Maurice Seymour, Chicago.) **309. EVERETT MARSHALL** (died 1944). Operatic baritone; at Metropolitan Opera 1927–31. N.Y. shows: *George White's Scandals of 1931* ("That's Why Darkies Were Born," "The Thrill Is Gone"); *Melody* (1933); *Ziegfeld Follies of 1934* ("Wagon Wheels"); *Calling All Stars* (1934); revival of *Blossom Time* (1938); revivals of *The Student Prince in Heidelberg* (1939 & 1943); and Billy Rose's *Aquacade* at the N.Y. World's Fair (1939 & 1940). (Photo: in 1930 film *Dixiana*.)

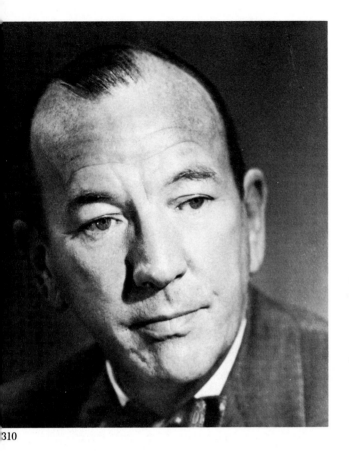

310

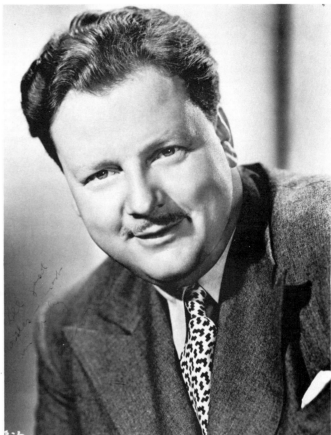

311

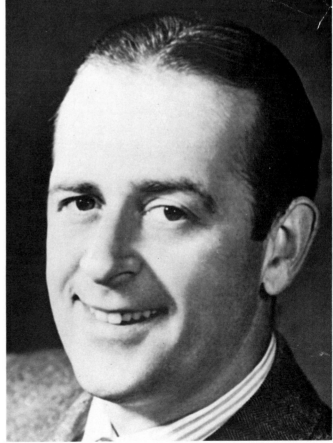

312

310. NOËL COWARD (1899–1973; English). All-round man of the theater. On stage 1911; N.Y. appearances from 1930s to 1950s, chiefly nonmusical. Participation in N.Y. musicals (written by him, done earlier in London): *This Year of Grace* (1928) and *Tonight at 8:30* (1936). **311. WALTER SLEZAK** (born 1902 in Austria). On N.Y. stage (including straight plays) 1930–58. Musicals: *Meet My Sister* (1930); *Music in the Air* (1932; Kern; "I've Told Every Little Star"); *May Wine* (1935); *I Married an Angel* (1938; Rodgers & Hart); *Fanny* (1954). (Photo: Ernest A. Bachrach, for RKO-Radio Pictures, 1943.) **312. EDDIE FOY, JR.** (born 1910). Singer, dancer, comedian, son of Eddie Foy, Sr. (see No. 65). In vaudeville at age 5. N.Y. musicals, 1929–57, included: *Show Girl* (1929; Gershwin); *The Cat and the Fiddle* (1931; Kern); *At Home Abroad* (1935; Schwartz); and *The Pajama Game* (1954).

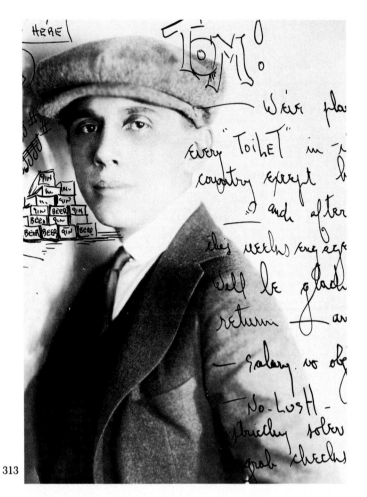

313

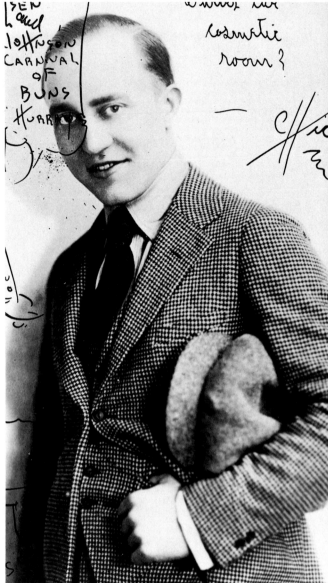

314

315

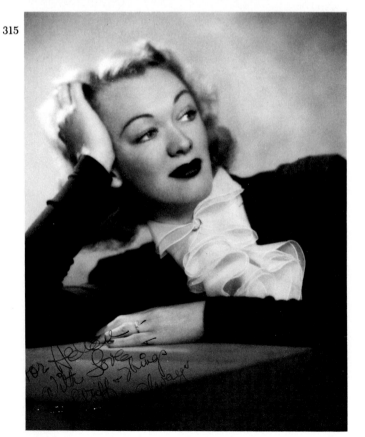

313. **OLE (John Sigvard) OLSEN** (1892–1963). **314. CHIC (Harold Ogden) JOHNSON** (ca. 1891–1962). Zany partners for decades in vaudeville, films and three N.Y. shows that they produced: *Hellzapoppin* (1938); *Sons o' Fun* (1941); and *Laffing Room Only* (1944). In Chicago production of *Take a Chance* (1933). (Photos: mid-1920s; No. 313 by Hixon-Connolly.) **315. EVE ARDEN** (born 1912; real name Eunice Quedens). On stage from 1928; used real name in 1930 film *The Song of Love*. In the Pasadena revue *Lo and Behold* (1933). To N.Y. 1934; musicals: *Ziegfeld Follies of 1934* and *1936* ("I Can't Get Started With You" in duet with Bob Hope); *Parade* (1935); *Very Warm for May* (1939; Kern); *Two for the Show* (1940); *Let's Face It* (1941; Porter). Then, films, radio and television. Toured with *Hello, Dolly!* in 1966. (Photo: G. Maillard Kesslère, N.Y.)

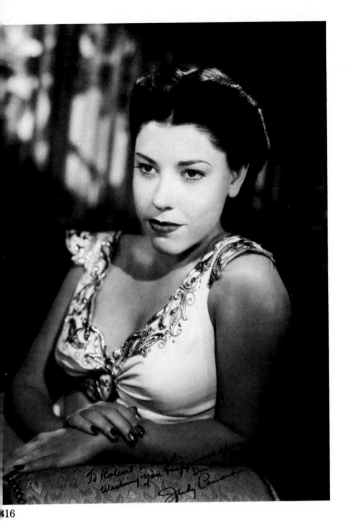

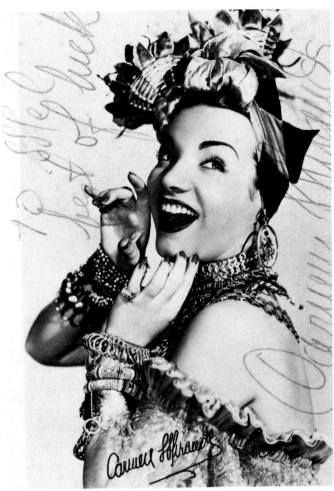

317

316

316. JUDY (Juliet) CANOVA (born 1916). Popular hillbilly singing comedienne of radio and films. In N.Y.: *Ziegfeld Follies of 1936* and *Yokel Boy* (1939; "Comes Love"). (Photo: Joe Walters.)
317. CARMEN MIRANDA (1904–1955; real name Maria Miranda da Cunha; born in Portugal). Active in Brazil in 1930s as sensational samba songstress. In N.Y. shows *The Streets of Paris* (1939; "The South American Way") and Olsen & Johnson's *Sons o' Fun* (1941); unforgettable film career.

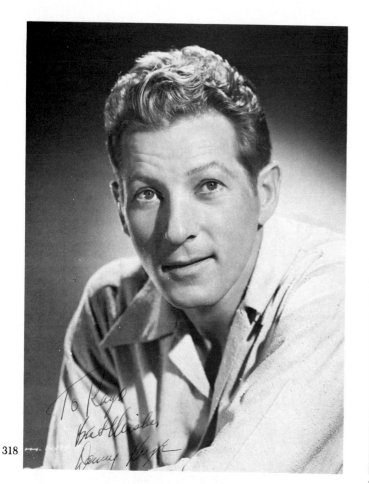

318

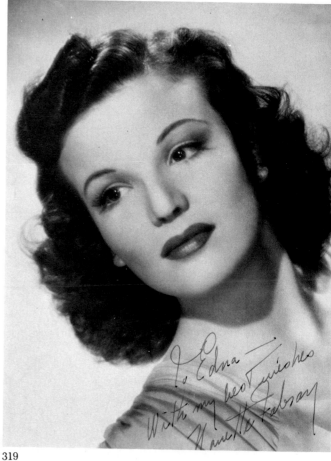

319

320

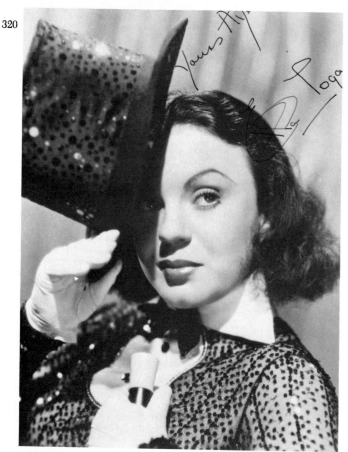

318. DANNY KAYE (born 1913; real name David Kominski). N.Y. stage credits: *Straw Hat Revue* (1939; "Anatole of Paris"); *Lady in the Dark* (1941; Weill); *Let's Face It* (1941; Porter); *Two by Two* (1970; Rodgers); as well as appearances in his own evenings 1949, 1953, 1955 and 1963. Much vaudeville in U.S. and England; important film work. **319. NANETTE FABRAY** (born 1920; real surname Fabares). In vaudeville at age 3; much stage work in California; came to N.Y. 1940 in show of 1939 Hollywood origin, *Meet the People*. Highlights of Broadway career: *Let's Face It* (1941; Porter); *High Button Shoes* (1947); *Love Life* (1948; Weill); *Make a Wish* (1951); *Mr. President* (1962; Berlin; latest show). **320. ELLA LOGAN** (1913–1969; born in Scotland). On stage in infancy; long European career. N.Y. shows: *Calling All Stars* (1934); *George White's Scandals of 1939* ("Are you Having Any Fun?"); Olsen & Johnson's *Sons o' Fun* (1941); *Show Time* (1942); *Finian's Rainbow* (1947; "How Are Things in Glocca Morra?" & "Look to the Rainbow"). USO work in World War II. (Photo ca. 1942.)

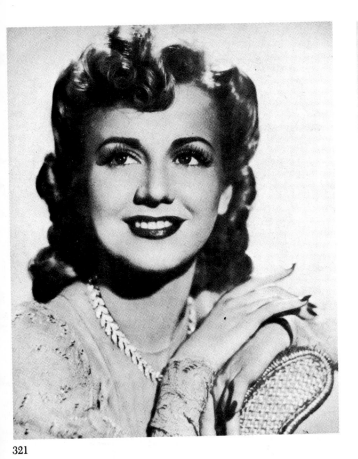

321

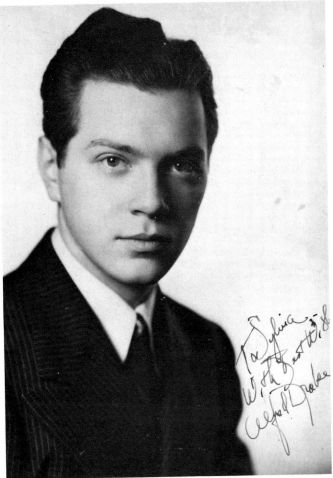

322

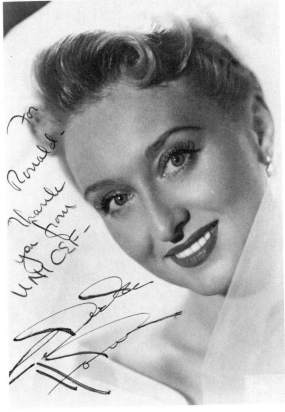

323

Stars of the original production of Rodgers & Hammerstein's *Oklahoma!* (1943). **321. JOAN ROBERTS** (born 1918). The original Laurie: "Many a New Day," "Out of My Dreams" and (duet with Drake) "People Will Say We're in Love." Other N.Y. shows: *Sunny River* (1941); *Marinka* (1945); *Are You With It?* (1945); replacement in *High Button Shoes* (1948). (Photo 1945.) **322. ALFRED DRAKE** (born 1914; real surname Capurro). The original Curly: "Oh, What a Beautiful Mornin'," "The Surrey with the Fringe on Top." In N.Y. show choruses from 1935. Other major shows: *Babes in Arms* (1937; Rodgers & Hart); *Two for the Show* (1940; "How High the Moon"); *Beggar's Holiday* (1946; Duke Ellington score); *Kiss Me, Kate* (1948; Porter; "Wunderbar," "Where Is the Life That Late I Led?"); *Kismet* (1953, and 1965 revival). Latest show: *Gigi* (1973). (Photo ca. 1937.) **323. CELESTE HOLM** (born 1919). The original Ado Annie: "I Cain't Say No,""All'er Nothin'." On stage (and in N.Y.) from 1934, chiefly in nonmusical plays. Other N.Y. musicals: *Bloomer Girl* (1944; Arlen); revival of *Oklahoma!* in 1951; *The Utter Glory of Morrissey Hall* (1979; lasted one night).

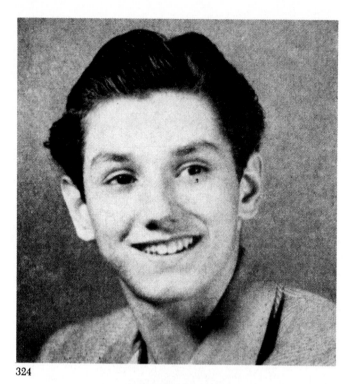

324

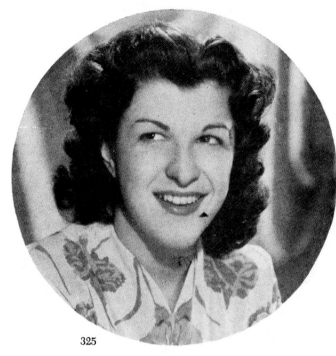

325

326

327

328

329

324. **TOMMY RALL** (born 1929). Vaudeville, ballet. N.Y. shows, 1948–70, include: *Look, Ma, I'm Dancin'* (1948); *Miss Liberty* (1949; Berlin); *Call Me Madam* (1950; Berlin); *Milk and Honey* (1961). (Photo early 1940s.) 325. **NANCY WALKER** (born 1922; real name Anna Myrtle Swoyer). N.Y. shows, 1941–60, include: *Best Foot Forward* (1941); *On the Town* (1944; Bernstein); *Look, Ma, I'm Dancin'* (1948). (Photo 1944.) 326. **SONO OSATO** (born 1919). With major ballet companies 1934–43. In shows *One Touch of Venus* (1943; Weill) and *On the Town* (1944); other appearances 1948, 1955, 1975. (Photo 1944.) 327. **HAROLD LANG** (1920–1970). Ballet; N.Y. shows, 1945–65, including: *Look, Ma, I'm Dancin'* (1948); *Kiss Me, Kate* (1948; Porter); revival of Rodgers & Hart's 1940 show *Pal Joey* (1952). (Photo early 1940s.) 328. **ALICE PEARCE** (1917–1966). Apprentice from 1940; in N.Y. plays to 1961. Major musicals: *New Faces of 1943*; *On the Town* (1944); *Look, Ma, I'm Dancin'* (1948); *Gentlemen Prefer Blondes* (1949). (Photo: Marcus Blechman, N.Y.; signed 1951.) 329. **JOAN McCRACKEN** (1923–1961). Featured dancer in *Oklahoma!* (1943); then, in four shows from *Bloomer Girl* (1944; Arlen) to *Me and Juliet* (1953; Rodgers & Hammerstein). (Photo: Maurice Seymour, Chicago.) 330. **JUNE ALLYSON** (born 1917; real name Ella Geisman). In N.Y. shows, 1938–41 (then, big film career) and 1970, especially: *Very Warm for May* (1939; Kern); *Panama Hattie* (1940; Porter); and *Best Foot Forward* (1941). (Photo: MGM.)

330

331

333

332

Central European stars on Broadway in the 1940s. **331. OSKAR KARLWEIS** (ca. 1895–1956; Austrian). Top star of Berlin revues and films. In N.Y. operetta *Rosalinda* (1942); straight N.Y. appearances to 1955. (Photo: Binder, Berlin, early 1930s.) **332. SIG (Siegfried) ARNO** (1895–1975; real surname Aron; German). On stage from 1913, especially in operetta. Left Germany 1933; to U.S. 1939; on Broadway to 1964, especially in *Song of Norway* (1944, and 1959 revival). (Photo: UFA, Berlin, early 1930s.) **333. JARMILA NOVOTNÁ** with **ERNEST TRUEX** in *Helen Goes to Troy* (1944). Mme. Novotná (born 1907; Czech) was with the Vienna Opera 1934–38, at the Metropolitan Opera between 1940 and 1957. Truex (1889–1973), on stage as a child, was in N.Y. plays from 1908 to 1965; musicals, 1910–51, included: *Very Good Eddie* (1915; Kern) and *The Third Little Show* (1931). **334. MARTA EGGERTH** (born 1919 in Hungary) and her husband **JAN KIEPURA** (1902–1966; Polish) in the N.Y. revival of *The Merry Widow* in 1943. Miss Eggerth went on stage in 1928 in Budapest; to Vienna 1931; in N.Y.: *Higher and Higher* (1940; Rodgers & Hart) and (with Kiepura) *The Merry Widow* (1943 & 1957) and *Polonaise* (1945). The operatic tenor Kiepura was at the Metropolitan Opera 1937–39 and 1941–42. (Photo: Vandamm, N.Y.)

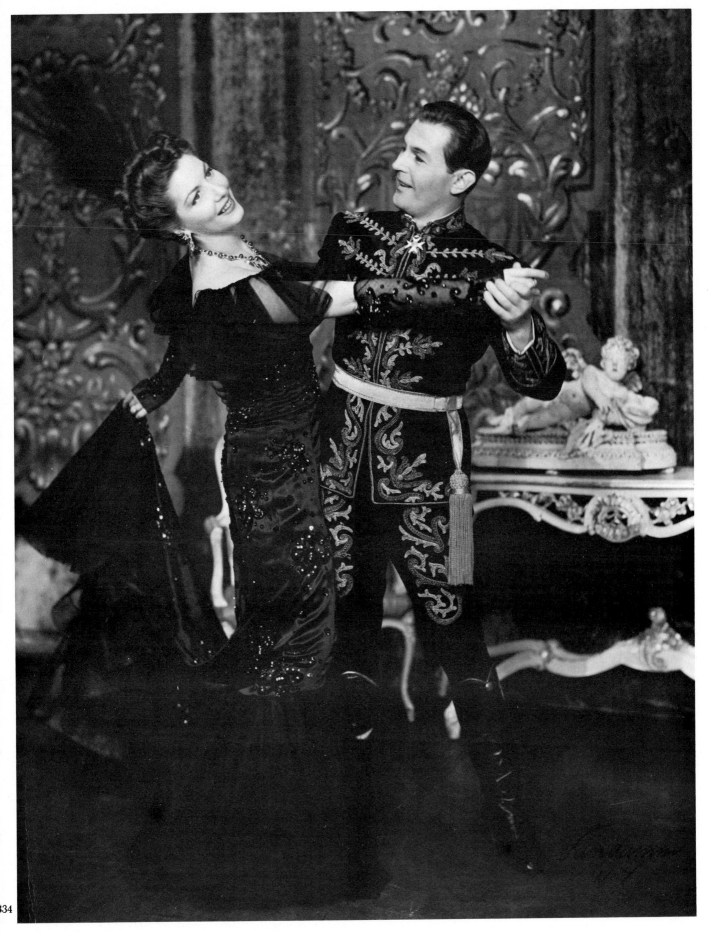

335

336

337

335. **PAUL HAAKON** (born 1914 in Denmark). Dancer and choreographer; worked with Pavlova. N.Y. appearances, 1933–44, included: *At Home Abroad* (1935); *The Show Is On* (1936); *Hooray for What!* (1937); *Mexican Hayride* (1944). (Photo: Maurice Seymour, Chicago; signed 1943.) 336. **JUNE HAVOC** (born 1916; real surname Hovick; sister of Gypsy Rose Lee, see No. 300). Vaudeville from infancy; N.Y. plays, 1936–66, included four musicals: *Forbidden Melody* (1936); *Pal Joey* (1940); *Mexican Hayride* (1944); *Sadie Thompson* (1944). (Photo: as "Dainty June," mid-1920s.) 337. **BAMBI LINN** (born 1926; real name Bambina Linnemier). Dancer. In chorus of *Oklahoma!* (1943); in *Carousel* (1945; Rodgers & Hammerstein; also revivals of 1950, 1954, 1957) and other musicals to 1962. (Photo signed 1945.) 338. **BURL IVES** (born 1909). Actor, folk singer. N.Y. stage 1938–67 (musicals to 1954), including: *The Boys from Syracuse* (1938); *This Is the Army* (1942); *Sing Out Sweet Land* (1944). (Photo: MCA.) 339. **RAY MIDDLETON** (born 1907). In N.Y. musicals 1931–65, including: *Roberta* (1933); *Knickerbocker Holiday* (1938; Weill); *Annie Get Your Gun* (1946); *Love Life* (1948); *Man of La Mancha* (1965). (Photo: Murray Korman, N.Y., ca. 1946.) 340. **WILBUR EVANS** (born 1908). Oratorio, opera, operetta. N.Y. shows 1942–54, especially *Mexican Hayride* (1944) and *Up in Central Park* (1945, shown here; Romberg). 341. **WILLIAM TABBERT** (1921–1974). In Chicago Civic Opera 1940–42; to N.Y. 1943. Shows 1944–54, especially *The Seven Lively Arts* (1944); *South Pacific* (1949); *Fanny* (1954). (Photo ca. 1954.)

338

339

340

341

343

344

342. **JAN (Jane) CLAYTON & JOHN RAITT** (both born 1917) rehearsing *Carousel*, 1945. Jan Clayton was in California theater—including *Meet the People* (1939)—before her N.Y. career (other musicals: revivals of *Show Boat*, 1946, and of *The King and I*, 1956). John Raitt, on stage from 1936 (California & Chicago), appeared in 6 other N.Y. musicals, especially *Three Wishes for Jamie* (1952) and *The Pajama Game* (1954). **343. KENNY BAKER** (born 1912). In *One Touch of Venus* (1943; "Speak Low") and out-of-N.Y. revivals. Films; especially radio work. (Photo ca. 1937.) **334. JANE PICKENS** (birth year unavailable). Radio with sisters. N.Y. musicals, 1934–51, included: *Thumbs Up* (1934); the second edition of *Ziegfeld Follies of 1936*; and Marc Blitzstein's opera *Regina* (1949, and 1952 revival.) (Photo: G. Maillard Kesslère, N.Y., mid-1930s.) **345. JANE FROMAN** (1907–1980; real name Ellen Jane Ross). In N.Y. shows, 1934–43 (especially *Ziegfeld Follies of 1934*). Highly promising career interrupted by crippling accident.

345

346

347

348

349

346. (Eileen) PATRICIA MORISON (born 1915). Long film career. In N.Y. musicals *The Two Bouquets* (1938); *Allah Be Praised!* (1944); and *Kiss Me, Kate* (1948; Porter; "Wunderbar" with Alfred Drake, "So in Love," "I Hate Men"; also in 1951 & 1965 revivals). (Photo: Paramount Pictures.) **347. GENE KELLY** (born 1912). Dancer, choreographer, producer, director, ... singer. Major film career following the N.Y. musicals: *Leave It to Me* (1938; Porter); *One for the Money* (1939); *Pal Joey* (1940; Rodgers & Hart; "I Could Write a Book"). (Photo: in the 1948 film *The Three Musketeers.*) **348. DOOLEY WILSON** (1894–1953). Was bandleader; onto N.Y. stage 1936. Musicals: *Cabin in the Sky* (1940) and *Bloomer*

Girl (1944; Arlen; "The Eagle and Me"). Gained immortality as Sam in the 1942 film *Casablanca*, reviving the song "As Time Goes By" from the 1931 Broadway show *Everybody's Welcome.* **349. KATHERINE DUNHAM** (born ca. 1910). Dancer, choreographer, folklorist, author. After dancing in the Chicago area, she was with the New York Labor Stage 1939–40; then, in the 1940 show *Cabin in the Sky.* Formed own touring troupe doing dances from many black cultures. Other N.Y. appearances: *Tropical Revue* (1943 & 1944); *Concert Varieties* (1945); *Carib Song* (1945); *Bal Nègre* (1946); *Katherine Dunham* (1950).

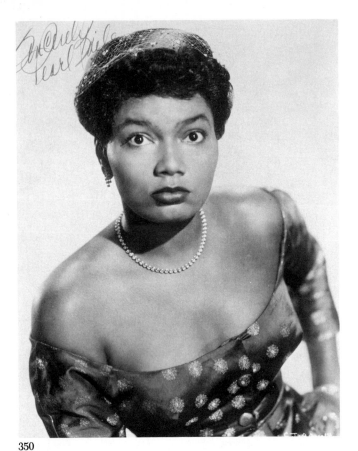

350

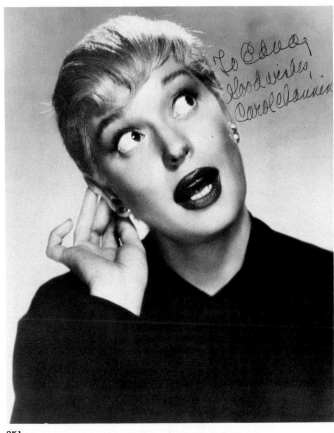

351

350. PEARL BAILEY (born 1918). Inimitable "lazy" song stylist; in vaudeville from 1933; much club work. N.Y. shows: *St. Louis Woman* (1946; Arlen; "Legalize My Name"); *Arms and the Girl* (1950); *Bless You All* (1950); *House of Flowers* (1954; Arlen); revival of *Hello, Dolly!* (1975). **351. CAROL CHANNING** (born 1921). Nonmusical N.Y. appearances 1941–42; understudied Eve Arden in *Let's Face It* (1941). Breakthrough in *Lend an Ear* (1948), lasting fame in *Gentlemen Prefer Blondes* (1949; "Diamonds Are a Girl's Best Friend"), consecration in *Hello, Dolly!* (1964; also 1978 revival). Other musicals 1955, 1961, 1974. (Photo: Moss, N.Y.) **352. BETTY GARRETT** (born 1919). N.Y. plays 1942–64; musicals 1942–60, especially *Something for the Boys* (1943; Porter); *Laffing Room Only* (1944); and *Call Me Mister* (1946; "South Amer-

ica, Take It Away"). (Photo: MGM, 1949.) **353. SHIRLEY ROSS** (ca. 1913–1975; real name Bernice Gaunt). Mainly films. In N.Y. show *Higher and Higher* (1940; Rodgers & Hart) introduced "It Never Entered My Mind." (Photo: still from late 1930s film.) **354. PHIL SILVERS** (born 1911; real surname Silver). Professional from 1925; much vaudeville and burlesque. N.Y. shows: *Yokel Boy* (1939); *High Button Shoes* (1947); *Top Banana* (1951); *Do Re Mi* (1960). USO work, films, television. (Photo: as Sgt. Bilko, TV, 1950s.) **355. BETTY BRUCE** (ca. 1924–1974). Dancer and singer; in major ballet companies 1931–35. N.Y. shows, 1938–45, included: *The Boys from Syracuse* (1938); *Something for the Boys* (1943); *Up in Central Park* (1945, shown here).

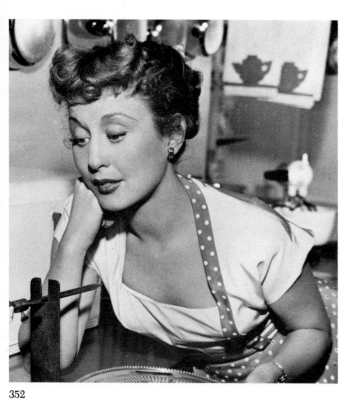

352

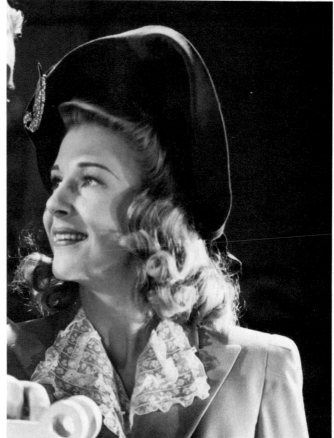

353

355

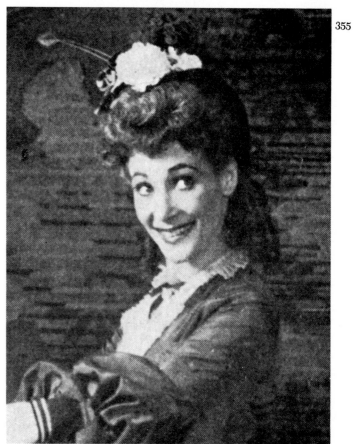

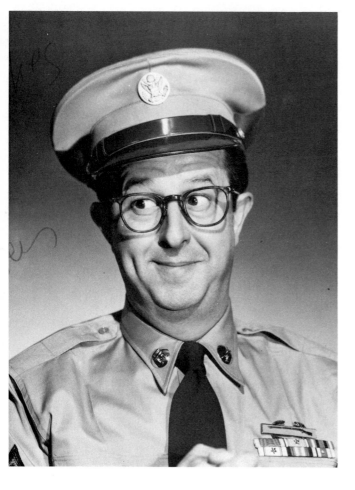

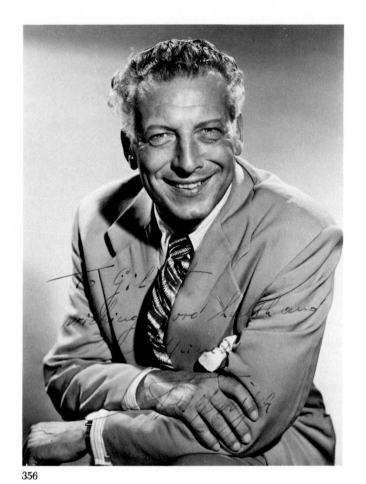

356

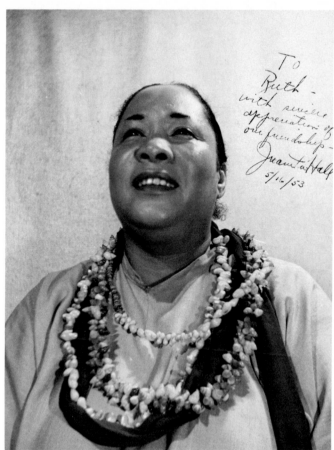

357

Stars of the original production of Rodgers & Hammerstein's *South Pacific* (1949). **356. EZIO PINZA** (1892–1957; born in Italy). The original Emile de Becque: "Some Enchanted Evening." Magnificent basso; at Metropolitan Opera 1926–47. Other N.Y. show: *Fanny* (1954). **357. JUANITA HALL** (1902–1968; real surname Long). The original Bloody Mary: "Bali Ha'i," "Happy Talk." On N.Y. stage from 1930. Major musicals: *Sing Out Sweet Land* (1944); *St. Louis Woman* (1946; Arlen); *South Pacific* (shown here, also 1957 revival); *House of Flowers* (1954; Arlen); *Flower Drum Song* (1958; Rodgers & Hammerstein). (Photo signed 1953.) **358. MARY MARTIN** (born 1913). The original Nellie Forbush: "I'm in Love with a Wonderful Guy," "I'm Gonna Wash That Man Right Outa My Hair." N.Y. shows: *Leave It to Me* (1938; Porter; "My Heart Belongs to Daddy"); *One Touch of Venus* (1943; Weill); *Lute Song* (1946); *South Pacific*; *Peter Pan* (1954); *The Sound of Music* (1959; Rodgers & Hammerstein; title song, "Do, Re, Mi"); *Jennie* (1963); *I Do! I Do!* (1966). She toured in *Annie Get Your Gun* in 1947–48, and in *Hello, Dolly!* in 1965.

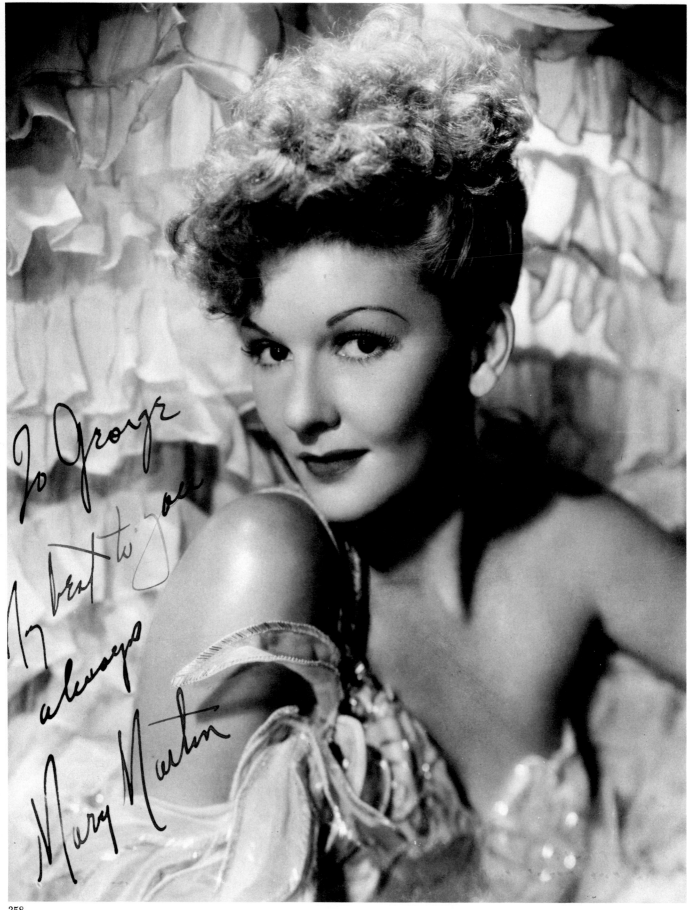

To George
My best to you
always
Mary Martin

358

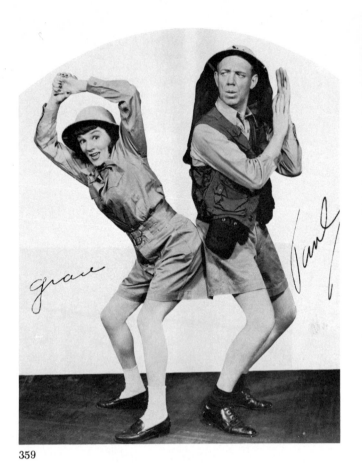

359

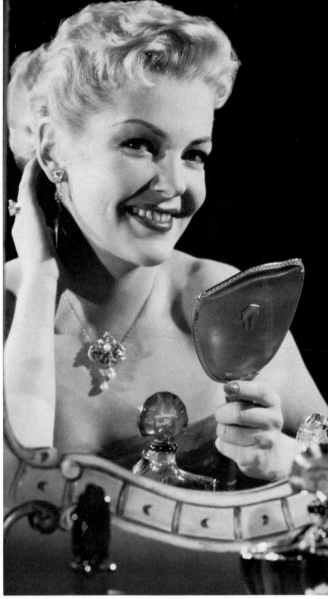

360

359. GRACE & PAUL HARTMAN. Hartman (ca. 1904–1973), on stage from infancy, was in vaudeville with Grace (1907–1955; née Barrett) before their first N.Y. show, *Ballyhoo of 1932*. Paul was on his own in the Porter shows *Red, Hot and Blue!* (1936) and *You Never Know* (1938). The couple were reunited in *Keep 'Em Laughing* (1942); *Top-Notchers* (1942); *Angel in the Wings* (1947, shown here); *All for Love* (1949); and *Tickets Please* (1950). Paul was on his own again in the 1952 revival of *Of Thee I Sing* and the 1957 revival of *The Pajama Game*, and made an appearance in 1961. **360. VIVIAN BLAINE** (born 1921; real name Vivienne Stapleton). 1950, the limit year of the present volume, was brightened by Frank Loesser's *Guys and Dolls*, in which Vivian Blaine sang "A Bushel and a Peck," "Take Back That Mink" and "Adelaide's Lament." Earlier she had been in vaudeville, singing with bands and acting in films, Later N.Y. show appearances: *Say Darling* (1958); revival of *Guys and Dolls* (1966); replacement, 1971, in 1970 show *Company*.

INDEX

The numbers are those of the illustrations.

Abarbanell, Lina, 108
Adams, George H., 11
Albert, Eddie, 285
Allen, Fred, 272
Allyson, June, 330
Arden, Eve, 315
Arno, Sig, 332
Astaire, Adele, 168, 169
Astaire, Fred, 168
Atherton, Alice, 30

Bailey, Pearl, 350
Baker, Belle, 186
Baker, Josephine, 191
Baker, Kenny, 343
Baker, Phil, 246
Balieff, Nikita, 183
Barnabee, H. C., 24
Barris, Harry, 163
Barton, James, 279
Basquette, Lina, 197
Bayes, Nora, 118
Beckett, Harry, 3
Bell, Digby, 51
Bell, Laura Joyce, 28
Benny, Jack, 273
Berle, Milton, 282
Berlin, Irving, 135
Bernard, Sam, 79
Bernie, Ben, 247
Blaine, Vivian, 360
Blake, Eubie, 194
Bledsoe, Jules, 227
Boland, Mary, 276
Bolger, Ray, 257
Bordoni, Irene, 156
Brian, Donald, 95
Brice, Fanny, 201
Brisson, Carl, 302
Broderick, Helen, 275
Brown, Joe E., 189
Brox, Bobbie, 163
Brox, Lorraine, 163
Brox, Patsy, 163
Bruce, Betty, 355
Bubbles, John, 269
Buchanan, Jack, 161
Butterworth, Charles, 255

Cahill, Marie, 67
Caine, Georgia, 102
Canova, Judy, 316
Cantor, Eddie, 199
Carle, Richard, 103
Carlisle, Kitty, 288
Carus, Emma, 94
Castle, Irene, 139
Castle, Vernon, 138
Catlett, Walter, 176
Caupolican, Chief, 213
Cawthorn(e), Joseph, 141
Channing, Carol, 351
Chasen, Dave, 280

Christie, Audrey, 258
Claire, Ina, 145
Clark, Bobby, 167
Clark, Marguerite, 38
Clayton, Bessie, 83
Clayton, Jan, 342
Clayton, Lou, 172
Cohan, George M., 80
Cole, Bob, 70
Collins, José, 120
Collins, Lottie, 44
Conor, Harry, 41
Cook, Joe, 281
Cottrelly, Mathilde, 17
Courtney, Inez, 239
Coward, Noël, 310
Cowles, Eugene, 23
Coyne, Joseph, 96
Crawford, Clifton, 147
Crawford, Joan, 236
Crosby, Bing, 163
Crumit, Frank, 229

Dailey, Peter F., 59
Dale, Charles, 233
Daly, Dan, 54
Daniels, Frank, 42
Davenport, Harry, 50
Davies, Marion, 116
Davis, Bessie McCoy, 85
Davis, Jessie Bartlett, 25
Dawn, Hazel, 134
Day, Edith, 148
Dazie, 104
De Angelis, Jefferson, 64
De Haven, Carter, 143
Delysia, Alice, 158
Demarest, Frances, 133
Deslys, Gaby, 125
Dickson, Dorothy, 196
Dixey, Henry E., 12
Dixon, Adèle, 266
Dockstader, Lew, 62
Dolly, Jenny, 184
Dolly, Rosie, 184
Donahue, Jack, 219
Dooley, Ray, 202
Dowling, Eddie, 149
Drake, Alfred, 322
Dressler, Marie, 92
Dunbar, Dixie, 290
Duncan, Rosetta, 188
Duncan, Todd, 270
Duncan, Vivian, 188
Dunham, Katherine, 349
Dunne, Irene, 235
Durante, Jimmy, 172

Earle, Virginia, 75
Eaton, Mary, 207
Ebsen, Buddy, 259
Ediss, Connie, 107
Edouin, Willie, 29

Edwards, Cliff, 236
Edwards, Gus, 144
Eggerth, Marta, 334
Ellis, Mary, 155
Ellis, Melville, 125
Eltinge, Julian, 130
Emmet, J. K., 31
Errol, Leon, 204
Etting, Ruth, 166
Evans, George
 "Honey Boy," 63
Evans, Wilbur, 340

Fabray, Nanette, 319
Fagan, Barney, 68
Faust, Lotta, 89
Fay, Frank, 190
Fields, Lew, 57
Fields, W. C., 121
Ford, Helen, 237
Fox, Della, 37
Fox, G. L., 10
Foy, Eddie, Jr., 312
Foy, Eddie, Sr., 65
Franklin, Irene, 82
Friganza, Trixie, 105
Froman, Jane, 345

Gabriel, Master, 99
Gallagher, Edward, 205
Gallagher, Richard
 "Skeet(s)," 240
Gardella, Tess, 225
Gardiner, Reginald, 274
Garrett, Betty, 352
Gaxton, William, 294
Gear, Luella, 292
Geva, Tamara, 255
Glendinning, Ernest, 125
Gordon, Kitty, 112
Grafton, Gloria, 262
Gray, Alexander, 206
Gray, Gilda, 200
Green, Mitzi, 297
Greenwood, Charlotte, 146
Groody, Louise, 154
Grossmith, George, Jr., 107
Gunning, Louise, 98

Haakon, Paul, 335
Hajos, Mitzi, 111
Haley, Jack, 286
Hall, Adelaide, 193
Hall, Bettina, 265
Hall, Juanita, 357
Hall, Pauline, 19
Harrigan, Edward, 14
Harrold, Orville, 113
Hart, Tony, 14
Hartman, Grace, 359
Hartman, Paul, 359
Havoc, June, 336

Healy, Ted, 243
Heath, Thomas K., 78
Heatherton, Ray, 299
Held, Anna, 73
Herbert, Evelyn, 150
Hitchcock, Raymond, 131
Hoctor, Harriet, 215
Hoffa, Portland, 272
Hoffman(n), Gertrude, 128
Hogan, Ernest, 69
Holloway, Sterling, 230
Holm, Celeste, 323
Holman, Libby, 306
Hope, Bob, 284
Hopper, De Wolf, 36, 38
Hopper, Edna Wallace, 91
Howard, Eugene, 126
Howard, Joseph E., 77
Howard, Willie, 126
Howland, Jobyna, 185
Hoyt, Caroline Miskel, 40
Hoyt, Flora Walsh, 39

Irwin, May, 66
Ives, Burl, 338

Jackson, Eddie, 172
Janis, Elsie, 90
Jansen, Marie, 18
Jemima, Aunt, 225
Johnson, Billy, 70
Johnson, Chic, 314
Johnstone, Justine, 119
Jolson, Al, 124
Jones, Allan, 308
Joyce, Laura, 28

Kane, Helen, 187
Karl, Tom, 22
Karlweis, Oskar, 331
Kaye, Danny, 318
Kearns, Allen, 175
Keeler, Ruby, 174
Kellerman(n), Annette, 129
Kelly, Gene, 347
Kelly, Patsy, 255
Kiepura, Jan, 334
King, Charles, 236
King, Dennis, 214
Knight, June, 304
Kossa, Tessa, 173

Lahr, Bert, 271
Lake, Harriette, 303
Lane, Lupino, 157
Lang, Harold, 327
La Rue, Grace, 165
Lawrence, Gertrude, 160
Laye, Evelyn, 267
Lee, Gypsy Rose, 300
Leonard, Eddie, 106
Le Roy, Hal, 291
Levey, Ethel, 81

Lewis, Ada, 49
Lightner, Winnie, 180
Lillie, Beatrice, 162
Lingard, W. H., 6
Linn, Bambi, 337
Lloyd, Alice, 84
Logan, Ella, 320
Losch, Tilly, 254
Luce, Claire, 260

MacDonald, Christie, 109
MacDonald, W. H., 21
Mack, Andrew, 35
Mack, Charles, 209, 210
Mann, Louis, 52
Markham, Pauline, 1
Marsh, Howard, 224
Marshall, Everett, 309
Martin, Mary, 358
Marx, Chico, 182
Marx, Groucho, 182
Marx, Harpo, 182
Marx, Zeppo, 182
Matthews, Jessie, 159
May, Edna, 48, 50
Mayfair, Mitzi, 289
McCoy, Bessie, 85
McCracken, Joan, 329
McCullough, Paul, 167
McHenry, Nellie, 9
McIntyre, James T., 78
McNaughton, Tom, 132
Merman, Ethel, 250, 251
Middleton, Ray, 339
Miller, Marilyn, 115
Mills, Florence, 195
Minevitch, Borrah, 245
Miranda, Carmen, 317
Miskel, Caroline, 40
Mitzi, 111
Montgomery, Dave, 88
Moore, Grace, 164
Moore, Victor, 275
Moran, George, 208, 210
Morgan, Helen, 221, 222
Morgan, Leone, 140
Morison, Patricia, 346

Munson, Ona, 153
Murphy, George, 307
Murray, J. Harold, 218
Murray, Mae, 117
Myrtil, Odette, 256

Nagel, Conrad, 236
Nicholas, Fayard, 296
Nicholas, Harold, 296
Nielsen, Alice, 43
Niesen, Gertrude, 293
Novis, Donald, 263
Novotná, Jarmila, 333

Oland, Warner, 139
Olcott, Chauncey, 34
Olsen, George, 211
Olsen, Ole, 313
O'Neal, Zelma, 241
Osato, Sono, 326
Otero, Caroline, 46

Painter, Eleanor, 110
Pastor, Tony, 26
Patricola, Isabelle, 179
Patricola, Tom, 179
Pearce, Alice, 328
Pearl, Jack, 283
Pennington, Ann, 181
Pickens, Jane, 344
Pinza, Ezio, 356
Powell, Eleanor, 253
Powers, James T., 55
Preisser, June, 298
Primrose, George H., 61
Printemps, Yvonne, 301
Puck, Eva, 226
Purcell, Charles, 244

Quedens, Eunice, 315

Raitt, John, 342
Rall, Tommy, 324
Reynolds, Earle, 73
Richman, Harry, 178
Ring, Blanche, 72
Rinker, Al, 163

Ritchie, Adele, 74
Roberti, Lyda, 278
Roberts, Joan, 321
Robertson, Guy, 264
Robeson, Paul, 228
Robinson, Bill, 192
Rogers, Ginger, 249
Rogers, Gus, 97
Rogers, Max, 97
Rogers, Will, 203
Rooney, Pat, Jr., 142
Ross, Shirley, 353
Roth, Lillian, 231
Rowland, Adele, 147
Russell, Lillian, 20

Sabel, Josephine, 93
Sanderson, Julia, 141
Santley, Joseph, 136
Savo, Jimmy, 277
Scanlan, William J., 33
Scheff, Fritzi, 101
Schenck, Joe, 122
Seabrooke, Thomas Q., 53
Seeley, Blossom, 198
Segal, Vivienne, 152
Shaw, Oscar, 170
Shean, Al, 205
Shutta, Ethel, 212
Silvers, Phil, 354
Skelly, Hal, 234
Slezak, Walter, 311
Smith, Joe, 233
Smith, Kate, 242
Smith, Queenie, 171, 221
Sothern, Ann, 303
Steel, John, 137
Stone, Dorothy, 232
Stone, Fred, 86, 88
Summerville, Amelia, 13
Suratt, Valeska, 127
Sykes, Jerome, 56

Tabbert, William, 341
Tamara, 305
Tanguay, Eva, 76
Tempest, Florence, 100

Tempest, Marie, 27
Templeton, Fay, 60
Terris, Norma, 220
Terry, Ethelind, 217
Thomas, John Charles, 169
Thompson, Lydia, 2
Tilley, Vesta, 45
Tinney, Frank, 123
Trentini, Emma, 114
Truex, Ernest, 333
Tucker, Sophie, *frontispiece*

Vallée, Rudy, 248
Van, Gus, 122
Velez, Lupe, 261
Vokes, Jessie, 7
Vokes, Rosina, 7, 8
Vokes, Victoria, 7

Walker, George W., 71
Walker, Nancy, 325
Walker, Polly, 238
Walters, Charles, 258
Warfield, David, 58
Waters, Ethel, 268
Webb, Clifton, 140, 255
Weber, Joseph M., 57
West, William H., 61
Wheeler, Bert, 216
White, George, 177
White, Sammy, 221
Whiting, Jack, 295
Williams, Bert, 71
Williams, Gus, 32
Wilson, Dooley, 348
Wilson, Francis, 16
Winninger, Charles, 223
Wood, Peggy, 287
Woolsey, Robert, 216
Worrell, Jennie, 4
Worrell, Sophie, 5
Wynn, Bessie, 87
Wynn, Ed, 151

Yeamans, Annie, 15
Yohe, May, 47

Zorina, Vera, 252